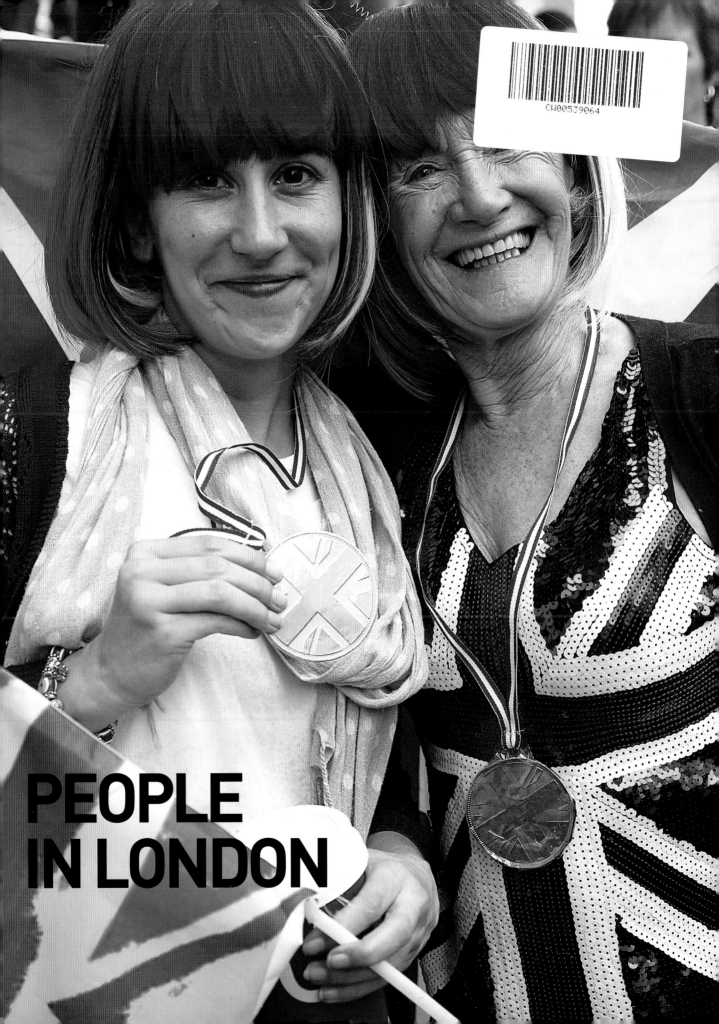

PEOPLE IN LONDON

CW00539064

PEOPLE IN

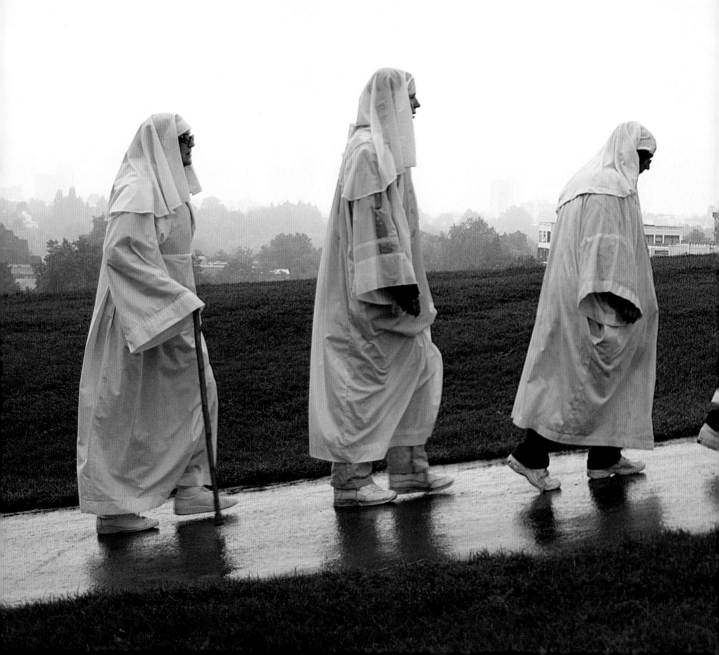

LONDON

ONE PHOTOGRAPHER FIVE YEARS **THE LIFE OF A CITY**

RICHARD SLATER

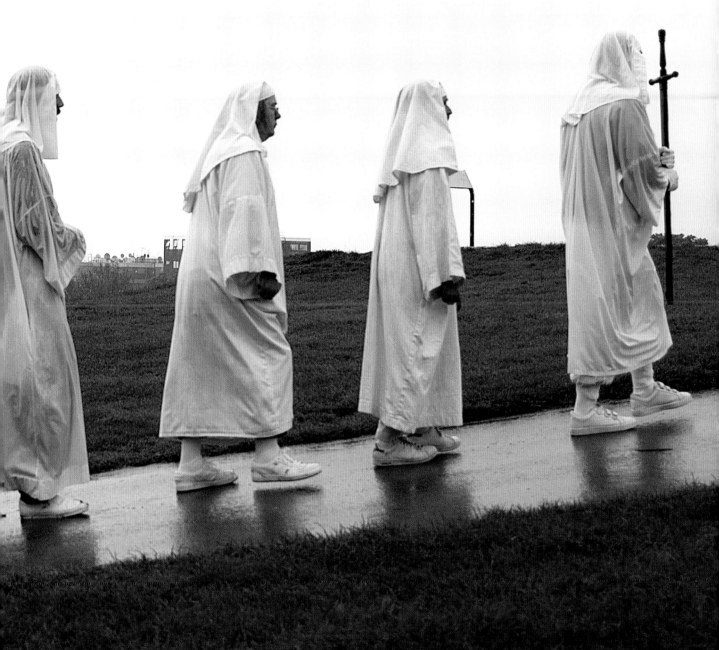

Elliott &Thompson

Published to coincide with the opening of the exhibition
PEOPLE IN LONDON at the Royal Geographical Society, London
8 September to 17 October 2014

First published in Great Britain in 2014 by
Elliott & Thompson Ltd
27 St John Street
London WC1N 2BX
www.eandtbooks.com

Text and photographs © 2014 Richard Slater

All rights reserved. No part of this publication may be reproduced,
stored in or introduced into a retrieval system, or transmitted, in
any form, or by any means (electronic, mechanical, photocopying,
recording or otherwise) without the prior written permission of the
publisher. Any person who does any unauthorised act in relation to
this publication may be liable to criminal prosecution and civil claims
for damages.

ISBN 978-1-78396-098-9

British Library Cataloguing in Publication Data
A catalogue record for this book is available from the British Library

Design Raymonde Watkins
Editorial Project Management Johanna Stephenson
Maps designed and drawn by Sally Stiff
Printed and bound in Italy by Printer Trento

Page 1: A lot of Union Jacks and gold medals were on
show at the 2012 Victory Parade through central London.
Pages 2–3: Members of the Ancient Druid Order on
their way to the top of Primrose Hill for the Autumn
Equinox ceremony.
Page 8: Notting Hill Carnival.

TRIBAL
LONDON
PAGE 10

FAITH
IN LONDON
PAGE 58

THE LONDON
MELTING POT
PAGE 108

CELEBRATING
LONDON
PAGE 144

STREET
LONDON
PAGE 184

LONDON
SURPRISES
PAGE 214

Contents

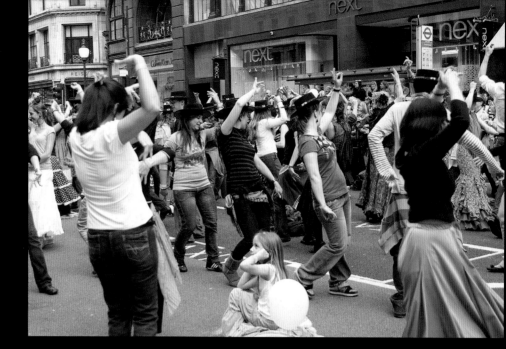

I T WAS a fine Saturday afternoon in May. Regent Street would normally have been full of shoppers and tourists but, instead, it was closed to traffic. The reason? There was going to be an attempt on a World Record. The organisers of the Taste of Spain Festival were hoping that, in central London that day, they'd have more people doing a *Sevillanas* dance than anyone had ever managed before. They'd publicised the event, obviously, but they had no idea how many people would show up. And so they were a little anxious.

They need not have worried. Londoners love any kind of street party. If there's music and dancing and a chance to dress up, then so much the better. According to the Guinness officials, 456 people danced the dance that day and so, yes, a new World Record was set.

They were young and old, male and female, black and white and from a wide range of social backgrounds. Many of the women were wearing flouncy dresses and Flamenco dance shawls with long fringes. They'd put combs or flowers in their hair too. And everywhere you looked, there were men in black sombreros *Sevillanas*. That big crowd hadn't just happened to be there. They'd heard about the event and planned for it.

Once they got there, they were going to make sure that they had as much fun as possible. Hardly

anyone had done a *Sevillanas* dance before but they tried to follow the bit of tuition offered by the organisers at the start and gave it their best shot. What most people did, if they lost their way, was put an arm in the air and stamp a foot like a Flamenco dancer and then catch the others up.

That was one of my first street parties when I set out five years ago to take the photographs for this book. It turned out to be typical of many that followed. A lot better than I expected and a huge amount of fun. I've been struck again and again by how much Londoners seem to enjoy each other's company at any street parade, festival, celebration or party. The city offers an endless stream of opportunities to have a good time free of charge and, whatever it is, people are up for it.

There are other, less pleasurable, reasons for taking to the streets, of course. London has always been the setting for political protest and I photographed some of the demonstrations that made the national news in the last five years. The experience was sometimes alarming when violence erupted between the crowd and the police or when, as happened once, I was kettled.

There was only one occasion when I faced aggression from the people I was trying to photograph. It was when I was taking pictures of a group queuing for a free meal in Camden Town.

Everywhere else, people either ignored me or were friendly or asked politely why I was taking photographs – and were then genuinely interested in what I told them. This was true even in the parts of London where I stood out like a very sore thumb as I wandered around with my camera.

I was surprised again and again by how readily religious bodies allowed me to take photographs in their churches, mosques, temples, synagogues and so on, provided, of course, that I did nothing to disturb whatever devotions were taking place there.

A lot of the religious ceremonies that I have photographed in the last five years were extremely colourful. But so too were lots of the other events – all the carnivals and parades and seasonal celebrations for instance. Even day to day, London's streets have become much brighter and more cheerful than they used to be. And the city's population is altogether more lively and interesting than it was, say, forty years ago. I remember very well how drab and dreary London was in the 1970s. It has changed out of all recognition since then. By far the most powerful overall impression made on me over the last five years, as I've gone backwards and forwards across the city, has been just what an exciting, stimulating and colourful place London really has become. I hope this book bears that out.

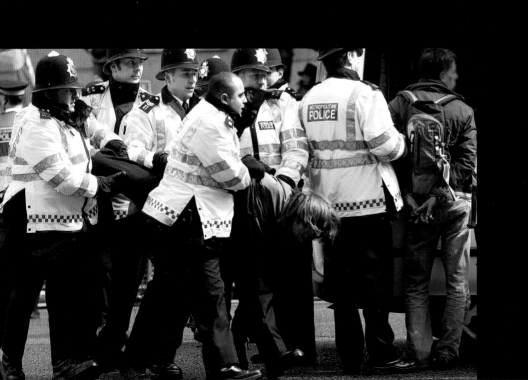

This calendar shows, in rough chronological order, the time of year when some of the events photographed in the book took place. The numbers refer to the pages on which they appear.

Calendar

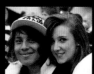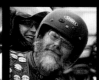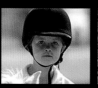

Tribal London

WE HUMANS are social animals. There are many reasons why we get together in groups. Sometimes it's because we want to spend our leisure time in the same way as the others do – taking some kind of exercise, watching sport, riding motorbikes or tinkering with veteran cars. Or it might be simply that we have the same sexual orientation or that we like to dress in a particular way or that some branch of popular culture appeals to us. Or perhaps just that we work in the same place or live in the same community. And in other cases, it might be external circumstances that bring us together. Whatever the reason, once we're in the group, we relax a bit, we feel among our own, we're in our tribe, we know what's expected of us.

This chapter looks at some of the tribes of London. When I made a list of the tribes that I could photograph, the possibilities were endless. But I could fit in only a few of them and so I decided to go for variety.

I mingled with the crowd in the Royal Enclosure on Ladies' Day at Ascot. The same sort of people were in the Queen's Stand at Epsom on Derby Day but I spent the afternoon with a different tribe on the Hill, where there are lines of open-topped buses, a massive fairground and one giant party. London has some clubs, like the MCC and Hurlingham, that it takes half a lifetime to get into. I photographed their members. At the other end of the social scale, I spent time at the 999 Club, a shelter for the homeless in Deptford, and also with rough sleepers and *Big Issue* sellers.

There are two very different crowds that I've always been a bit in awe of: people who ride horses in Hyde Park and Harley Davidson bikers. Getting close enough to photograph them cured me of this. Skateboarders, on the other hand, continue to be a mystery to me, even though I

spent quite a bit of time at their skateboarding park on the South Bank. A brilliant discovery was the large group of in-line skaters who start out from Hyde Park twice a week in the summer and tear around the streets accompanied by a boom box. And an even better one was the World Naked Bike Ride, which takes a thousand naked cyclists through central London every year.

I had fun with the gay community, who loved posing for pictures at the Pride in London Parade. Conversely, even the most flamboyant punks were curiously reluctant to be photographed until I'd chatted to them for a bit. Football fans were definitely up for it but then they were up for the FA Cup at Wembley and would have stood on their heads if I'd asked them to. You'll see in this chapter the very obvious difference between the football and rugby tribes because I took some shots at Twickenham too.

Do you have any idea how the Lord Mayor gets elected? No, nor did I until, as a special privilege, I was allowed into the Guildhall to photograph the City's liverymen doing it at an event called Common Hall. I thought that getting permission to take pictures of freemasons would be hard but I found a couple walking openly through streets in the Lord Mayor's Show.

Concern for the environment brings people together. I took some pictures of people who were actually getting down and dirty – really dirty – slopping about in the Thames mud at low tide, picking up and bagging the rubbish.

I wanted to see the contrast between different shopping scenes. So this chapter contains photographs of a designer label shop in Bond Street, a pound shop in Peckham and a car boot sale in Kilburn. Londoners will always put in time raising money for charity. I went to photograph them running, jogging, walking and paddling. And they were almost always dressed in silly outfits.

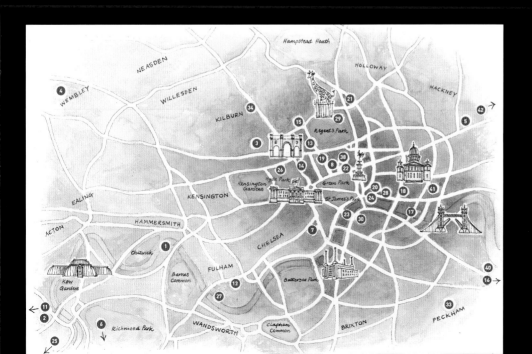

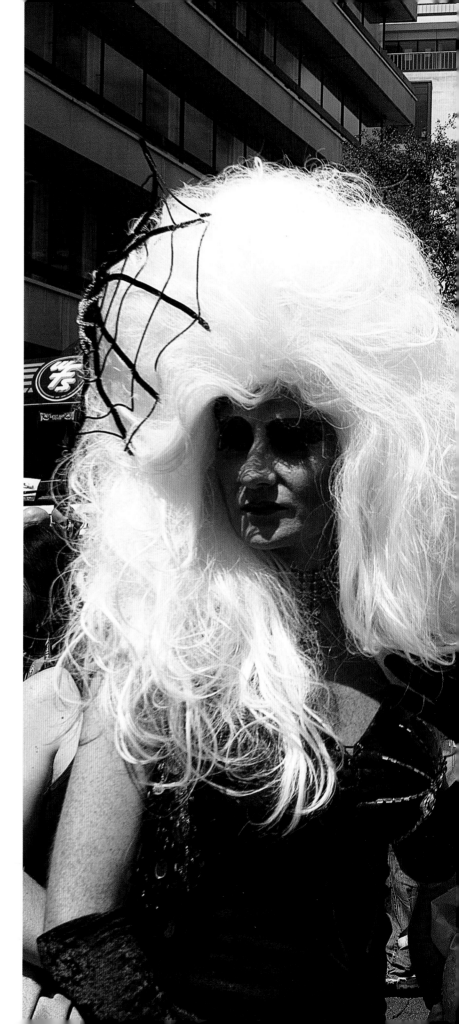

PRIDE IN LONDON PARADE, BAKER STREET

The riot that took place at the Stonewall bar in New York on 28 June 1969 got some media coverage but only a fraction of what it would have had if its effect on future events had been known. On that night in 1969, continuous harassment and frequent violent raids finally got to the LGBT community in the city and they rose up in protest. LGBT stands for lesbian, gay, bisexual and transgender. This was the spark which ignited the equal rights movement round the world.

Three years later, on the Saturday in June which was closest to the anniversary of that Stonewall riot, the first UK Gay Pride Rally was held in London. It was a relatively small affair. By the mid 2000s, the name Pride London had been adopted, Regent Street and Oxford Street were closed to traffic for the parade and thousands were taking part. It has changed its name again now – to 'Pride in London' – and the theme for 2014 is 'Freedom to', or, as they put it: 'Freedom to ... be ourselves, love who we want, change society, live without fear, be an Olympic medal winner Whatever the Freedom is that you cherish, this is the chance to celebrate it.' **19**

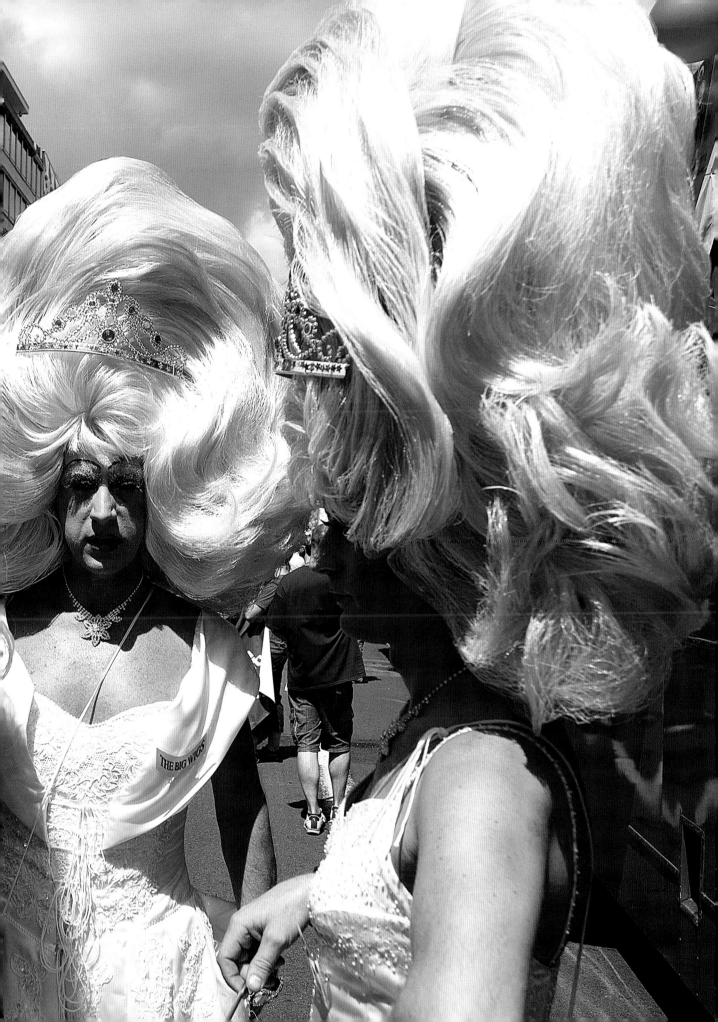

THE BIG WIGS

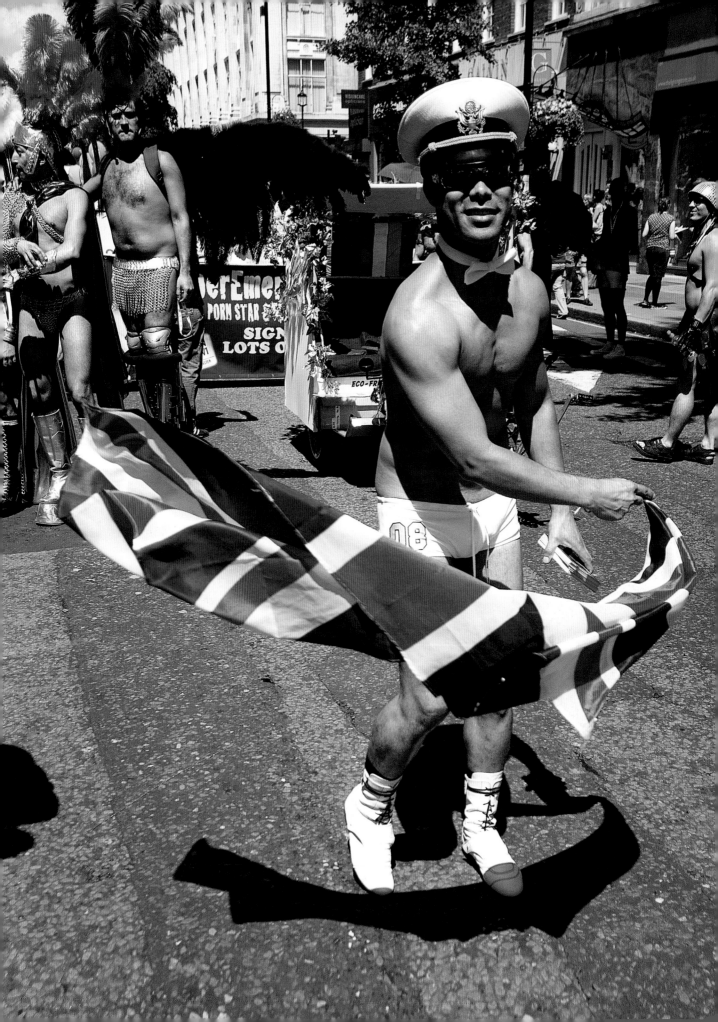

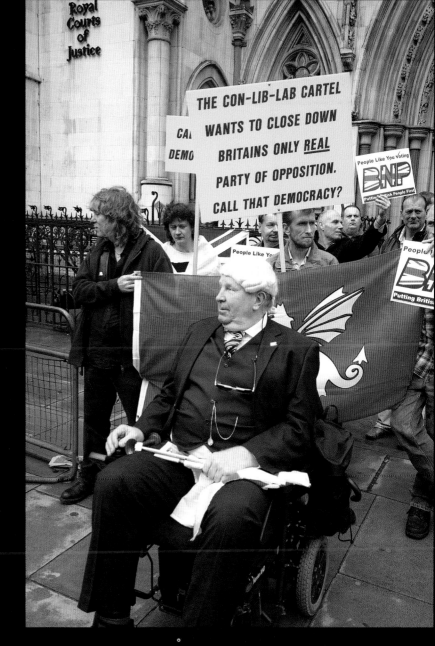

BEING THERE WITH A CAMERA
... at the Pride in London Parade

The parade formed up in Baker Street before it set off along Oxford Street. This gave everyone who was in it a great chance to pose for photographers and show off the costumes that they'd put so much ingenuity into creating. In that short stretch, there were sailor boys, what I took to be romantic brides with enormous hairdos (they were wearing badges proclaiming themselves the 'Big Wigs'), Viking warriors, witches, nuns, a group of bare-chested boys in rainbow wigs, Tahitian maidens, Flamenco dancers, Japanese matrons complete with parasols and many, many more.

BNP DEMONSTRATION, LAW COURTS, THE STRAND

It's not Rumpole, obviously, though it looks like him. I'm not even sure if he's a real barrister. But one thing is clear. He's a member of the British National Party. A group of them were demonstrating outside the Law Courts because a hearing was going on inside into the question of whether the party's constitution was lawful. It said that only 'indigenous British people' could be members and the Equality and Human Rights Commission had claimed that this was a breach of the Race Relations Act. The case had dragged on for months, with adjournments for this and that reason, and, while it was going on, there had been a massive brouhaha about whether the party's leader, Nick Griffin, should or should not appear on the BBC's *Question Time*. Wild claims and counterclaims had been bandied about. People had got very excited.

Postscript: The BNP lost the case and had to change its constitution. Undeterred, Nick Griffin declared that this was a David and Goliath victory. **20**

THE HILL, DERBY DAY, EPSOM RACECOURSE

The first 'Derby' was run in 1780. It was a pretty informal affair. Lord Derby had a group of friends over to his house, The Oaks, and they got a race up for some of their best horses on the nearby Epsom Downs. By the end of the 18th century the meeting had become well established and very popular with Londoners. In fact, lots of them were bunking off work to go to it. So, from the very beginning, you had hobnail boots and polished spats, flat caps and top hats at the same event.

At the same event but not really together. English racecourses have always offered you the chance to mix with your own tribe – and only your own tribe – in an enclosure reserved for you. And working-class Londoners have got a huge space at Epsom. It's called the Hill and it's the whole of the middle of the racetrack. Derby Day has been a recognised day out for over two centuries. Dickens described a visit there some time in the 1850s. In 1858 William Frith produced a painting of the scene on the Hill which was such a sensation that the Royal Academy had to put up railings to keep the crowds back from it.

People still come in their thousands today. Just about every open-topped bus in London is commandeered. They're parked along the inside rail for several furlongs up to the finishing line and the people in them get just as good a view as those in the Queen's Stand. And probably a lot more laughs. Just behind the buses is a massive funfair. There are thrill rides of every kind, flinging people into the air, round and round, upside down, with flashing strobe lights and a perpetual din. Groups are having picnics everywhere. Some are well organised with tables and chairs. Others just have a few beers and grab hot dogs from the food stalls. The people on the Hill have come to watch the racing. Have some fun at the fair. Down a few drinks. Lay a few bets. Maybe win some money. Maybe lose some. Who cares? They're here to have a good time. And they certainly do that. **6**

 TAKING THE PICTURES on Derby Day

Epsom Racecourse had given me a Press Pass and a blue Press vest, which allowed me to go anywhere I liked.

I started in the Queen's Stand, where the men were all dressed in morning suits and the ladies in smart dresses and hats. I soon found, though, that the Press vest made most people actively hostile. Hopeless if what you want to do is take their photograph.

So I headed across the track to the Hill. The contrast couldn't have been greater. Everyone was excited to be photographed and wanted to know what it was for. Would they be 'in the papers'? As I wandered round the funfair, groups of young people came up and actually asked if I would take their pictures. They didn't want to be sent copies. Just to be photographed.

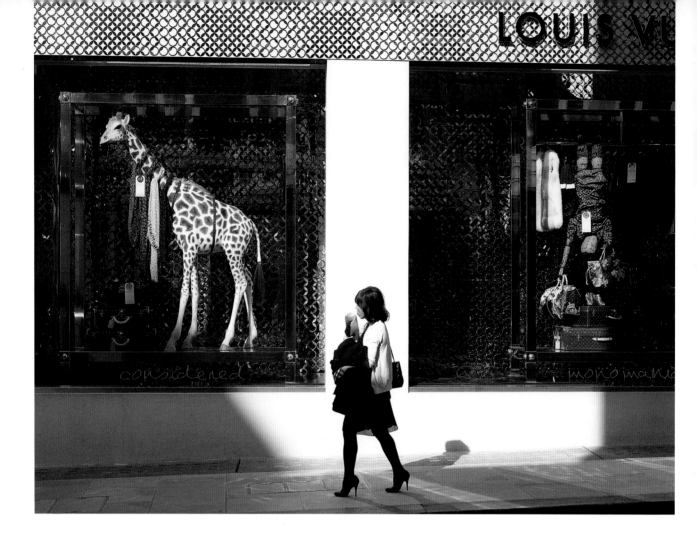

BOND STREET

It's not surprising that the prices on Bond Street are a bit steep. The rents, which in some cases have gone above £1,000 a square foot, are reckoned to be the highest in the world. Think about it. A square foot is roughly the space that your waste-paper basket takes up. Rents, and the value of the real estate, climb and climb. But in the world where luxury fashion, shoes, jewellery and watches are sold, you can't hold your head up unless you've got a suitably lavish shop on Bond Street.

A lot of the customers who come through the doors are tourists and especially, in recent years, Chinese ones. But the Japanese are keeping their end up too. And there are still natives shopping there. Apparently, plenty of us believe that these are 'must-have' items and we'll fork out, for example, £5,000 for a handbag.

This is a cut-throat world, though, and you can't rest on your laurels. Why should your international tourist with money to burn buy his Gucci loafers or her Jimmy Choo shoes in London rather than Paris, New York or Milan? So there's a plan for a makeover of Bond Street. Not too dramatic, because they don't want it to lose its individuality, but enough to keep attracting top dollar. There'll be a grand entrance, seating, a concierge service that will deliver shopping to your hotel and they're taking away lots of ugly street furniture. **8**

CAR BOOT SALE, KILBURN

The first impression is that a bomb's exploded here. But when you look again, you realise that, among all those milling people, things are actually in some sort of order. There are quite a few racks of clothes and they don't look bad at all. Some tables have got electronic and electrical goods on them. Isn't that a fan and wasn't it impossible to buy one in the recent hot spell, even on Amazon? Come to think of it, we need a new washing-up brush. There's sure to be one somewhere here. Get in there and you find that even the stuff on the ground is neatly displayed. And the goods on sale are wildly and wonderfully unpredictable.

So it's no surprise that hundreds of people come to this car boot sale every Saturday, whether as sellers or as buyers. It takes place in a school playground and it goes on for hours. **34**

PUNKS, CAMDEN TOWN

I'm sure that you know one when you see one but can you describe a punk in a few words? I'd be amazed if you can because the term covers such a wide range of fashion, music, political views, art, literature, film, dance and lifestyle generally that it requires a full *Sunday Times* Style Magazine to do it justice. We'll stick here to what punks look like.

 Shocking. Literally. Because exactly what they're setting out to do is shock you. With their clothing, hairstyles, make-up, tattoos, jewellery and body piercing. In the early days, bin-liners were used a lot, often held together by safety pins or wrapped with masking tape, but you don't see that much any more. Black leather jackets are very common, decorated with metal studs or spikes and maybe with painted band logos. Tight jeans are the norm but you do occasionally see tartan trousers, kilts and skirts on men. Hair's a big deal, of course. They favour vibrant, unnatural colours, mohawks, spikes and other weird shapes that stand up as high as possible. Chains are important too, worn in all kinds of different places, including round the neck. Sometimes padlocks are added. And footwear? Doc Martens, naturally, but also Converse sneakers, skate shoes and brothel creepers. **21**

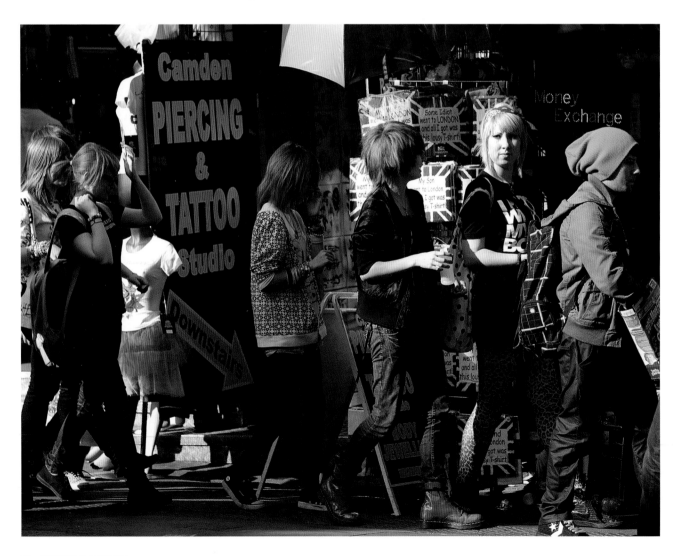

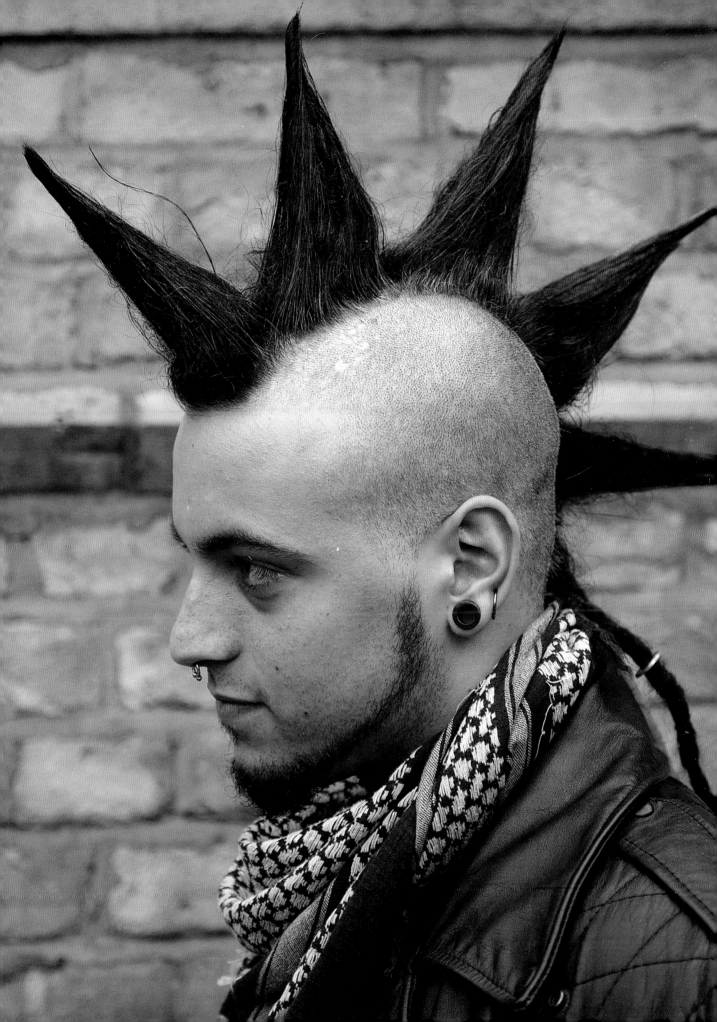

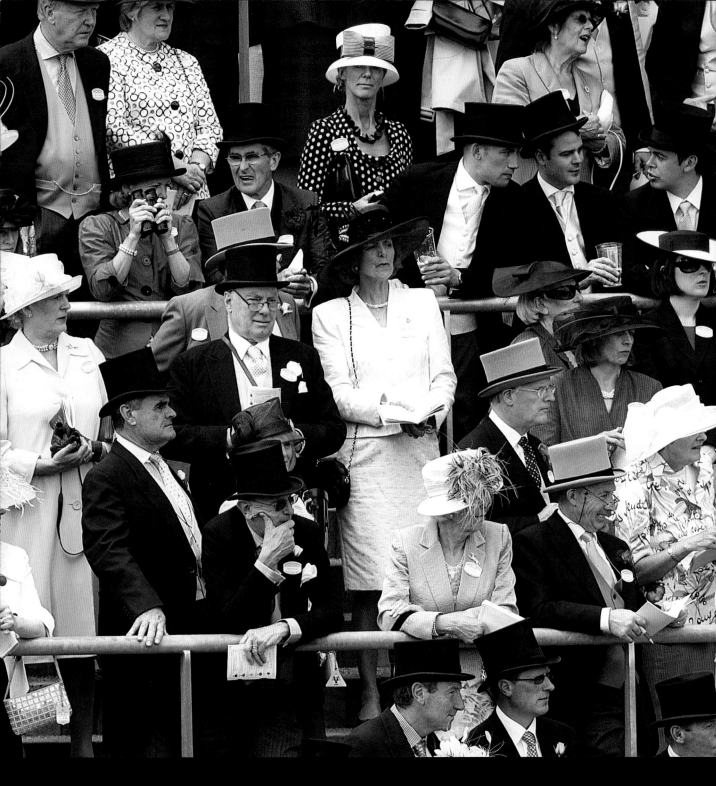

ROYAL MEETING, ASCOT RACECOURSE

If you're watching racing on the telly one day and you think, 'Wouldn't it be cool to go to the Royal Enclosure at Ascot next June? I'll buy a new dress, killer heels and an amazing hat so that I get my picture in the papers', you need to get on the case right away. First off, you've got to find a Royal Enclosure Member who'll sponsor you. And not all of them will do. It must be a Member who's been in the Royal Enclosure at least four times. Unless you're a foreign national, that is. Then you've got another way in. You can ask your embassy or high commission to submit your name. And whichever route you take, you can't hang about. Sponsorship forms have to be in months ahead.

The Royal Meeting lasts for five days. I went on 'Ladies' Day'. This is when the most extravagant and ridiculous hats are on show. Although the Group 1 Gold Cup was run on this day, I couldn't help noticing that some ladies were more interested in what their female 'competitors' were wearing than in which horse had won the race. **11**

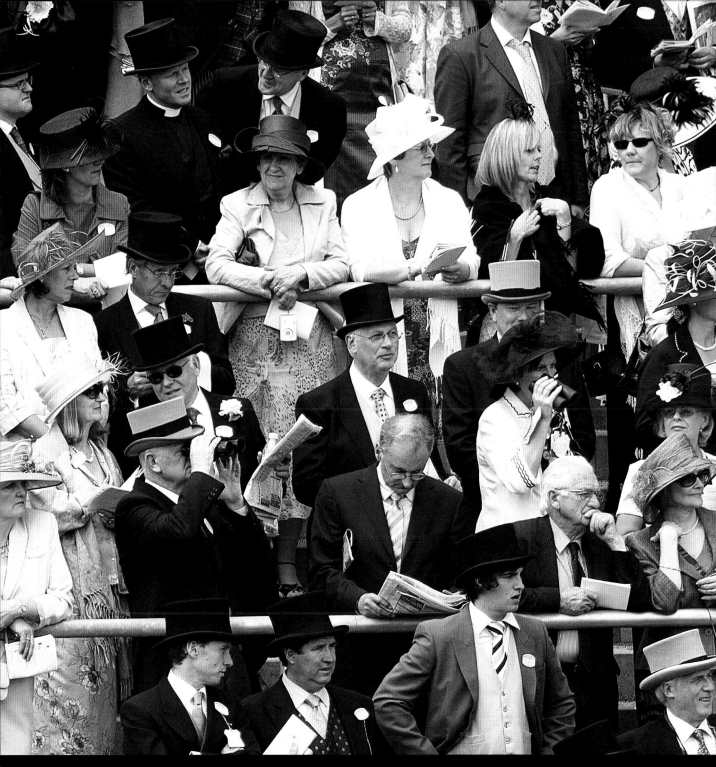

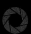

Step 1: Get special permission and a complimentary entry ticket from the PR department of Ascot Racecourse.

Step 2: Find out what time people start going into the Royal Enclosure on Ladies' Day and make sure that I'm there then.

Step 3: Join the scrum of press photographers round the main gate waiting to intercept celebrities and the ladies wearing the most outrageous hats and jostle to get the best position for a photograph whenever one of them arrives.

Step 4: Discover that the press pack is really only interested in celebs and that I can get the shots that I want of unknown ladies with weird (and also just plain beautiful) hats. Also discover that almost all these ladies are only too pleased to pause and have their photographs taken by someone with an impressive looking camera.

Step 5: Move on to the Royal Enclosure itself and take group shots there.

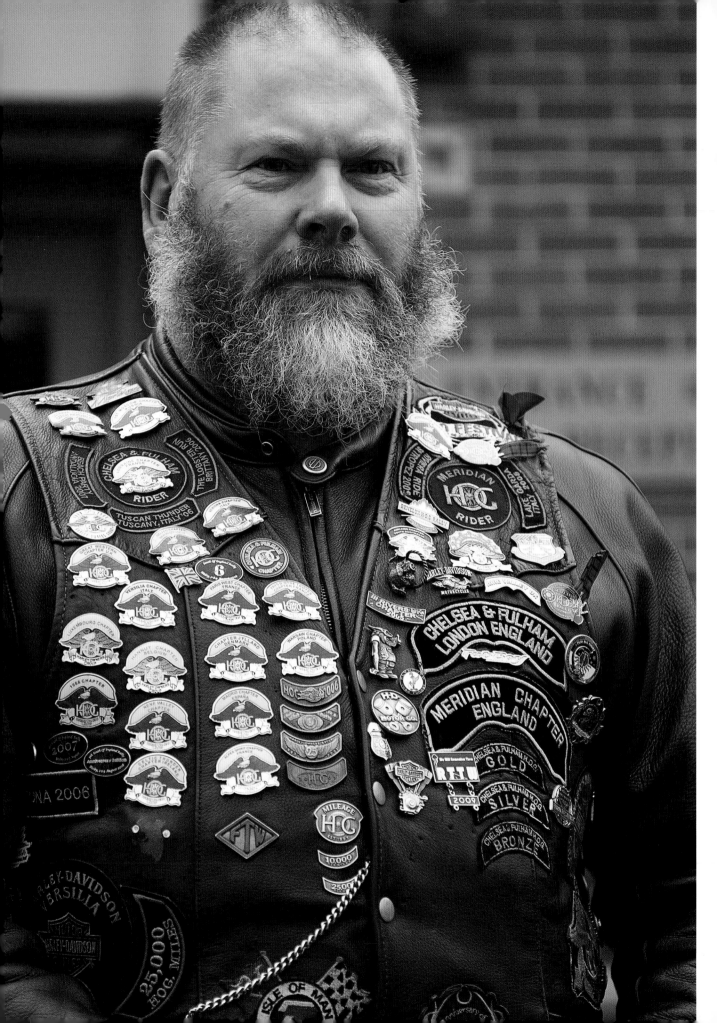

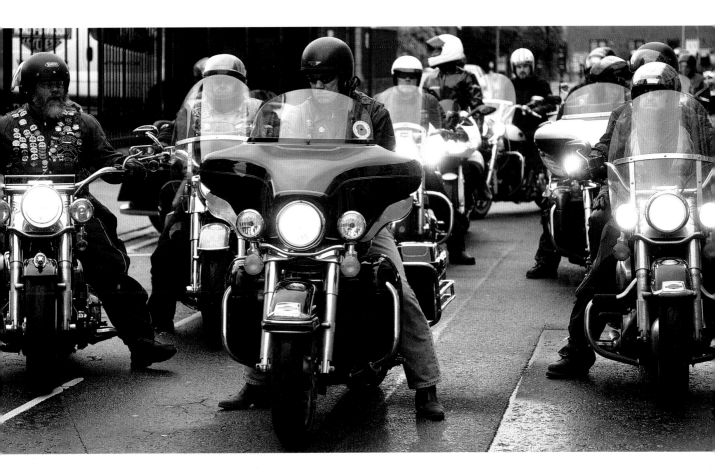

CHELSEA AND FULHAM HARLEY OWNERS GROUP, CHELSEA

The guy with the impressive beard is called Grizzly. You don't have to ask him. It's written on his back in big letters and you can read that without his noticing. If he lets you read his front (which he's perfectly happy to do, being a friendly individual), you'll find out that he's a Rider with Chelsea and Fulham HOG and a Rider, or connected in some other way, with HOGs in places all over the world. HOG, if you haven't worked it out already, stands for Harley Owners Group.

If you own a Harley-Davidson bike and belong to the national HOG, then you can join the Chelsea and Fulham Group and put their patch on your leathers without having to sign a form or pay a fee or anything. But it's a bit more difficult to get the round Rider's patch that Grizzly sports. To do this, you actually have to go on two C&F HOG-approved rides within a twelve-month period.

The photographs here were taken at the start of one of those outings. Every year, on Remembrance Sunday, a large contingent set off from their base on the King's Road to ride to Elstead, a village in Surrey. They lay a wreath at the War Memorial there and someone recites a poem. In the year when I took this picture, some Old Contemptibles were still alive and the ceremony was dedicated to them. 'Old Contemptibles' was the name which the British troops in the 1914 regular army gave themselves, supposedly because of a remark made by the Kaiser.

Another, more ambitious approved ride is the annual Run to the Sun. This is when Harley riders from all over Europe converge on St Tropez for a weekend. They're welcomed by overhead banners in the streets of the town and treated to a programme of events organised by the council. It's the only weekend of the year when sightseers don't gawp at the superyachts moored in the harbour. They're too distracted by the rows of highly polished motorbikes parked in front of them. The most telling fact, though, is that you can't get near the stall in St Tropez market which sells €10 reading specs. **12**

CITY WORKERS, LONDON BRIDGE

'Six twenty-six, six forty-one, six fifty-six, seven eleven. Those are the times of the trains. It takes me twelve minutes to get from my desk to the barrier at London Bridge station. So, if I'm going for the six forty-one, say, then I need to be out of the front door of the office by six twenty-nine. And I know that if I reach the stone which marks the middle of London Bridge after six thirty-six, then I've really got to quicken my pace. Before six thirty-five, I can slow up a bit. Of course, I won't get a seat if I don't leave till six twenty-nine. If I wanted a seat, I'd have to leave about five minutes earlier. It's a choice.'

This is someone who works in the City speaking. He has to trek across London Bridge every day because his train comes in to London Bridge Station. He does the walk along with a great tribe of other people moving north in the morning and south in the evening. They hardly talk or even acknowledge each other's existence but move in private bubbles. Their lives are ruled by timetables. They dread leaves on the track or the wrong kind of snow or a big hike in the price of a season ticket. **17**

WORLD NAKED BIKE RIDE, PICCADILLY

Every year on the second weekend of June, people all over the world get together and stage a group cycle ride through the cities where they live. There's nothing very remarkable about that. Except that they've got no clothes on. Or, at least, most of them haven't. The message is 'Go As Bare As You Dare', and so some people wear a G-string or keep their knickers on.

So Londoners going about their business on a June Saturday afternoon suddenly find that the road is blocked by more than a thousand naked cyclists. And since some of them are, frankly, not very competent cyclists, you get quite a long time to look at them as the column straggles by.

Why would all these people want to do this? There are some clues in what they've got written on their backs. 'One Less Car!', 'Exposed to the Traffic', 'Burn Fat Not Oil' and 'Stop Climate Change' are examples. This is the World Naked Bike Ride. And in more than fifty cities round the world, it's a protest against cars. Partly on the environmental level – cycling's more carbon-friendly – but also aiming to show how vulnerable you are if you're on a bike in the middle of city traffic. Some of these cyclists are making a different statement too. They're saying jump on your bike, throw off your clothes, forget about society's norms, be free! **22**

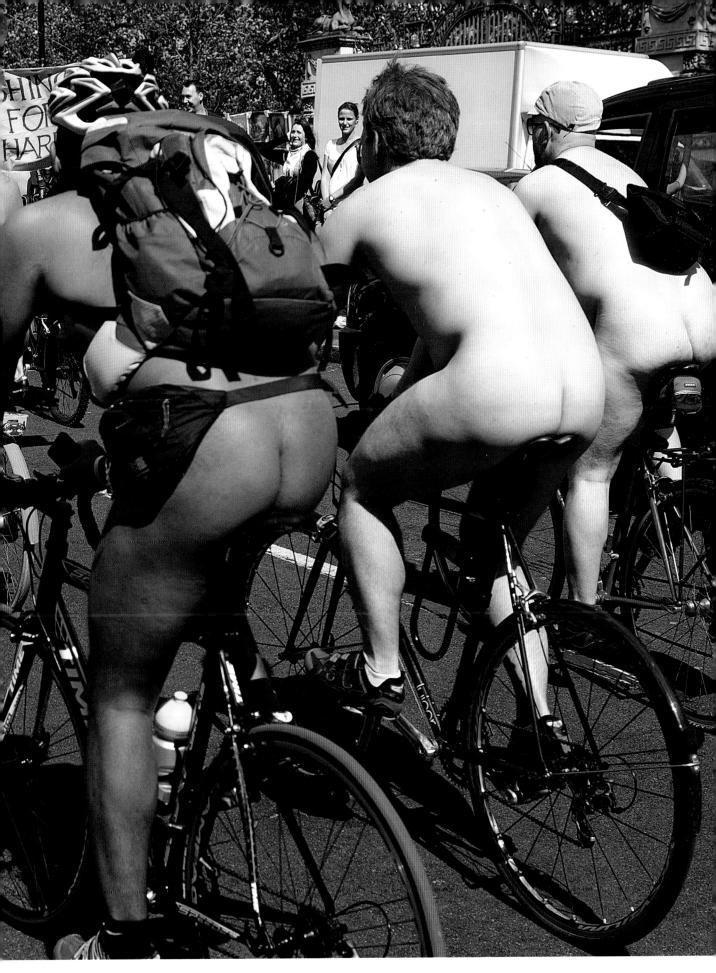

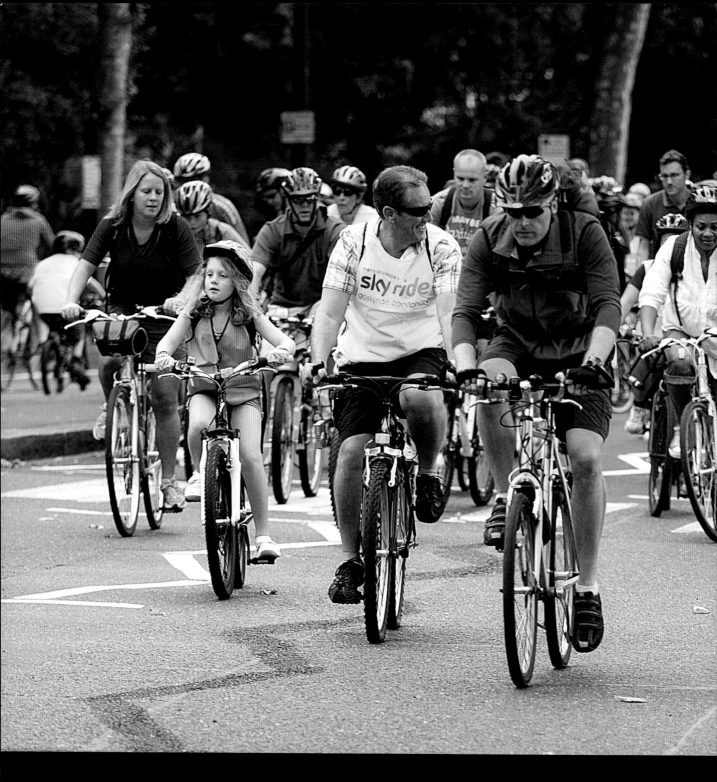

THE MAYOR OF LONDON'S SKYRIDE, VICTORIA EMBANKMENT

It's not surprising that Londoners jump at the chance to cycle round some of the city's best streets and take in its top sights without having to worry about cars, buses or lorries. That's what's been happening on a Sunday in September for about five years. A big circuit is closed to traffic and it's handed over to cyclists. Result: thousands and thousands of people flock there. They're all ages, from toddler wobblers to pensioner pedallers. Some of them come on conventional bikes and others on the strangest custom-built contraptions that you've ever seen. Lots more get to central London by public transport and grab every Boris bike on the stands

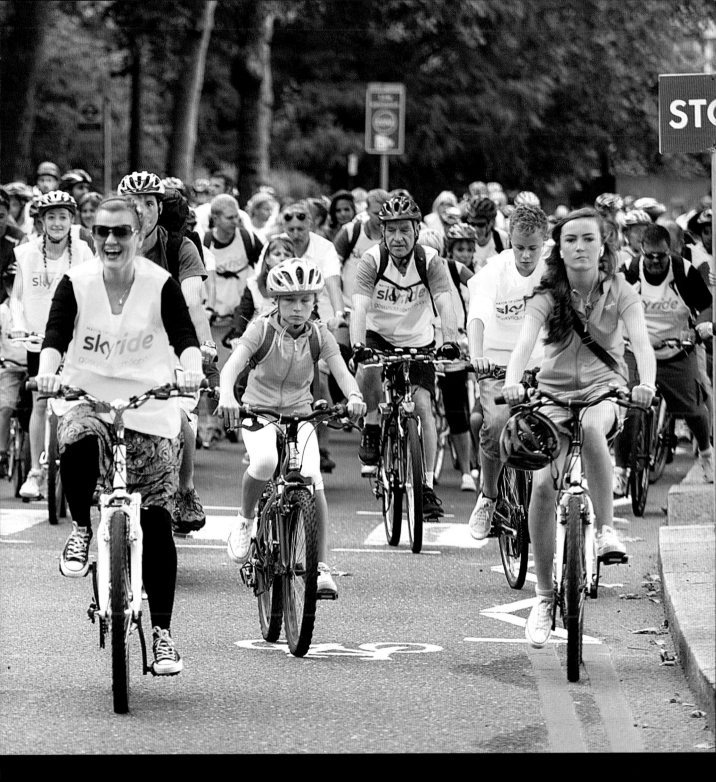

there. Some wear racing cyclists' Lycra. Others prefer just to turn
up in what they'll be wearing for lunch in the pub afterwards. And
Spiderman, Superman, gorilla and other inventive outfits are on
show too.

For a few years, the event was called the Mayor of London's
Skyride. There was a gap in 2012 because of all the Olympic
cycling events in central London, and since then things have been
reorganised. But cyclists still get the run of central London's
streets on a Sunday in September in what's now known as the
Prudential RideLondon FreeCycle. **24**

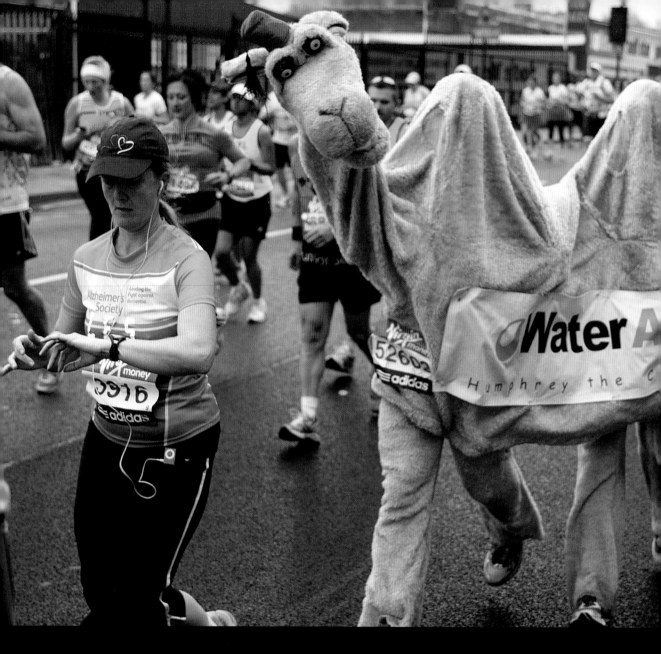

LONDON MARATHON, DEPTFORD

Runners in the London Marathon are divided into three groups which start at different places in Greenwich. They head east towards Woolwich and then back through Greenwich and Docklands before crossing the river at Tower Bridge. After that, it's east again to Canary Wharf until, at last, they can turn for home and come all the way along the river past the Tower, Big Ben and the Houses of Parliament to the Mall and the finishing line next to St James's Palace. That's the standard distance for a marathon, which is 26 miles and 385 yards.

There's always a group of elite runners competing, both male and female, and in some years a world record is set. But the vast majority of the thirty thousand or so people taking part are amateurs who are raising money for charity. Although the official London Marathon website offers lots of advice on training and fitness, it was obvious that quite a lot of the people passing me when I was taking these photographs had not taken that aspect very seriously. They were really not very far into the race at that point but some of them could no longer be described as

runners since they'd already been reduced to walking. In a few cases, this was because they'd been overambitious with the design of their fancy dress. In addition to the costumes on this page, I saw a rhinoceros, two beer bottles, a bee, a chicken, a Red Indian Chief, a policeman, Darth Vader, Big Bird, Paddington Bear, a lion, Mr Blobby and five people roped together. It's surprising, when you see what some people lumber themselves with, that they complete the course at all. In 2002 a man wearing a deep-sea diving suit actually made it all the way round.

Perhaps the most astonishing story of all, though, is that of Michael Watson, a professional boxer who was injured in a fight and told that he'd never be able to walk again. Undaunted, he entered himself in the London Marathon and battled his way round the course over a period of six days.

The sums of money that competitors have raised for charity are almost equally impressive. A number of individuals, including Sir Steve Redgrave, have collected over £1 million and the £2 million barrier was broken in 2011 by Steve Chalke.

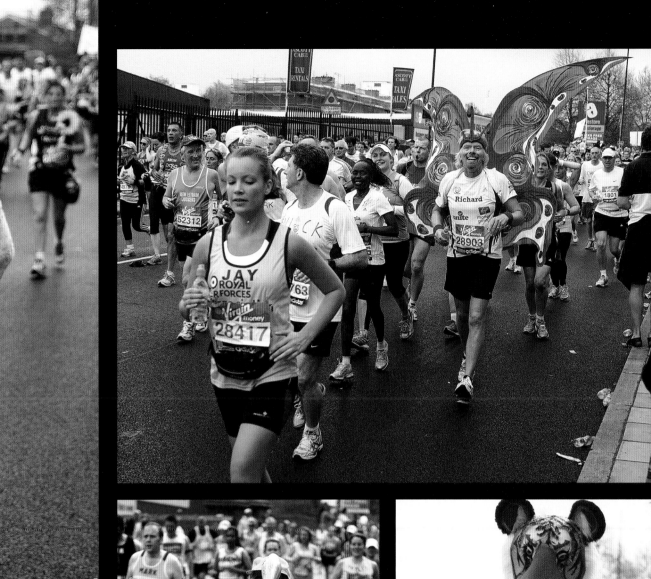

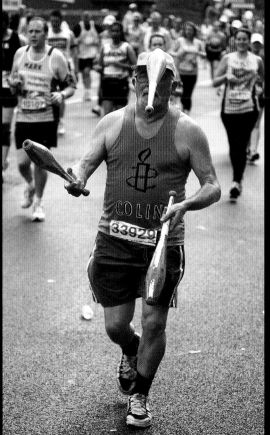

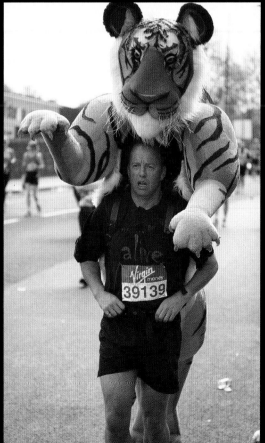

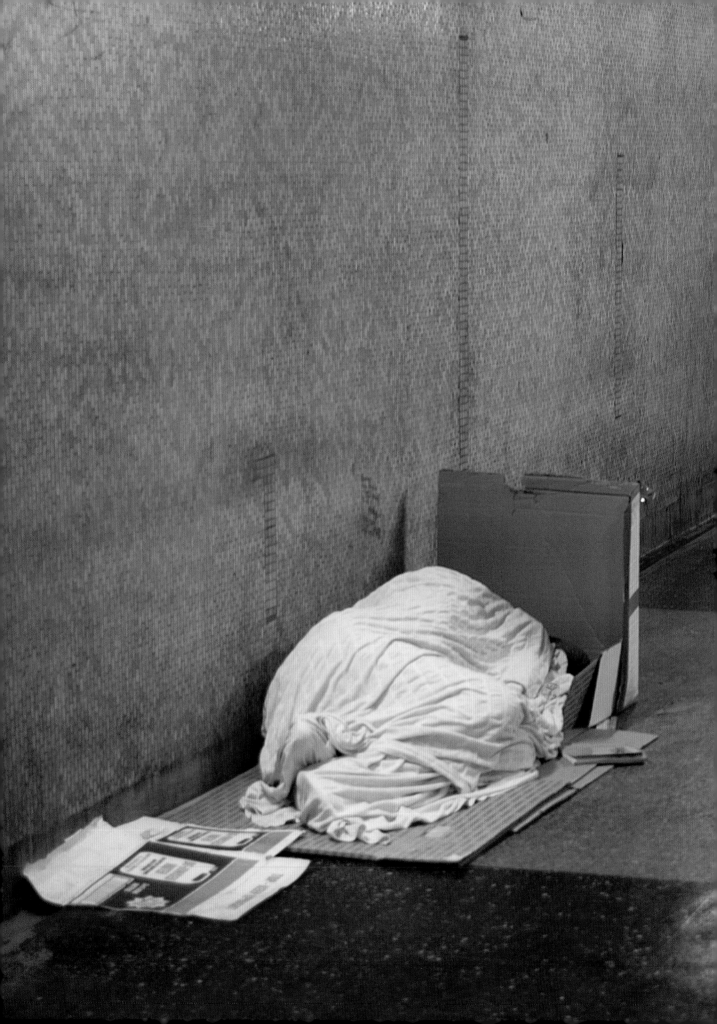

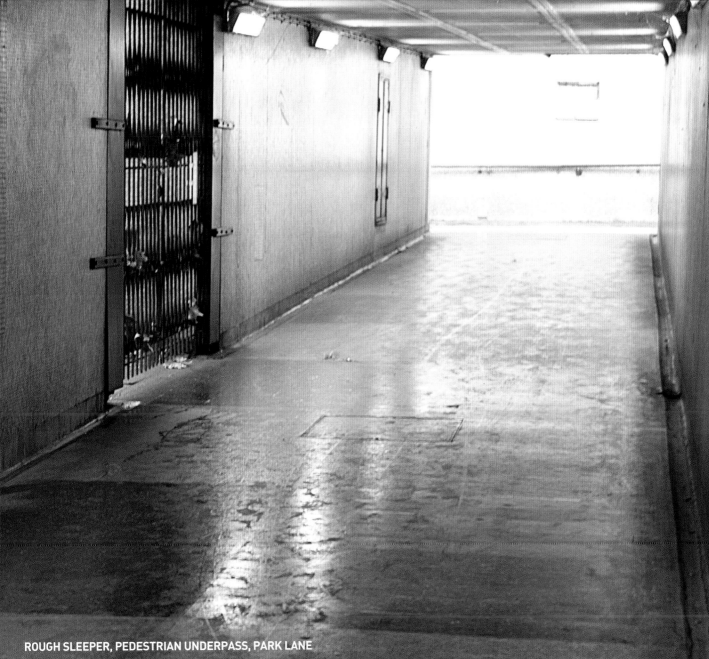

ROUGH SLEEPER, PEDESTRIAN UNDERPASS, PARK LANE

Rough sleepers are a familiar sight in London, though you tend to notice them more during the day than at night. They're usually sitting up then, a sleeping bag round their legs, a bundle of belongings somewhere to the side and a polystyrene cup with a few coins held out in front of them. Sometimes there's a very passive dog lying there too. These people are at the end of the road. Everything about them says that there's no hope left. But how much worse the picture looks at night. Now they try to find obscure corners where they won't be noticed. Preferably sheltered ones where they won't get wet or freeze to death. They cover themselves in sleeping bags or blankets or cardboard, whatever they can get hold of, so that their faces aren't visible. And, ostrich-like, they hope that they'll get through the night without being attacked.

We walk past them all the time. Maybe, occasionally, something stirs in us and we drop a coin in the cup. At night, we certainly feel a surge of sympathy. But most of us probably have no idea how many rough sleepers there are in London or what's being done to help them.

It's virtually impossible to give an exact number precisely because a lot of rough sleepers hide themselves away at night. But, equally, there are a lot of people out and about in London trying to find them and provide them with some support. Whenever anyone like that makes contact with a rough sleeper, their details are entered onto a database maintained by CHAIN (Contact, Help, Advice and Information Network), an online mutual support network for people working in health and social services.

According to CHAIN, 6,437 people slept rough in London in 2012/13. This was an increase of 13% on the previous year's total and a massive 62% increase over two years. Which must have made very sober reading for all the people involved in the drive to end rough sleeping in London, started by the Mayor in 2008. Not that they've been idle. Not by any means. There are figures which show that 20,000 people have been helped off the streets of London by this campaign in the last ten years. Their 'No Second Night Out' initiative resulted in 70% of new rough sleepers spending only one night on the streets.

JOB CENTRE, MARYLEBONE

Why the Plus, I wondered. Why are they called Jobcentre Plus offices? I knew that people went there for help to find a job, obviously, and to claim Jobseeker's Allowance while they were out of work. But a bit of research revealed that the staff in these offices can also advise people on apprenticeships and careers skills and training. And the Access to Work scheme, which provides people with money to help them to do their job if they've got a disability or health problem. Young people looking for work experience or an internship call in there too. **13**

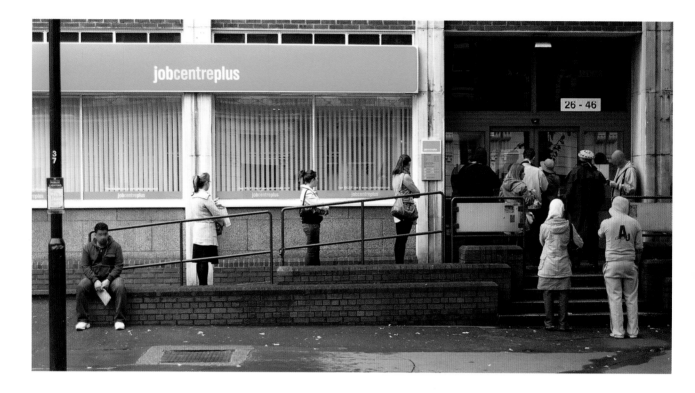

BIG ISSUE SELLER, CAVENDISH SQUARE

Big Issue sellers are part of the London scene. You see them everywhere. Some of them just smile quietly at you and hold out the magazine. Others have little routines to attract you. Maybe a song or, around Christmas, a carol. I bumped into one in Knightsbridge recently who could do an amazing balancing, flipping thing with his magazine. It made me laugh. How could I not buy a copy after that?

It made me think, too. Here's a really amusing, energetic guy breaking his back to sell this magazine on the streets for a few quid. Why? What's put him there? And how does the whole *Big Issue* thing work? What's in it for the sellers?

Well, at its simplest level, the Big Issue Foundation is a charity for the homeless. Things happen, all kinds of different things, which shatter people's lives. And in no time, people whose worlds had been perfectly stable are sleeping rough on the streets. They need help in lots of ways and the Big Issue Foundation is there to provide it.

One of the biggest problems is a massive loss of self-confidence. Once you're NFA – of No Fixed Abode – you become, as they say, invisible. So, right from when it was started in 1991, the *Big Issue* scheme has given homeless people and others like them the chance to take some control of their own lives again and earn a legitimate income. They make the choice to buy the magazine from the Foundation with their own money at 50% of the cover price. They're entirely responsible for sales and so the other 50% is their revenue. The deal's not sale or return and so they take the risk that they'll make the sales. While the Foundation does what it can to help the vendors to develop their little businesses, they're its customers and are treated as such.

Now that I know that, I look at those *Big Issue* sellers in a new light. **38**

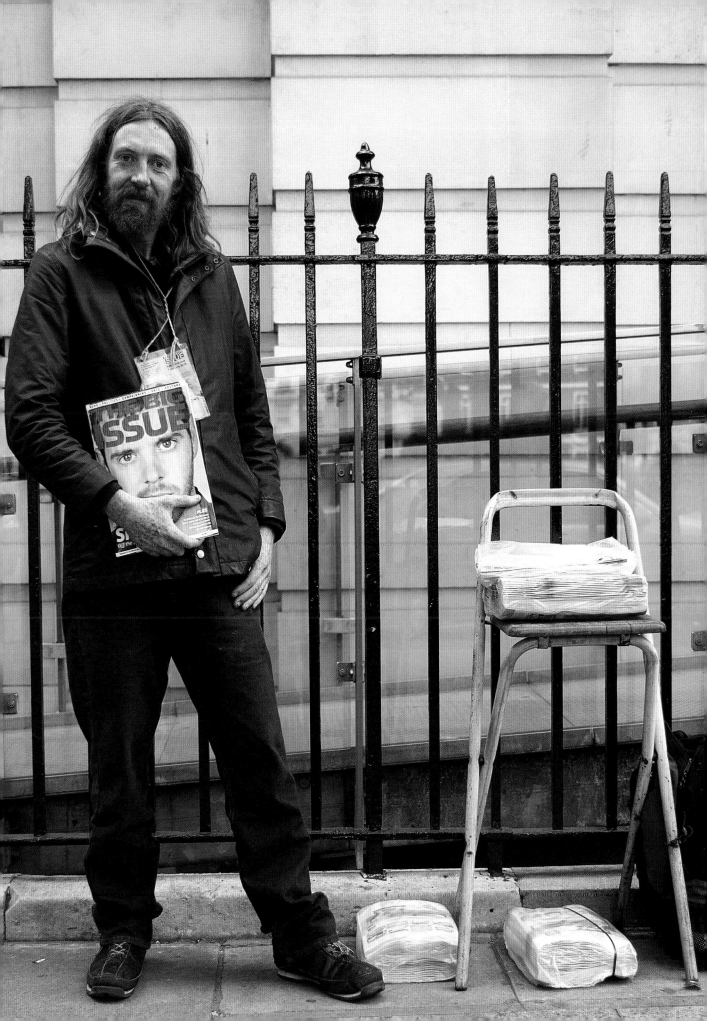

How do you write about people setting off from London for Venice on the Orient Express without sounding like a travel brochure? The mystique of one of the world's most famous train journeys, etc. Well, the travel brochures are obviously working because the old trip is still a magnet for trainloads of people. And it's a serious business once they're on board. Everyone dresses up in smart clothes, not only for the multi-course dinner which is served after they've crossed the Channel, but even for the brunch which comes while the Pullman cars are trundling down through Kent. **7**

RIGHT 999 CLUB, DEPTFORD **16**

LONDONERS TALKING

Robert Block, former Chief Executive, and Iris French, Operations Director, of the **999 Club,** a place in Lewisham with an open-door policy where you can go if you're desperate and lonely and have no one to turn to. It offers friendship, help, advice, links to professional agencies, a cup of tea and toast, a hot meal, a bed for the night.

IRIS FRENCH: Anyone is invited to come in no matter what they are, who they are or where they come from or anything. We just let everybody come in. For tea and toast and a chat ... Homeless people ... Sometimes we have a little scuffle here. Nothing really bad. Not fights. But sometimes I do have to bar them for a week or two to calm them down. And then they're begging to come back. That's what I do. Naughty boys. Naughty boys.

ROBERT BLOCK: Some of them really do need to be fed as well. We find that some of the Eastern Europeans who haven't access to any benefits at all, they really need to be fed. And also there are other people who are giving all their money to their drug dealers and they also need to be fed.

RICHARD SLATER: Tell me about the night shelter.

RB: We're open all winter, depending on how well we're funded ... We have twenty-five people a night sleeping in. Lewisham's homeless population is roughly normally about 20 people and so we'll have all the homeless of Lewisham and a few others. The people we keep out are the ones who are completely off their heads on drugs and who'll keep everyone else awake. Regrettably, we can't cope with that.

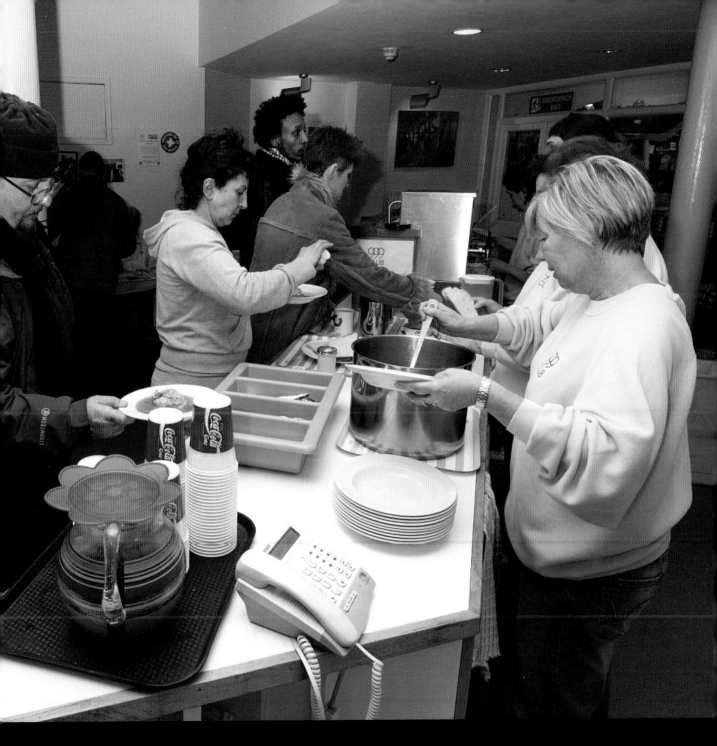

IF: We have tried.

RB: A solution's needed but that's not what we do. Actually, it's turned out that if you have people here during the day and at night too, it's much easier to get them into permanent housing and out of the night shelter. What we say we do is that we're giving our beneficiaries access to all the help they need but can't access themselves. So the people ... you know ... they're off their heads on drugs, they're very distressed, they distrust authority.

IF: They can't read or write.

RB: These are all reasons why they can't access normal statutory help. But with our help, they can.

IF: We rig them out in clothes too. Everything. Pants, vests, socks, shoes, everything. Sleeping bags. Coats.

RS: I imagine that people have often been very reluctant to go to doctors, to go to hospital and so on because of the language difficulty. Do you help them?

IF: I take them everywhere. I take them to the doctors. I take them to the hospital. I take them to the CRI, which is the drugs unit, to be detoxed, you know, all that sort of thing.

RB: The psychiatric unit.

IF: We seem to get through to them. I don't know how. Mummy. They call me Mummy.

GREAT GORILLA RUN, THE CITY

Any idea how many mountain gorillas there are left in the wild round the world? Eight hundred. Yes, you read that right: 800. So that's the limit on the number of people who could take part in the 2014 Great Gorilla Run. They were raising money in an effort to save the species from extinction and also to reduce poverty in Central Africa.

It's called a Run but nobody minds if people jog or even walk it. The route is 8 kilometres long and starts in the City. It takes in some great sights like the Tower of London and St Paul's Cathedral. The people taking part may have only a partial view of these buildings, though, since it's a requirement that you wear a gorilla suit. The good news is that you don't have to find your own suit. It's included in the registration fee of £50 and you get to keep it afterwards.

Fitness levels are rather mixed and so the field spreads out rapidly, but the start at Mincing Lane is quite a sight: eight hundred gorillas charging along a London street together. **41**

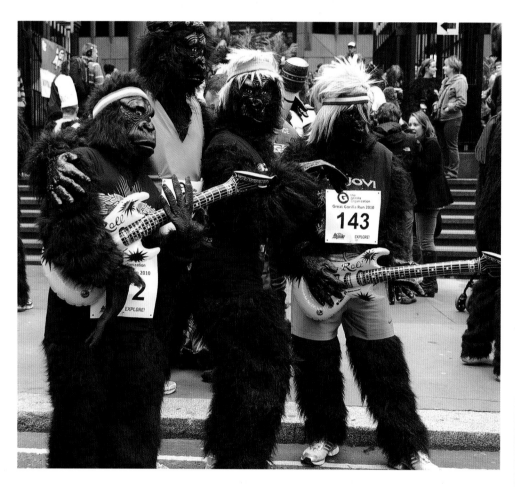

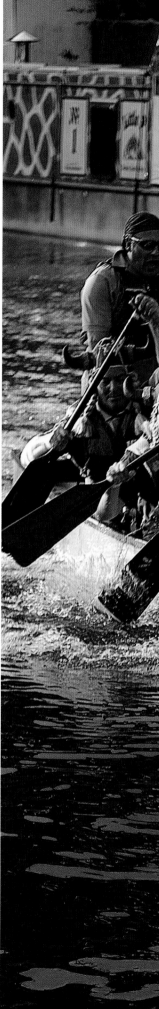

OVERLEAF

WHERE'S WALLY? FUN RUN, VICTORIA PARK

The whole idea of the *Where's Wally?* books was that you had to spot Wally among all the other people. The National Literacy Trust's *Where's Wally? Fun Run* turns that on its head. In 2013 there were 1,200 Wallies, so it was the non-Wallies who stood out.

A good cause. A flexible approach to exercise – you could run, jog or walk either 5 or 10 kilometres. A pleasant open space. And an outfit that was a laugh. These are all things that continue to attract Londoners. Especially, for some reason, the last one. Londoners love to dress up silly. So even though it was the first year that the Trust had run the event and even though there was snow on the ground, 1,200 Wallies turned out. **42**

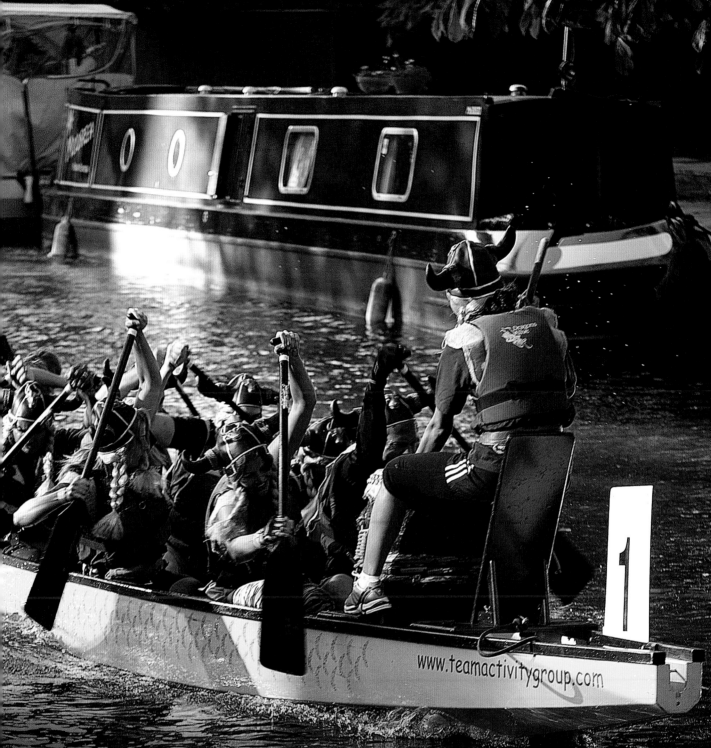

www.teamactivitygroup.com

CHARITY DRAGON BOAT RACING, LITTLE VENICE

Cliques form in offices. And if the clique gets a chance to have a laugh together, then it'll be grabbed with both hands. Especially if it means being allowed to bunk off early on a nice summer evening. Then if you throw into the mix that everyone can dress up in a silly outfit and go for a lot of drinks afterwards, it's a can't-miss event.

When everything's for charity and it's representing the office in dragon boat races against rival organisations, then you really are home and dry. Well, probably not in this case, because the chances are that you might get a bit wet. You need nine in your clique,

sorry, crew. Eight to paddle and one to sit up in the bow facing backwards and banging a big drum. Someone has to steer the boat, of course, and it can get a bit hairy as two competing boats thrash their way down the narrow canal at Little Venice. So amateurs are not trusted to do this. The people who hire out the dragon boats make sure that they keep tight hold of the tillers.

Naturally, pirate costumes, with their stripy T-shirts and skull-and-crossbones headscarves, are popular. And Viking outfits too, though the horned helmets and blond plaited pigtails are a bit of a nuisance. **3**

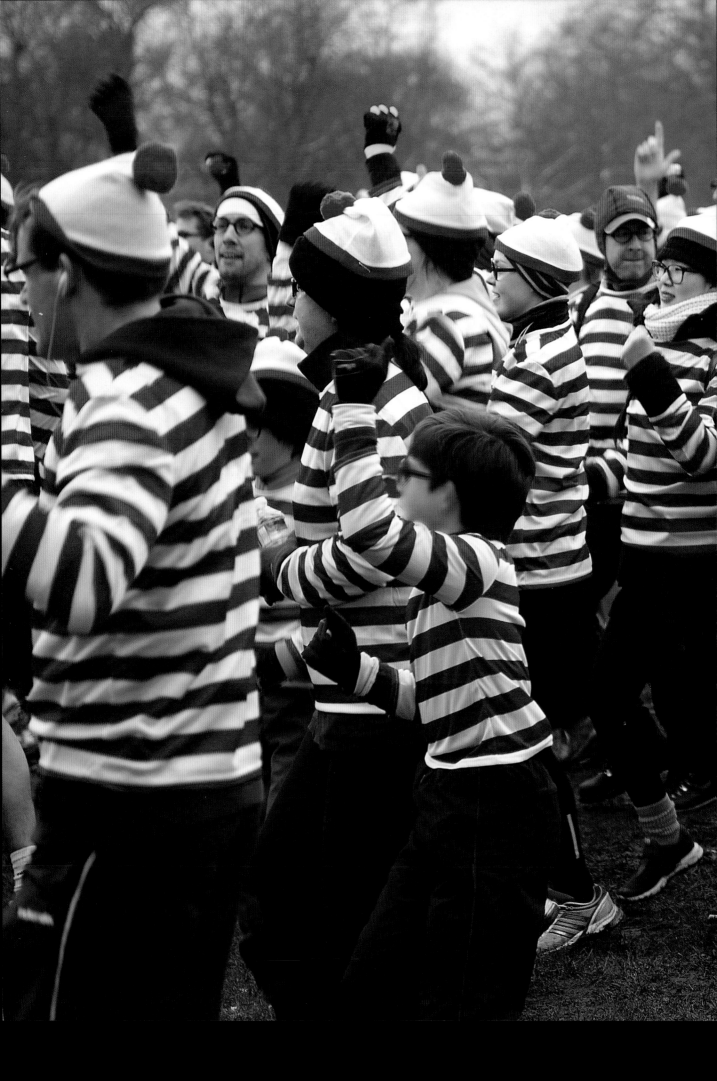

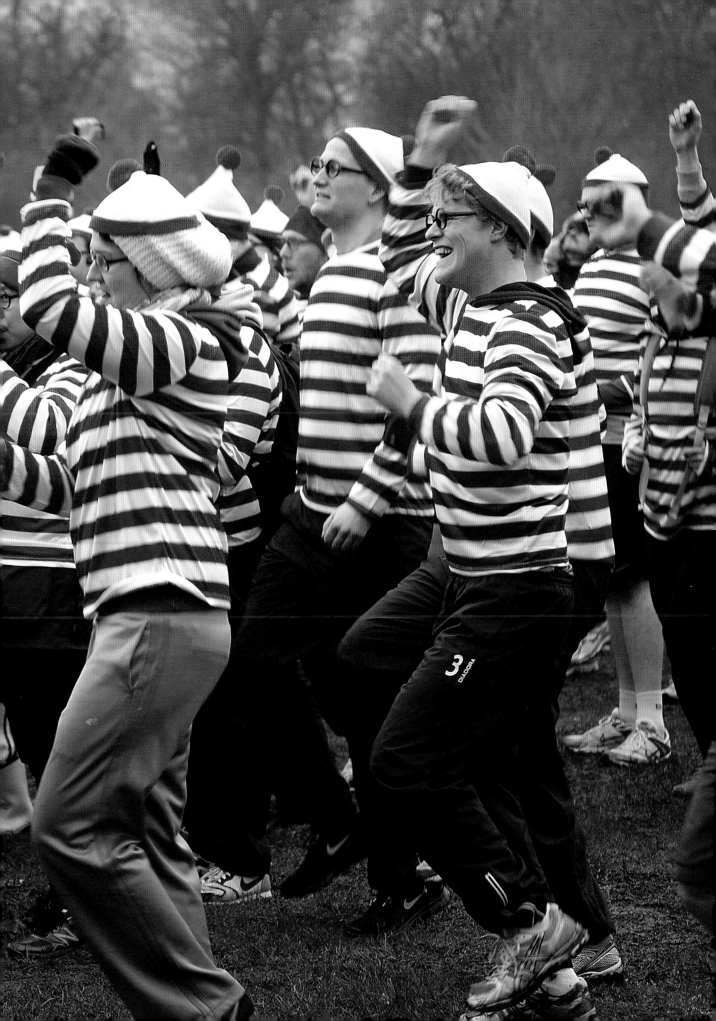

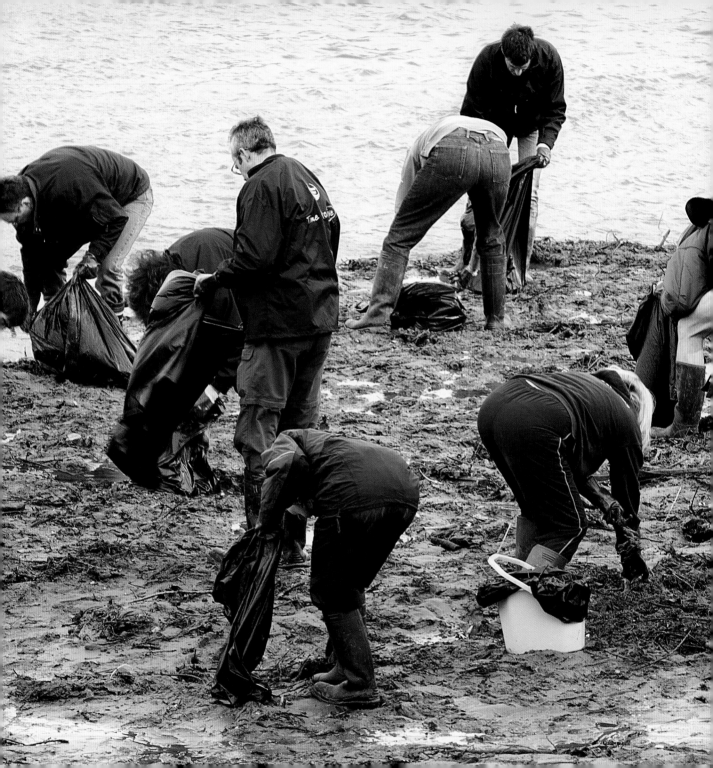

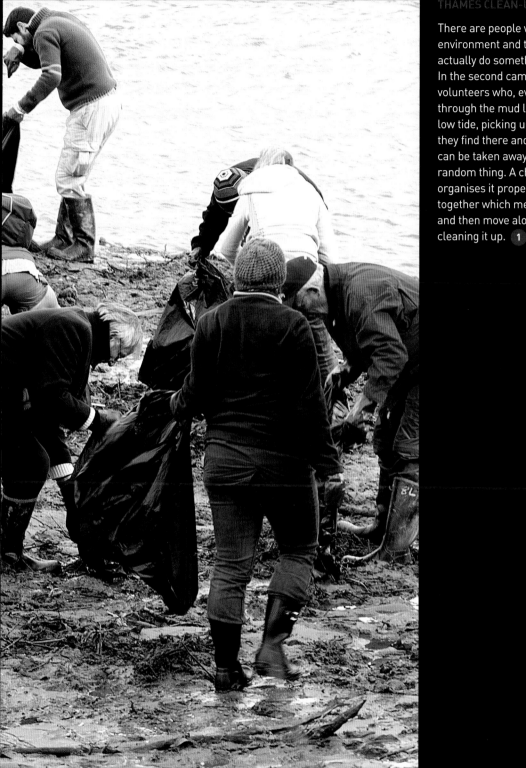

There are people who talk a lot about the environment and there are people who actually do something to improve it.
In the second camp are the thousands of volunteers who, every year, squelch through the mud left by the Thames at low tide, picking up all the garbage which they find there and bagging it so that it can be taken away. It's not just some random thing. A charity called Thames21 organises it properly. They get big groups together which meet at a specified time and then move along a stretch of river cleaning it up. 1

MCC MEMBERS, LORD'S CRICKET GROUND, ST JOHN'S WOOD

When did you last see a proper bus queue? Where people line up in a nice disciplined way in the order they arrive and then shuffle forward to get on the bus when their turn comes. It's a thing of the past, isn't it? Well, if you want to see people who still know how to queue, go down to Lord's Cricket Ground on the day of a Test Match. But you'll have to get up early.

Here's a delicious little irony. You wait over twenty years on the waiting list to become a member of the MCC, the Marylebone Cricket Club. This gives you the right not only to wear the very loud bacon-and-egg striped colours of the club, but also to enter Lord's free and sit in the famous Pavilion to watch Test Matches. But because there aren't enough seats in the Pavilion for all the members who want to sit there, if you want one you have to queue outside the ground before the gates open. And if England is playing the arch enemy Australia, you need to be there at about 6 a.m. to be sure of a decent spot. **15**

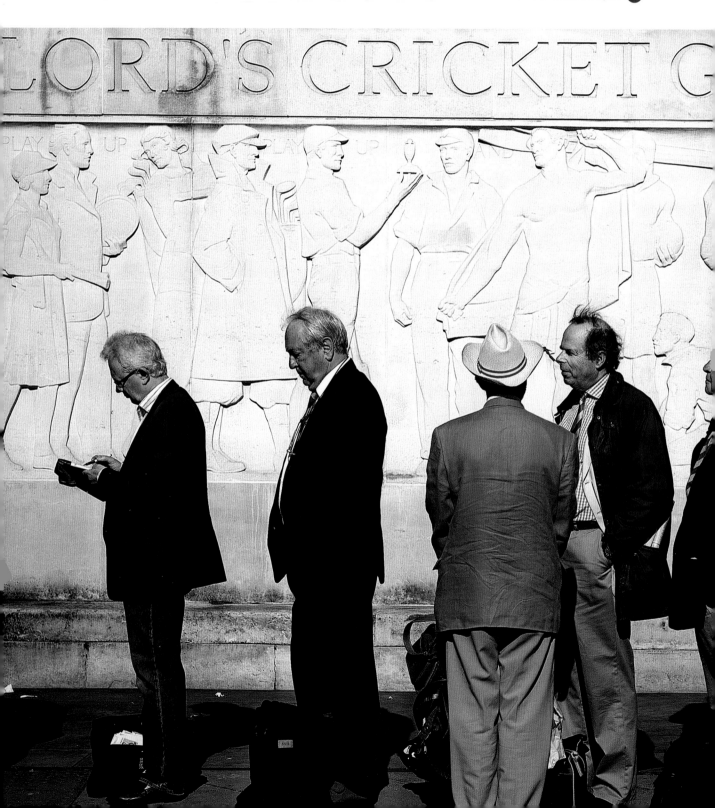

Here's a little tale of tribal behaviour. I went along on two separate occasions to take pictures of MCC members queuing outside Lord's. The first time there were a lot of death stares. Who's this tiresome man poking his camera into our special day out? For my second visit, I wore my MCC tie. The difference was amazing. People approached me, rather than the other way round. What was I taking the pictures for? Would I like to take one of them? They hoped that my project was a success. They'd love to come along to the exhibition.

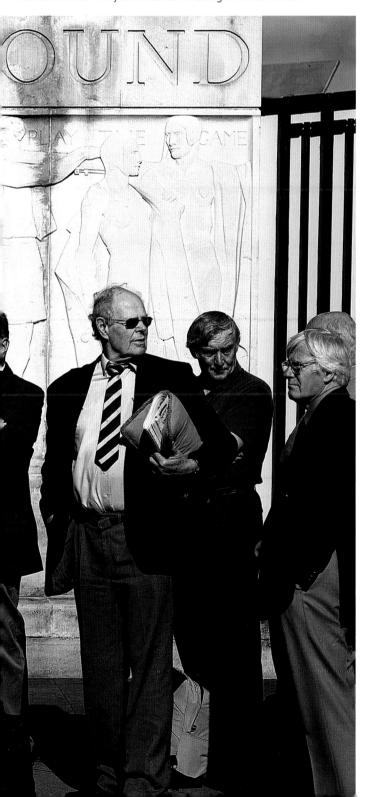

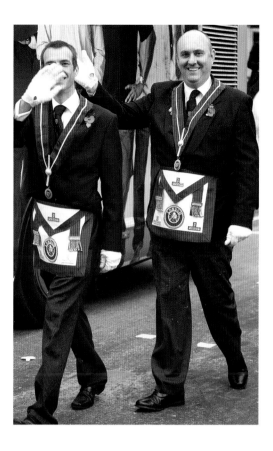

FREEMASONS, LORD MAYOR'S SHOW, THE CITY

Yes, you were right first time. These guys are Freemasons. So you might wonder why they are wearing their pouchy things and ribbons and white gloves in broad daylight, marching down the street as bold as brass. Grinning fit to beat the band and waving too so as to draw attention to themselves. Aren't they supposed to be a secret society? With signals like special handshakes so that one mason can recognise another without anybody else realising.

Well, no, that's all history apparently. Everything's out in the open now. Freemasons are free to tell anyone they want that they're in the club and what a great thing it is. This being 2014, they've got a smart website where you can find all kinds of information. And you can go on a tour of what you thought was the highly mysterious headquarters of the United Grand Lodge of England, the Freemasons' Hall in Great Queen Street. They even film blockbuster movies and hold fashion shoots there. 28

The gates at the end of Ranelagh Gardens in Fulham look rather nondescript. But the name of the club sounds classy. Hurlingham. And once you get past the security guards, it lives up to its name. Forty-two acres. Gardens. A lake. Any number of tennis courts, some of them the proper lawn jobs and others covered indoor ones. Croquet and bowls lawns. A children's playground. Squash courts. Indoor and outdoor swimming pools. Gyms. A very grand house. Reception rooms. Restaurants. Bars. Reading rooms. A theatre. A conservatory. A shop. An IT room. A crèche. The list goes on.

Sound enticing? No doubt. Unfortunately, you can't just fill in a form and join. There's a dauntingly long waiting list. Oh, and a (hefty) joining fee too. **27**

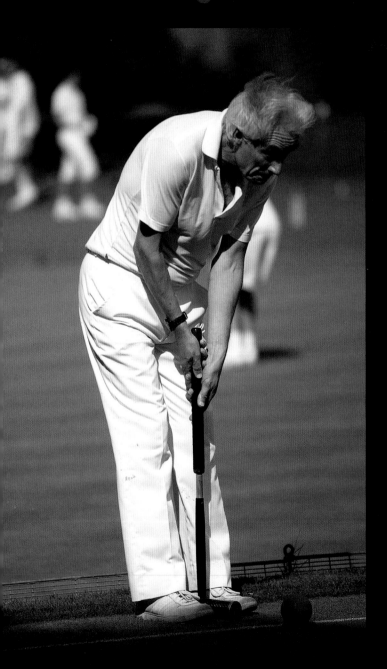

RIGHT FOOTBALL FANS, FA CUP FINAL, WEMBLEY
BELOW RIGHT RUGBY FANS, ENGLAND v SOUTH AFRICA, TWICKENHAM

No sport is more tribal than football. Each team has its colours, its songs and chants, its traditional enemies, its trophies, its permanent and not-so-permanent heroes, and its myths. If you want to belong to the tribe, you have to show your loyalty. You wear its shirt, its scarf or its flag. You paint your face blue or red or green or whatever other colour is required. You clap and cheer and chant on the Tube and in the street. And your eyes well up a bit with pride when the ground's full and you're two-nil up and the singing and clapping are so deafening that you wonder if the stadium's safe.

The event where you feel proudest and where, by the same token, you've got to put on the best show is the FA Cup Final. Your team – which includes you – has travelled the Long Road to Wembley. Here, on a Saturday afternoon in May, it's your tribe against another. So you take extra care with your uniform, your warpaint and your banner. You get to the battleground early to check out the enemy. And you ramp up the volume on your war cries.

There can be no doubt who the football fans are on the Tube and trains to Wembley, whichever team they support. Just as there's no mistaking the people on their way to the Emirates, Stamford Bridge, White Hart Lane or any of the other football grounds in London on the days when there's a match on.

If you're at Waterloo on a day when there's a rugby international at Twickenham, can you tell who's going to it? Of course you can. And do they look different from the Wembley, Emirates or Stamford Bridge crowds? Very. For while football fans have a passionate attachment to their own individual clubs, they do also, as a group, represent a tribe. And a markedly distinct one from the rugby followers' tribe.

You're going to tell me not to beat about the bush and to come out with the fact that it's a class thing. You're going to give me the tired old 'Rugby's a ruffian's game played by gentlemen' quote with its converse statement. That may once have been true and there may still be something of a class distinction. But the lines have become blurred. The price of a season ticket at a Premier League club in London has made it a much more middle-class sport there. And a great deal of the support at the top rugby clubs in the West Country and the Midlands comes from the working and lower-middle classes. **4** **2**

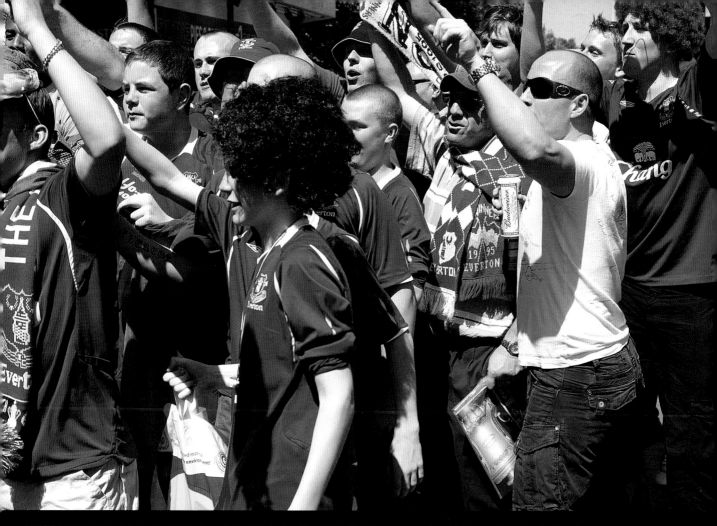

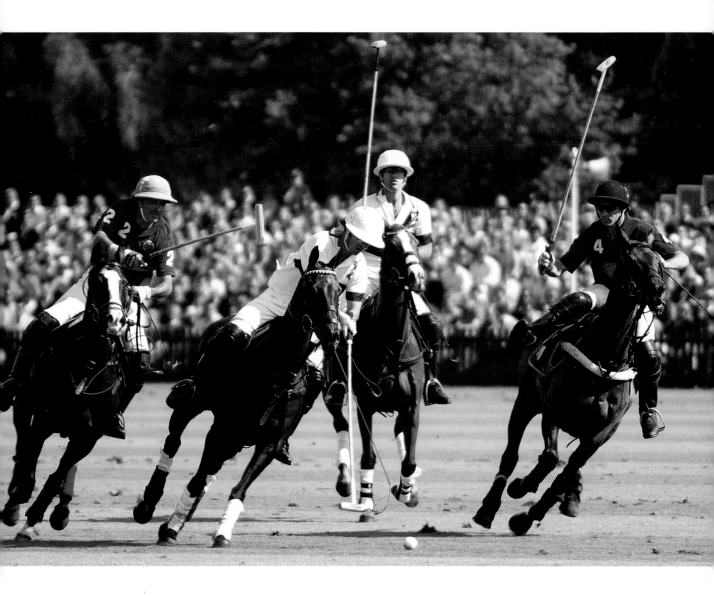

GUARDS POLO CLUB, SMITH'S LAWN, WINDSOR GREAT PARK

If you want to be seen with the 'right' people in the 'right' places, you really need to take June off. Or, better still, not have a job at all, so as to leave the month free. You'll be at the races twice, both times dressed properly of course. First for the Epsom Derby and then for Royal Ascot. A different get-up altogether will be required for the Stewards' Enclosure at the Henley Royal Regatta and, if you're a lady, you'll have to make sure that your hemline is below your knees, whatever they may say at the Paris or Milan Fashion Shows. The Stewards have their own ideas about dress lengths and they have hawk-eyed security guards on the gates turning away tearful ladies who thought they might risk it.

You'll have seen a lot of tennis by the end of the month because Queen's and the first week of Wimbledon fall in June. Of course, you'll have popped down to Glyndebourne for some opera and a picnic supper on the lawn. Probably more than once. And you'll definitely have been to Windsor Great Park to watch polo. Along with the Queen. Because the Cartier Queen's Cup is held in June. This is one of the top events organised by the Guards Polo Club, whose home is Smith's Lawn, and the Queen is always there that day to present the trophy at the end. **25**

MORRIS DANCERS, BETHNAL GREEN

Is it the bells and ribbons tied round their trouser legs? Or the feathers and flowers on their top hats? Or the sticks that they wave about and bang together? Maybe all the badges on their waistcoats? Anyway, on a scale of cool, with 10 being super-cool, Morris Dancers are hovering somewhere below the 1 mark. But they don't care. Because they're having the time of their lives. And it's our National Heritage, isn't it?

Yes it is. But no one can tell you with any confidence where Morris Dancing comes from or even when it started. 'At least 600 years ago and maybe even before that' is the closest you'll get. The records seem to show that they were part of the Court entertainment at the time of Henry VI (i.e. about 1500) but it's not clear how they spread into popular country culture from there. Some sides – that's the name for a group of Morris Dancers – can trace their origins back to around 1800 but most are much younger. Anyway, the good news (and sucks to all us cool urban try-hards) is that there's been a massive surge of interest in Morris Dancing. There are about 800 sides in the country and ... get this ... sides in foreign places too. Canada, New Zealand (well, you might expect that), Australia, USA, Hong Kong, Cyprus ... er, Cyprus?

Each side has a squire or captain, a bagman or secretary and often a foreman too, whose job is to teach the dances. Many of them also have a fool, who's also sometimes called the animal and who's supposed to make the audience laugh. All Morris Dancing sides may look the same to you but, in fact, their costumes all have special, often local, twists. ❺

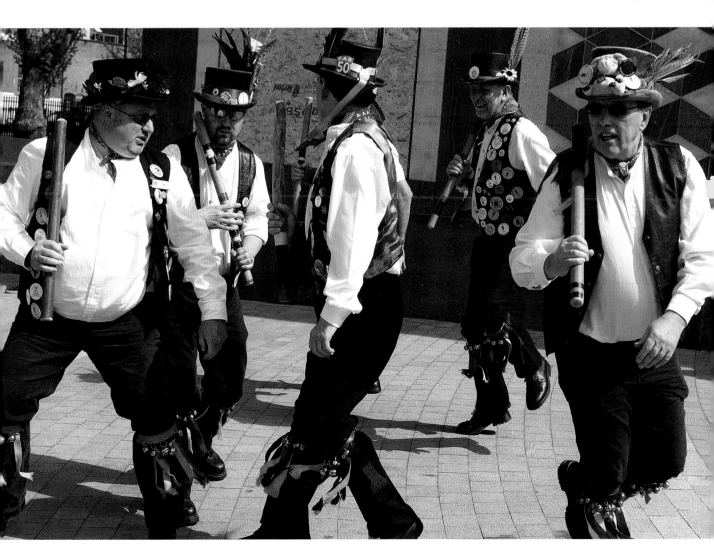

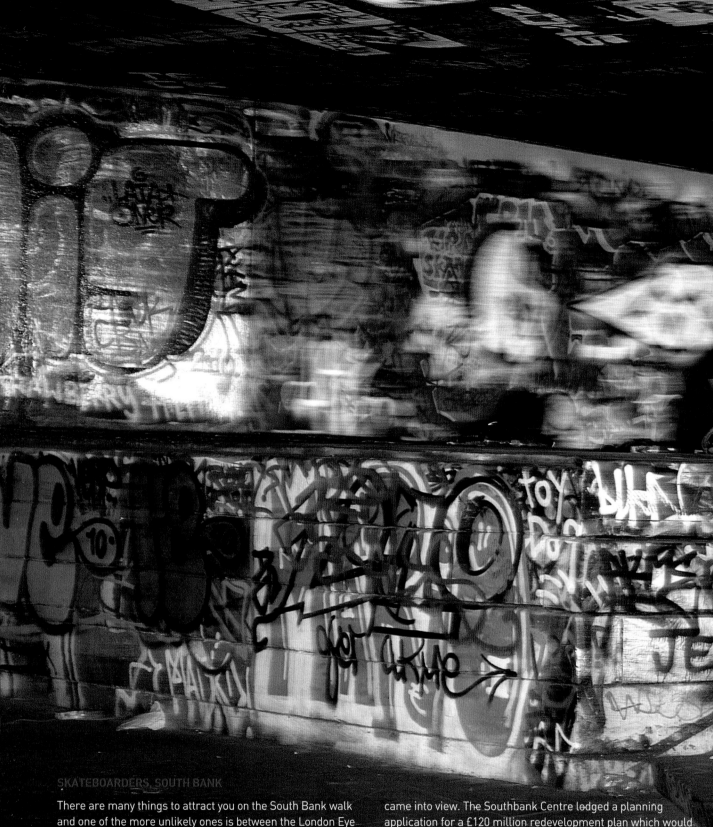

SKATEBOARDERS, SOUTH BANK

There are many things to attract you on the South Bank walk and one of the more unlikely ones is between the London Eye and the National Theatre. It's a brutal concrete undercroft that's absolutely plastered in graffiti and it has been a skateboard park for forty years. You really can't miss it. You'll be blown away by the anarchy of the artwork on the walls and, even before you get in sight of that, you'll hear the rumble of the skateboard wheels. None of the boarders ever says a lot. It's very much a little tribe with its own code of behaviour.

And like any tribe, they united against an enemy when one came into view. The Southbank Centre lodged a planning application for a £120 million redevelopment plan which would have seen the skateboard park being scrapped and replaced by shops and restaurants. The skateboarders were joined in their objections by some powerful allies. Not least the National Theatre and Boris Johnson. The Mayor said that the skateboard park was 'part of the cultural fabric of London'. Together, the alliance scored a notable victory. The planning application was withdrawn and the Southbank Centre declared that the future of the skateboard park was guaranteed. **30**

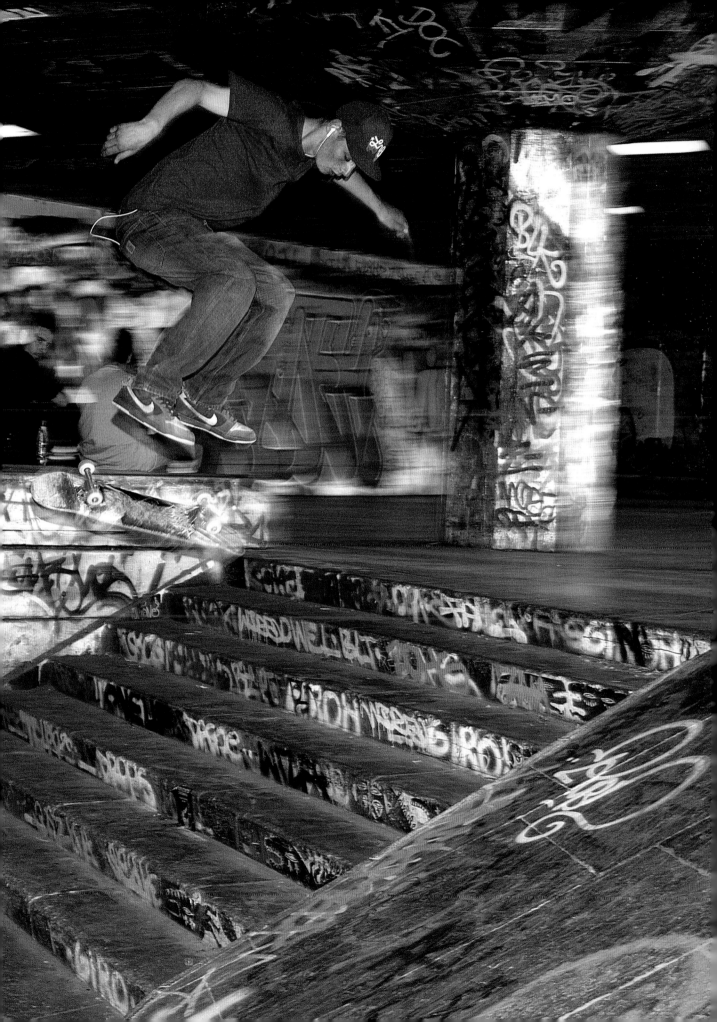

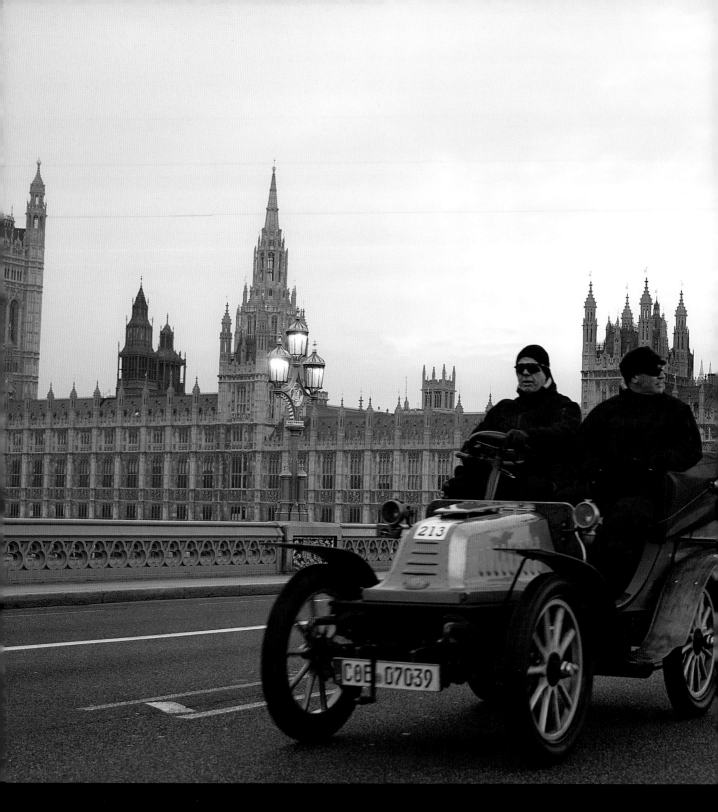

The cars in the annual London to Brighton Veteran Car Run are really old. We're talking pre-1905. And despite this, they get applications for more than 500 cars to take part. About a quarter of them are from abroad. (No, they don't drive over, in case you're wondering.) It's astonishing that so many vehicles which are that old are well-enough preserved to take on the 60-mile route to the Brighton seafront. Especially since the North and South Downs are on the way and they're serious hills.

When cars first appeared on the scene, the law insisted that a man with a red flag had to walk in front of them to warn pedestrians. Although this requirement was dropped in 1878, a red flag was symbolically burned at the start of what was known as the Emancipation Run in 1896. This was the first-ever run to Brighton and was arranged to celebrate the raising of the speed limit for motor vehicles on the highway from 4 to 14 miles per hour. And a red flag is still burned at the start of the Run today.

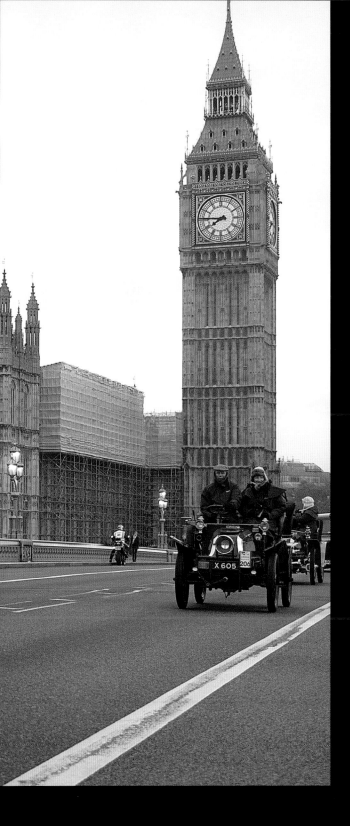

I've been a passenger on one of the cars in the Run. John Hickman kindly offered to drive me on his 1901 Panhard-Levassor. We met at about 6.45 a.m. in the semi-darkness on Hyde Park's South Carriage Drive, where all the vehicles line up before setting off. There were only a few feet between each of them and a lot of them had their engines running, presumably because, once they stopped, they might not start again. And there were hundreds of people milling about, tinkering with cars, loading supplies for the trip, greeting each other and trying to talk over the loudspeaker. It was freezing cold, pouring with rain and, if you stepped off the tarmac, very muddy.

Magnificent though it was, John's car didn't give driver or passengers any protection whatsoever from the weather. I was wearing a cashmere sweater, a fleece, a sheepskin-lined leather coat, a scarf, gloves and a hat. By the time we reached Buckingham Palace, I was starting to feel the cold. And rain was dripping from the brim of my hat. But all the same, I was pretty elated. All the way out of the park, across Hyde Park Corner and down Constitution Hill, we'd been cheered on by large crowds.

This was not a morning to take pictures of the Run. At Waterloo Bridge, I wimped out (as I'd told John I would). Instead of stills, I filmed a quick video interview with him and wished him good luck. The photograph on this page was taken another year, when the forecast guaranteed dry and bright conditions. As bright, at least, as it gets on Waterloo Bridge at 7.45 a.m. in November.

Thirty-three cars set off on the Emancipation Run in 1896 and only fourteen made it to the seafront. Although the roads have improved a good bit since then, quite a few of today's entrants find the challenge too tough for them and the call-out mechanics working for the owners and organisers of the Run, the Royal Automobile Club, have a busy day.

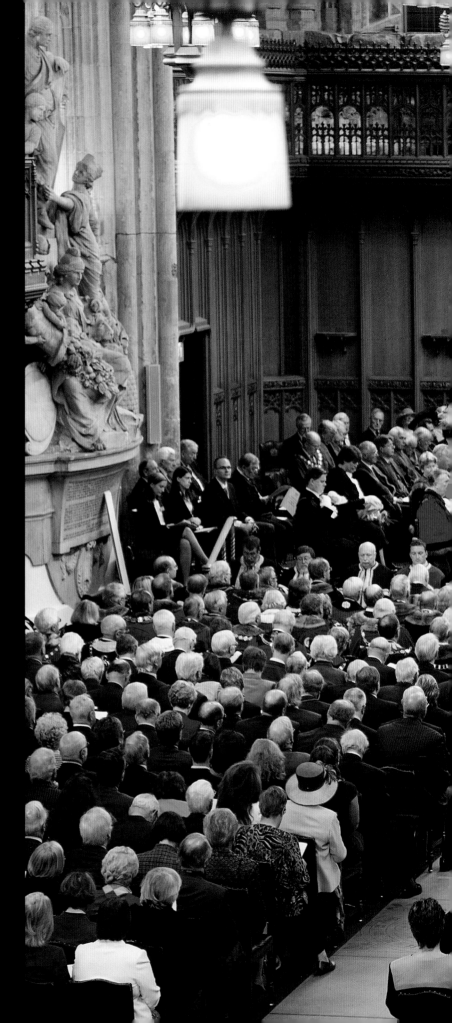

COMMON HALL, GUILDHALL, THE CITY

The difficult thing to get your head round is that this archaic scene is at the heart of one of the country's most important, constantly evolving and modernising institutions. This event is what's known as Common Hall. You might think from its name that anyone can go along but that's very much not the case. You can only get in if you're a liveryman, in other words a member of one of the City's livery companies. The Fishmongers, the Merchant Tailors, the Farriers and so on. They get together in the Guildhall once a year at Michaelmas to elect the new Lord Mayor.

Even Dick Whittington might have been deterred by the process of getting to be Lord Mayor today. First, you have to find a ward in the City where there's a vacancy for an alderman, stand in an election and win. Once you've served long enough as an alderman to have earned a reputation, you can put yourself forward for election as a sheriff at Common Hall – this is another thing that the liverymen do when they meet. If you get over that hurdle and you've done your time as a sheriff, you are at last qualified to stand for Lord Mayor. The liverymen choose two candidates in Common Hall and then the Court of Aldermen picks the winner from among those two.

Terrific stuff rooted in hundreds of years of history. But the pomp and circumstance is just a backdrop. Today's Lord Mayors are international ambassadors for that powerhouse of the country's economy, the City of London. So, difficult though it is to believe, behind the gowns and wigs and maces there's an up-to-date organisation at the cutting edge of the modern financial and business world. **18**

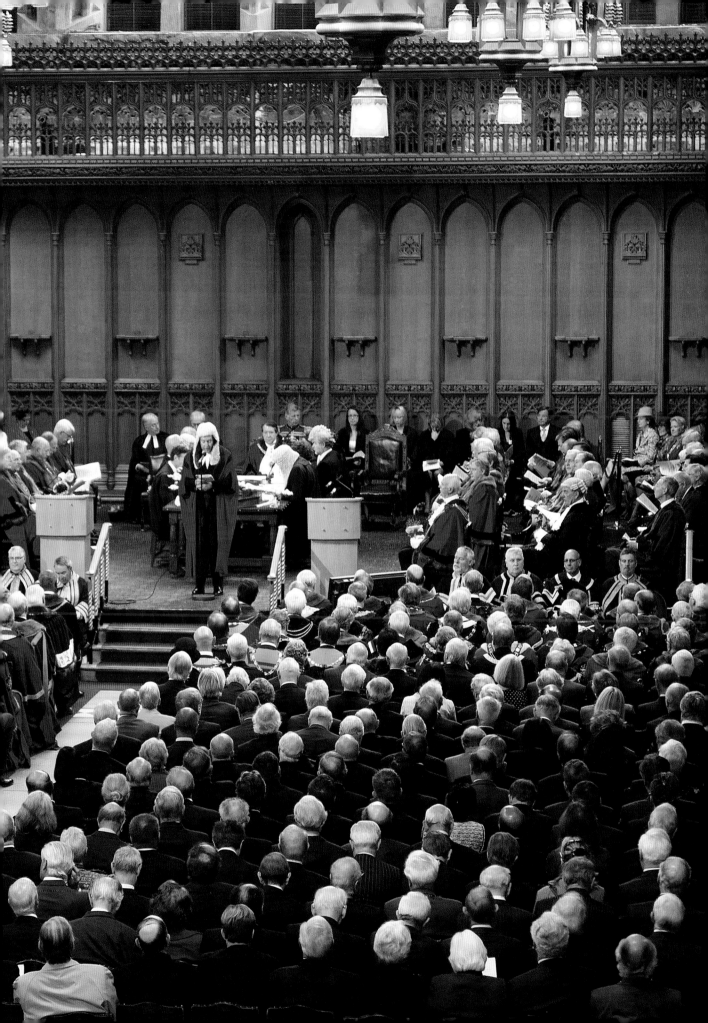

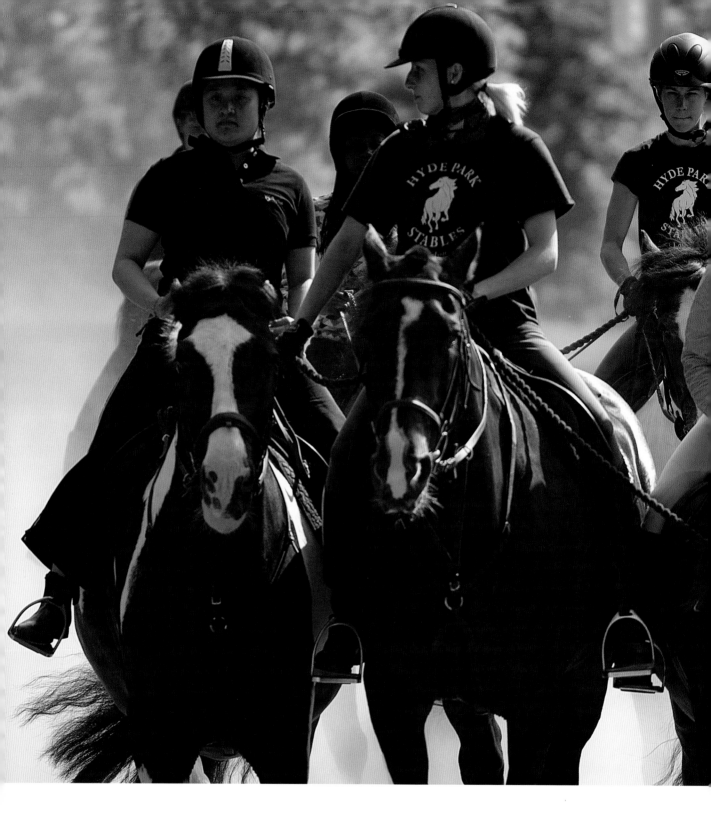

RIDING LESSON, HYDE PARK

Is it just me or do a lot of people get a faintly inferior feeling when someone on a horse rides by? It's bad enough when you're in a car but when you're only on foot, some ingrained gentry/peasantry thing surfaces. And those people who ride in Hyde Park. They seem to have an extra degree or two of hauteur. Are they so rich and privileged that they can afford to keep horses in central London? Have they all been galloping across their country estates and jumping fences since they emerged from their nurseries?

Well, almost certainly not. They're probably having a group lesson with one of the riding schools based in the mews streets just north of the Park. The horses that they're riding have done that circuit about five million times. And, if you look carefully, you might see that one or two of them are securely attached to the instructor by a leading rein. Feel better? **26**

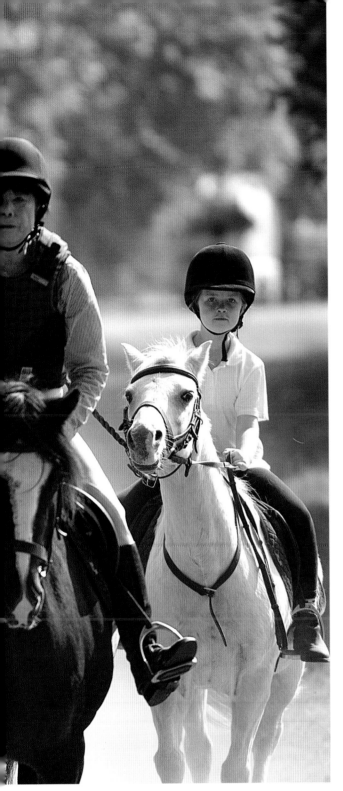

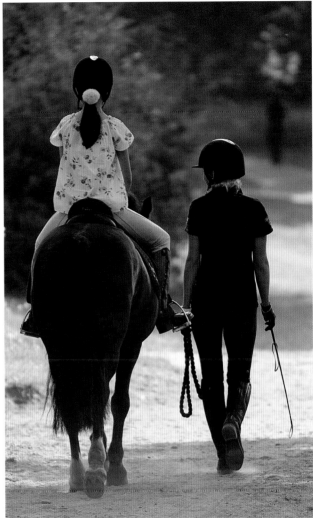

📷 TAKING THE PICTURES of a riding lesson in Hyde Park

I wanted a sunny morning for my pictures. The best place, I'd worked out, was on North Ride, not far from where lessons start and finish. But the weather forecast let me down on the first day that I went to take the photos and, by the time I got there, it had clouded over. I was OK with the sunlight on my second attempt. So far, so good. I'd remembered to check lesson times and so I got there just before a new group came into the park but I was unlucky with the spot that I chose because they used a gate about 40 yards up the track and rode away from me.

I didn't know where they'd appear from when they finished their lesson but I very much wanted them to come from the direction that I'd seen them disappear in. This was because a shot with the sun behind them was going to be much more dramatic than a fully sunlit one. Whichever direction it was, I had to wait the best part of an hour before I'd find out.

It was a nervous hour but ... brilliant! Here they were and coming from the same direction as the sun. But, my God, they were travelling fast. I stood in the middle of North Ride and, in the 4 or 5 seconds before they came up to me and I had to jump aside, shot off as many frames as I could.

Faith in London

IF YOU'RE STROLLING up Brick Lane, you can easily walk straight past the building on the corner of Fournier Street without giving it a second glance. What you'd definitely notice, on the Brick Lane side, is the shiny tower with a crescent moon on top and you'd think 'Wow!' and probably not look at the rather ordinary building behind it. But if you want to know about religious diversity in London, this 'ordinary' building is not a bad place to start. The story, of course, is all to do with immigration and how buildings and what they're used for change with the people who live round them.

The Huguenots who came to London in the late 17th century included a large number of silk weavers who settled in Spitalfields. It was soon a centre of the silk industry and the smart brick houses that the Huguenots built are still there today. They also established their own, French, churches and that building on the corner of Brick Lane and Fournier Street, *La Neuve Eglise*, was one of these. Soon, Spitalfields was being called 'Petty France'.

This first phase in the building's life continued until 1809. By then, silk weaving had pretty well died out in Spitalfields and the French congregation had shrunk to almost nothing. The church was leased to the London Society for Promoting Christianity Among Jews, a sort of missionary body whose main activity was printing and distributing copies of the New Testament and Christian prayer books in Hebrew. So, inevitably, while that was going on, people called the building 'the Jews' Chapel'.

Ten years later, everything changed again and the building's third life began, this time as a Methodist Chapel. The Methodists survived a lot longer than the missionary body which had tried to convert Jews. But, once more, it was what was going on around the building in Spitalfields that saw off the Methodists and resulted in the building's fourth tenants being ... well, well ... Jewish.

Pogroms in Russia during the last 20 years of the 19th century and economic hardship in other parts of Eastern Europe drove out much of the Jewish population and London – especially the East End – was one of the places where they settled in large numbers. The Huguenot houses were turned into multi-occupancy tailors' workshops and tenements and, guess what, Spitalfields' new name became 'Little Jerusalem'. The building on the corner of Brick Lane and Fournier Street switched to being the Great Synagogue of the ultra-religious group Mazhike Hadath.

But things never stand still and especially not in Spitalfields. Over time, the Jewish community moved from the area, attendances at the synagogue went down and it closed in 1952. Who started about that time to take the place of the Jews round Brick Lane? Single men began arriving from the area of Pakistan that later became Bangladesh. They never intended to settle here. The plan was to make loads of money and go home as rich men. But the plan didn't work out. They stayed on as immigrants and

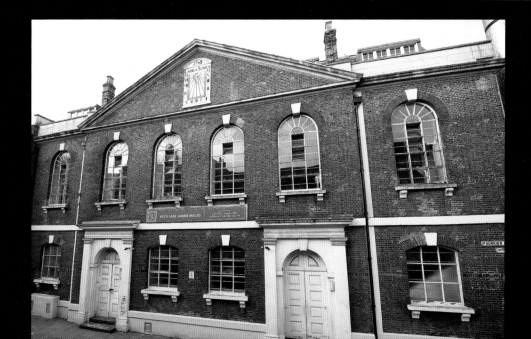

brought over wives and families. They found work in the clothing trade and leather garment workshops that had taken over from the old Jewish tailoring businesses. And the area's latest, and current, nickname is familiar to everyone who goes to grab a curry in 'Banglatown'.

These newest immigrants were, of course, mainly Muslims. In 1974 the Bangladeshi community bought the building and what had previously been an ultra-orthodox synagogue became a mosque. It's now in its fifth phase as the Jamme Masjid, as pictured on the previous page. And that is why, on the corner outside it, there's a tower with a crescent moon on top.

It's nowhere near large enough to serve all the Bangladeshi people in that area now, of course. Just round the corner on Whitechapel Road is the giant East London Mosque.

There's probably no other area of London which has seen as many changes of population over the last three hundred years as Spitalfields. But immigrant groups are now well established in many other parts of London and, as a result, the religions which they brought with them have taken root and places of worship have been established. We'll see lots of examples in this chapter.

Neasden, for example, is the unlikely setting for a beautiful white marble Hindu temple because of the large population of Indian origin which has settled in that area. Southall's a different story. Many of the people who live there are Sikhs and so Southall has a magnificent gurdwara. If you pick the right day, you can see a colourful and noisy Sikh ceremony winding its way through the streets round there.

Harrow, too, has people of Indian origin and they include some followers of Jainism. The result is a Jain temple in Harrow Wealdstone. There's also a Zoroastrian centre, once an Art Deco cinema, in a different part of Harrow. In India, Zoroastrians are sometimes called Parsis (from the word for Persians), which is a clue to the religion's origins in Ancient Persia. Fire ceremonies are important in Zoroastrianism and, believe it or not, they're performed in Rayners Lane.

Faith in London

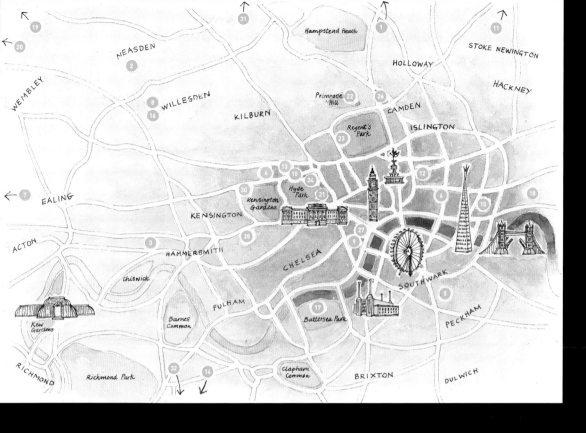

Nigerian immigrants have settled in parts of south-east London like Walworth. The Eternal Sacred Order of Cherubim and Seraphim, a Nigerian Christian sect dating from the 1920s, has turned a church near Elephant and Castle into its Cathedral of the Mount of Salvation and long Sunday services with guitars, drums, singing and clapping are held there.

Older pockets of immigrants in London followed exactly the same pattern. There's a well-established Greek community in Bayswater, near St Sophia's Greek Orthodox Cathedral. Within an area of about a square mile in Stamford Hill, there are more than 70 synagogues or shuls. And there's been an Italian Church in Clerkenwell, an area once known as 'Little Italy', since the mid 19th century.

TAKING THE PICTURES

People ask me, 'Aren't there problems with photographing religious ceremonies? Don't people object to your being there, taking pictures of them when they're praying or whatever? Isn't it very intrusive?' I tell them that I've been made very welcome at all the places where I've taken the shots in this chapter but that the amount of freedom that I've been given to wander around has varied a lot. You'll see what I mean when you read below the brief stories of my visits to some of the religious buildings and events that are shown in the photographs.

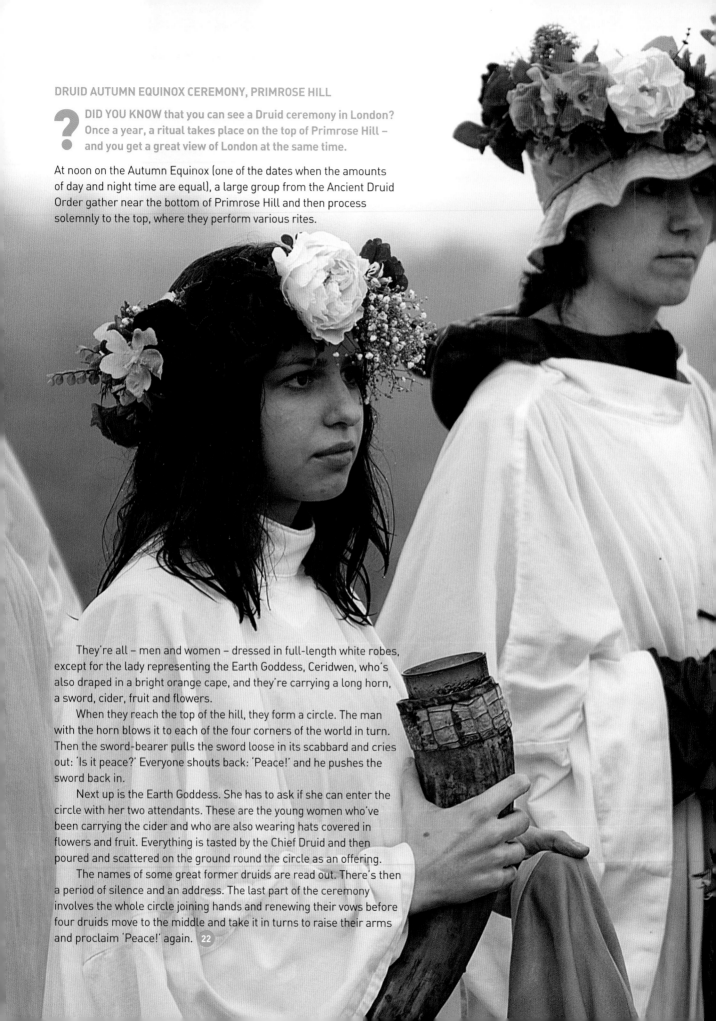

DRUID AUTUMN EQUINOX CEREMONY, PRIMROSE HILL

? **DID YOU KNOW** that you can see a Druid ceremony in London?
Once a year, a ritual takes place on the top of Primrose Hill –
and you get a great view of London at the same time.

At noon on the Autumn Equinox (one of the dates when the amounts
of day and night time are equal), a large group from the Ancient Druid
Order gather near the bottom of Primrose Hill and then process
solemnly to the top, where they perform various rites.

They're all – men and women – dressed in full-length white robes,
except for the lady representing the Earth Goddess, Ceridwen, who's
also draped in a bright orange cape, and they're carrying a long horn,
a sword, cider, fruit and flowers.

When they reach the top of the hill, they form a circle. The man
with the horn blows it to each of the four corners of the world in turn.
Then the sword-bearer pulls the sword loose in its scabbard and cries
out: 'Is it peace?' Everyone shouts back: 'Peace!' and he pushes the
sword back in.

Next up is the Earth Goddess. She has to ask if she can enter the
circle with her two attendants. These are the young women who've
been carrying the cider and who are also wearing hats covered in
flowers and fruit. Everything is tasted by the Chief Druid and then
poured and scattered on the ground round the circle as an offering.

The names of some great former druids are read out. There's then
a period of silence and an address. The last part of the ceremony
involves the whole circle joining hands and renewing their vows before
four druids move to the middle and take it in turns to raise their arms
and proclaim 'Peace!' again. **22**

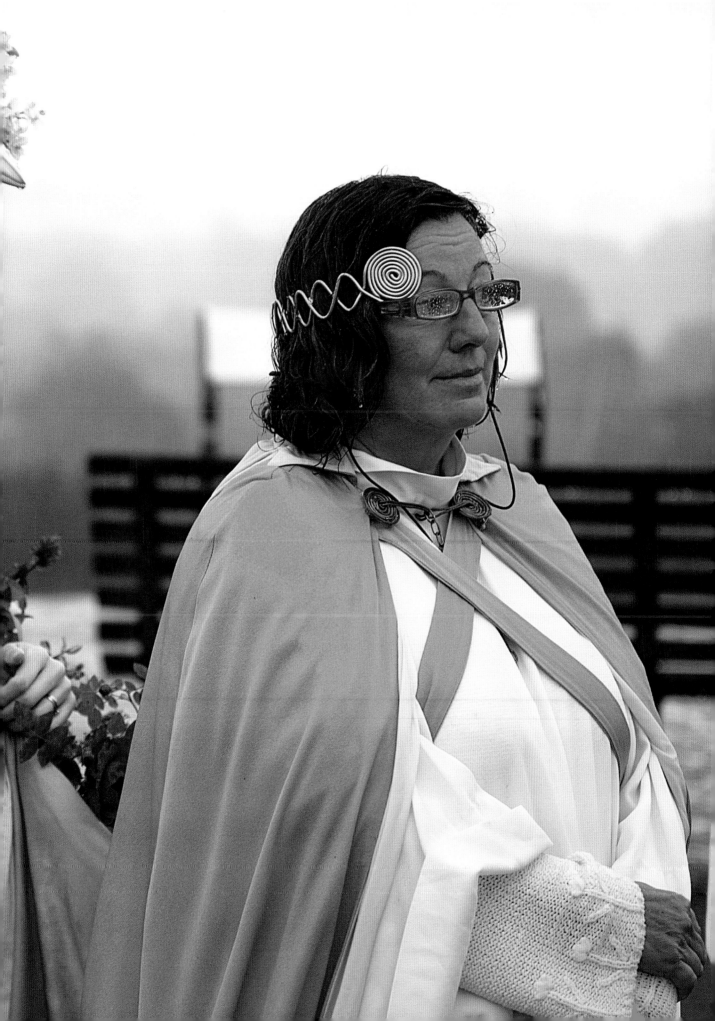

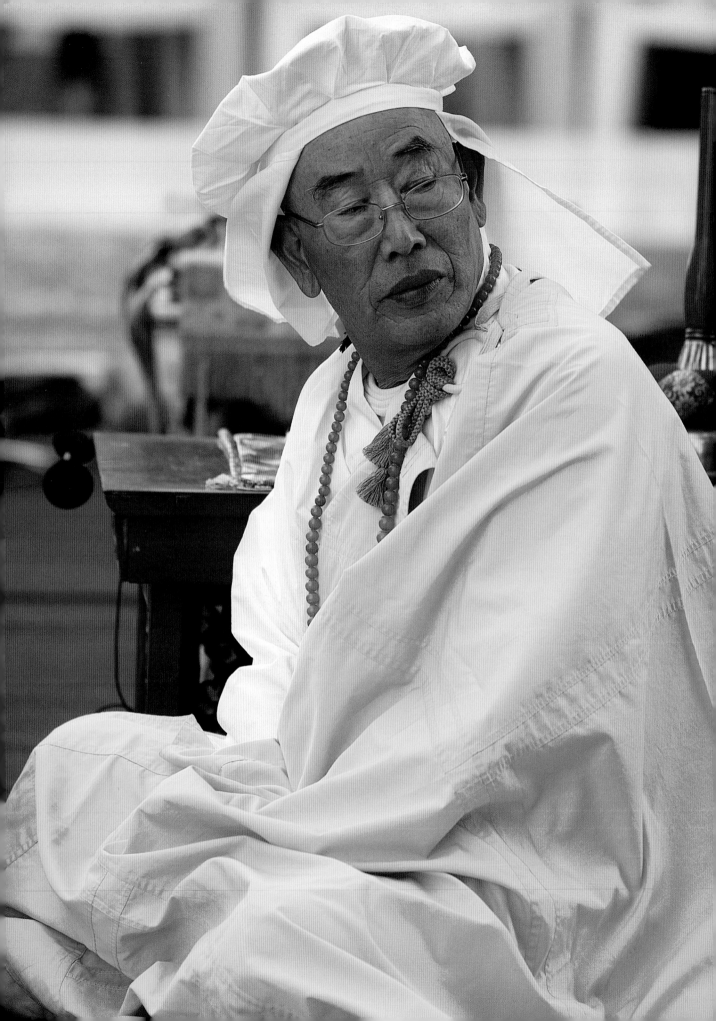

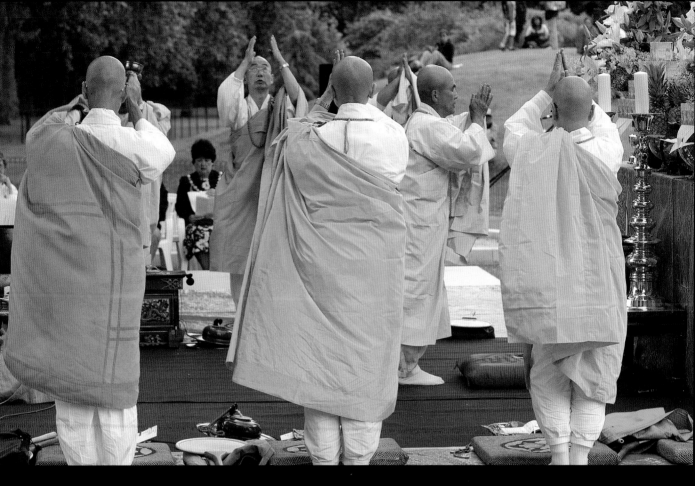

PEACE PAGODA, BATTERSEA PARK

Every year, a re-commemoration ceremony takes place at
the Peace Pagoda in Battersea Park. The Nipponzan Myōhōji
Order, which is a branch of Japanese Nichiren Buddhism,
was responsible for building the pagoda in the 1980s and
a contingent comes over from Japan for the ceremony.
The Order was founded by Nichidatsu Fujii, who, after the
horrors of Hiroshima and Nagasaki, dedicated his life to
getting nuclear weapons abolished. It was his idea to build
peace pagodas round the world and there are now more
than eighty of them.

One of the things that marks out Nichiren Buddhists is
that, while they honour and respect Buddha and try to learn
from his teachings, they don't worship him or pray towards
him. Everyone chants a mantra during the re-commemoration
ceremony. This is Nam Myōhō Renge Kyō (which translates
rather awkwardly as 'Devotion to the Mystic Law of the Lotus
Sutra' and is the Japanese title of the Lotus Sutra; it's also
referred to as *daimoku*). And while Buddhists from other
sects might focus their attention on a statue of the Buddha
as they pray or chant a mantra, Nichiren Buddhists gaze at
the horizon. **17**

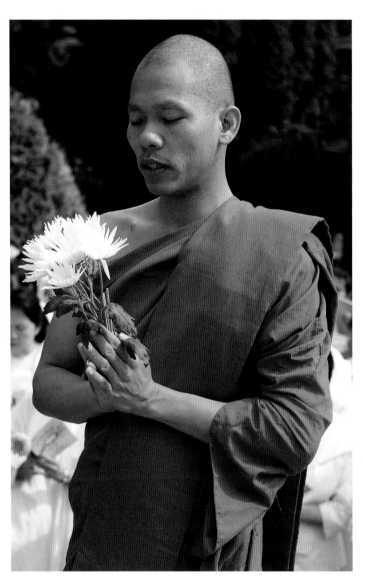

THAI BUDDHIST TEMPLE, WIMBLEDON

Wat Buddhapadipa, the Thai Buddhist temple in Wimbledon, was officially opened in 1982 by the elder sister of the King of Thailand. It's a beautiful, compact example of Thai temple architecture and although, curiously, it somehow doesn't look out of place set among the trees in its large grounds, you still find yourself gazing at it and wondering how this exotic building could possibly be in England at all.

The impression is all the stronger when you get inside. We're talking about a straight-up-and-down, no-expense-spared, classic Thai temple interior, with murals all over the wall and, of course, statues of the Buddha. Among them are replicas of the famous Emerald Buddha in Bangkok's Grand Palace and the Golden Buddha in its National Museum, as well as a smaller Golden Buddha originally presented to our Queen on one of her birthdays and then brought to the temple by Princess Alexandra when it was inaugurated.

Several religious festivals are celebrated at Wat Buddhapadipa in the course of the year. One of these is Asalhapuja, the day on which the preaching of the Buddha's first ceremony is commemorated. The three monks and meditation masters who are resident at the temple were joined on that day by a group of *silacarini*. *Silacarini* is the Thai word for lay Buddhist nuns and the ladies in this photograph, dressed all in white as tradition demands, were embarking the same day on a nine-day programme of meditation and simple living at the temple. **14**

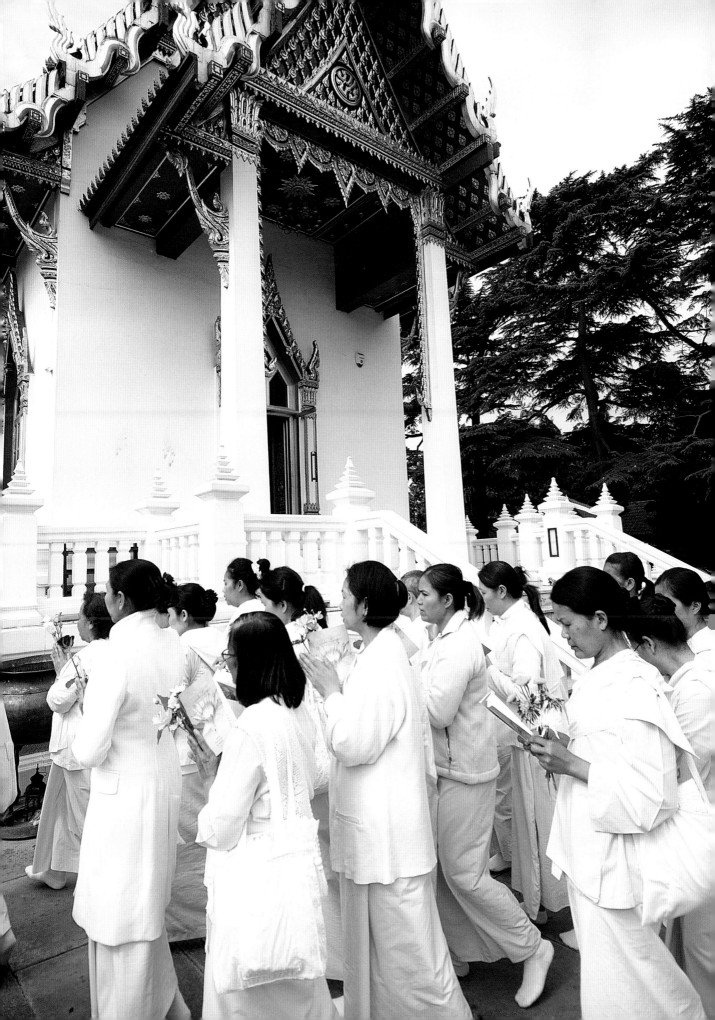

NEAR THE LONDON CENTRAL MOSQUE, ST JOHN'S WOOD

Some Muslim men and boys leave the Regent's Park Mosque after prayers on Eid al-Fitr, the festival to celebrate the end of Ramadan. **23**

OVERLEAF EAST LONDON MOSQUE, WHITECHAPEL

Everybody knows that, for the whole of Ramadan, Muslims fast during daylight hours. But you're not just supposed to eat less during Ramadan. You have to exercise more self-control in other areas of your life too. And people generally make a big effort to improve the way that they behave. A lot of charity work is done. And everyone goes along to their local mosque more often. Cue very full mosques, especially on a Friday morning, as was the case in the large East London Mosque when the photograph overleaf was taken. The congregation filled up all the available floor space, not only in the mosque itself but also in the East London Muslim Centre next door. Even then, one worshipper struggled to find a space to join the communal prayers.

These two buildings serve predominantly the large Bangladeshi community which began to settle in the Spitalfields and Whitechapel areas from the mid 1950s and gradually took over and reorganised the old Jewish tailoring workshops that had operated there since the late 19th century.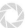

TAKING THE PICTURES at the East London Mosque

The Imam led Friday prayers in the large hall of a partially completed building at the East London Muslim Centre. TV images and sound were relayed to the mosque itself and to other parts of the building. There are galleries high up on two sides of this large hall and I was allowed to move around freely in these galleries taking as many pictures as I liked, although, of course, I had to do it as quietly as possible.

The big drawback was that this floor of the building was then still very much a construction site. There were bags of cement, planks, ladders and other builders' bits and pieces lying around everywhere. And it was filthy dirty. My clothes, my socks (I'd taken off my shoes at the entrance of course), my camera bag, everything I had with me that day ended up covered in dust. The exact opposite of what you normally expect when you go to take photographs in a mosque.

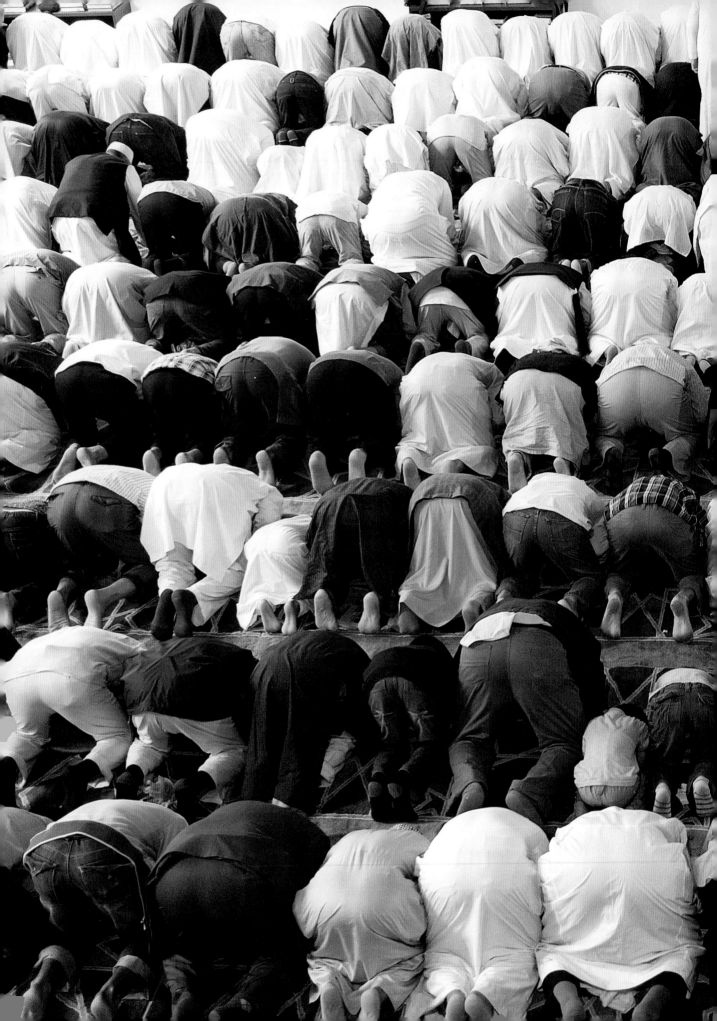

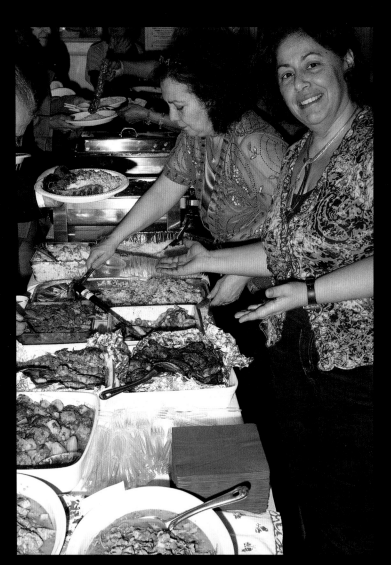

TAKING THE PICTURES of Bahá'ís

The Bahá'í faith has no clergy and virtually no rituals. So it was a challenge to take pictures which would portray a gathering of its members. Italian Catholics have street processions. Buddhists have heavily ornamented temples and colourful ceremonies where everyone wears orange, yellow or white robes. Hindus have numerous festivals. But Bahá'ís have nothing like this.

The solution was a Naw Ruz party in West Wimbledon. Naw Ruz is the Iranian New Year and it falls on the first day of spring, which is 21 March. It's a festival day for Bahá'ís too and they meet to pray, enjoy some music, dancing and other entertainment, and to eat. And they certainly do eat. An enormous buffet of wonderful Iranian dishes was laid out and I found my plate being piled high with a big spoonful from every one of them. I was made to feel very much part of the family.

BAHÁ'Í NAW RUZ CELEBRATIONS, WEST WIMBLEDON

The Bahá'í religion is one of the world's younger ones. It was started in Persia (today's Iran) in the mid 19th century and it was always going to have a hard time there. You can't understand why without knowing a bit about Shi'ism and the historical origins of the sectarian divide between Shi'a and Sunni Muslims. This takes us back to the 7th century AD and the question of who should succeed the Prophet Mohammed after his death.

Shi'as believe that the succession should have been through the male line of Ali, Mohammed's cousin and son-in-law and his closest male relative. They call him the First Imam. But after Ali's assassination, the Caliphate (or leadership) in fact passed to men who were unrelated to him. And Sunni Muslims think that this line of succession was correct.

Each of Ali's male successors, or, as they were known to the Shi'as, each Imam, was secretly murdered. This made the divide between Shi'a and Sunni more and more bitter. And then, eventually, the Twelfth Imam simply disappeared altogether. Shi'as believe that he's alive but invisible. And

that he'll return at the end of time as the Messiah (al-Mahdi) to bring peace, justice and unity to the world.

Iran has been an overwhelmingly Shi'a country since the 16th century and the reason why the Bahá'í religion has been so persecuted there lies in the core message that it always carried. This was that the Twelfth Imam had reappeared and stated that the Bahá'í religion was the fulfilment of the messianic expectations not only of Shi'as but also of all other religious traditions. Bahá'ís were in favour of world government, they thought that all humans were equal, regardless of sex or race and – this was especially unwelcome to the mullahs in Iran – they said that mankind no longer needed specialists in religion.

Bahá'ís believe in one God, who is omnipotent and perfect and has complete knowledge of life. They say that, over the centuries, he has sent us a series of messengers, such as Zoroaster, Abraham, Moses, the Buddha, Jesus and the Prophet Mohammed, who have been progressively revealing truths about the same God. It was just that this God had different names in different religions. It therefore follows, in their view, that all religions have valid origins. 32

BRAHMA KUMARIS, WILLESDEN

A large congregation has gathered, dressed all in white, at the Brahma Kumaris World Spiritual University in Willesden to listen to the movement's co-administration head, Dadi Janki.

The BKWSU was founded in Hyderabad, India. In 1936 a man called Lekhraj Kripilani, the son of a village schoolmaster, had some visions. He shared them with a small group of other men and women living there and what he said was enough to inspire them to form a small community called Om Mandali, who together decided that they'd live their lives according to his ideas. The key thing that he offered, and that BKWSU teachings still offer, they say, is a new insight into aspects of the soul, God and time which, when properly understood, enables you to lead an enlightened and better life.

They want you to acquire spiritual knowledge. They don't care what faith you profess. All religions are welcome. Whether you're a Christian, Muslim, Jew, Hindu, Buddhist or whatever, what they'd like you to do is to concentrate on deepening your understanding of spirituality. If you do that and if you master the art of meditation, you'll focus on your soul instead of your body, which is what we generally do in the modern world. Souls, say the BKWSU, are good, and through meditation, you can actively channel your thinking towards peace, love and harmony. They think that global harmony will come only through this approach.

Within fifteen years of Om Mandali being set up, the organisation had moved to Mount Abu in Rajasthan, where it has its world spiritual headquarters today. And, looking at the BKWSU presence in the world now, it has grown a bit from that modest beginning: it has 8,500 centres in 110 countries. 16

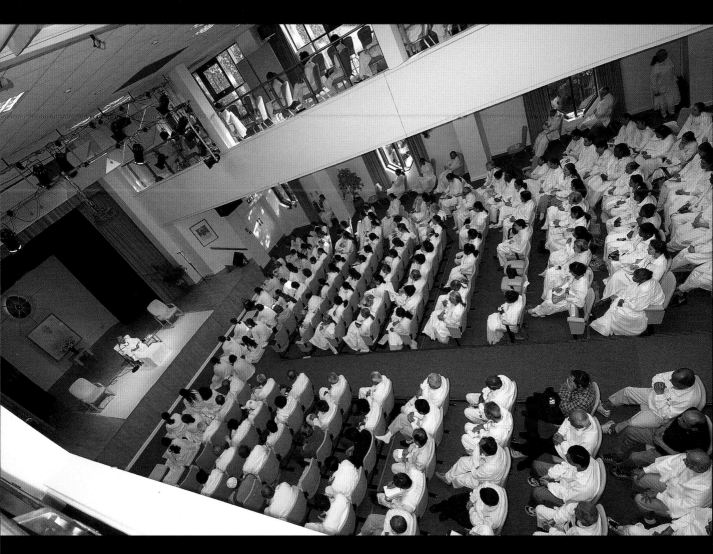

JEHOVAH'S WITNESSES, WESTMINSTER

Do you actually know what Jehovah's Witnesses believe?

When they've come to your house, have you said 'No thank you' and hurried to close the door?

Yes?

Have you read *The Watchtower*?

No?

But you're clear in your mind that what Jehovah's Witnesses believe is not for you?

Definitely.

OK. Can you just run over what those beliefs are for me, please?

Well, they're, um, Christians, aren't they? And ... well ...

Hey, I was the same as you until I photographed a couple of very friendly ladies going door to door in Westminster with their *Watchtowers* and I started to look into it.

Yes, of course, Jehovah's Witnesses are Christians but they're very different in lots of ways from most people who call themselves that. The first major thing that marks them out is that they reject the whole idea of the Trinity. They say that the only true God is God the Father, who ... yes ... they call Jehovah. They believe that Jesus, his son, is a mighty being but that he's inferior to God. And that the Holy Spirit is not a person at all but an active force used by God to achieve his ends. The second big difference with mainstream Christianity is that Jehovah's Witnesses don't believe in life after death. When a person dies, that's the end of their existence. And on a more down to earth level, Jehovah's Witnesses don't celebrate Christmas or Easter.

Those are just three things. There are lots more, of course, but it's a start. And it's a shame that we tend to close our minds as well as our doors. 9

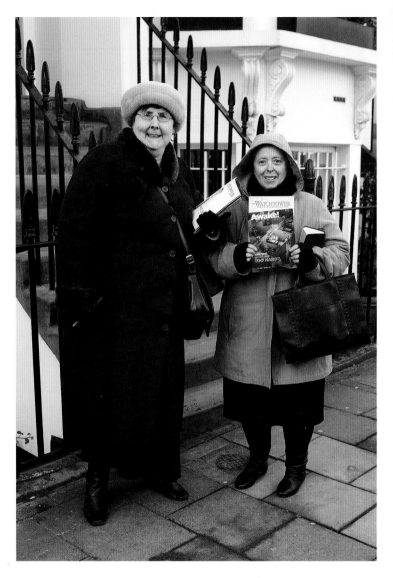

CHRISTIAN EVANGELIST, KENSINGTON

It was a summer evening on Kensington High Street. The pavement was busy with people on their way to hang out in a pub with friends, grab an early dinner, see a film or even go to the Proms up the road at the Albert Hall. Crowds poured from the concourse that leads to the Tube station. Buses pulled up outside the station every few minutes and added to the crush. There was heavy traffic on both sides of the road. It was a noisy, confused scene. But in the middle of it all, there was one figure who was standing still. Andy Lumeh. Evangelist preacher, singer, songwriter, music producer, motion picture director and tweeter. He was holding up a crucifix in his right hand and, utterly ignored by virtually everyone but still completely undeterred, he was trying to get his Christian message heard above the general din. 28

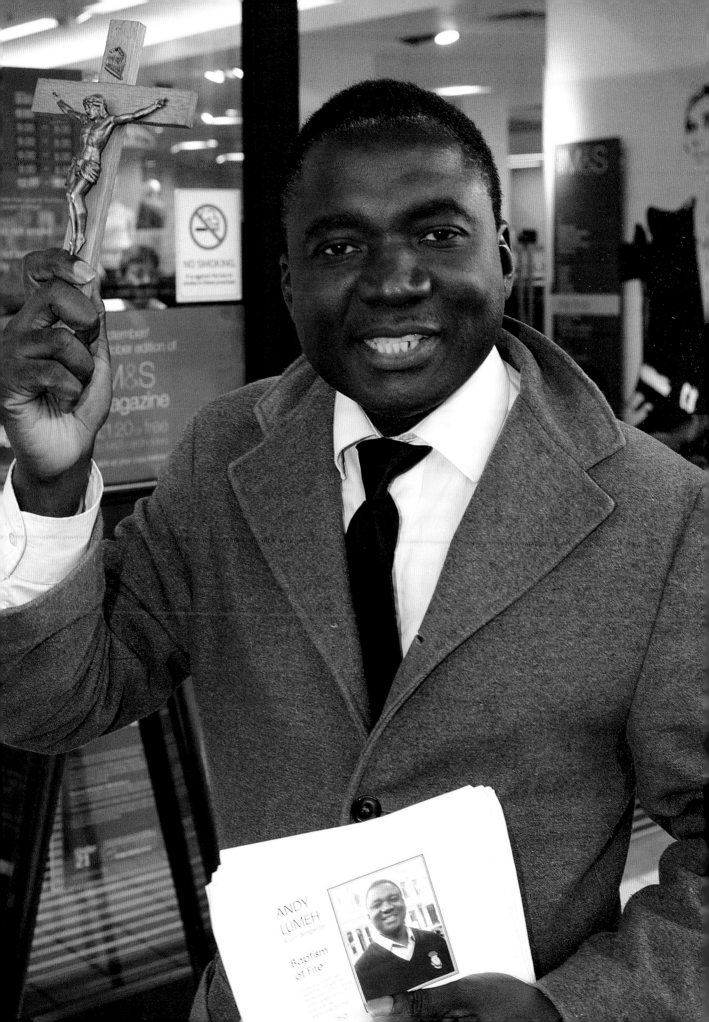

ANDY
LUMEH

Baptism
of Fire

SECOND CHURCH OF CHRIST, SCIENTIST, KENSINGTON

The Church of Christ, Scientist was founded by Mary Baker Eddy in the USA. Poor Mary was forever getting ill. She tried conventional medicine, alternative medicine, everything, but nothing worked. In 1866 she had a serious fall and things began to look really bad for her when she'd still shown no improvement after three days. It was then that she asked for her Bible. She chose two of the stories in which Jesus heals people, concentrated hard on them and, amazingly, found that she was completely better.

She'd always had this ability to heal other people and now she began to understand the science which lay behind it. It took years more study before she could say that she'd properly mastered what she characterised as the science of the Christianity that Jesus taught and lived. But then she devoted the rest of her life to teaching, preaching and healing others through the system that she'd worked out and that she called Christian Science. In 1875 she published her seminal book about it, *Science and Health with Key to the Scriptures*. This book and the Bible are still the foundation stones on which all Christian Science teaching is based.

So you'd hardly think, what with the name too, that Christian Scientists would need to stress to people that they're Christian. But they find that they do have to do this because their faith is often confused with Scientology, New Age practices, faith healing and Eastern religions.

What then is Christian Science exactly? At its core is the belief that it's never God's will for anyone to suffer, be sick or die. On the contrary, God's wish for everyone is health and happiness. All the problems in the world, whether on the level of personal relationships or international politics, can be sorted out by the power of prayer. ㉚

ST ANNE'S LUTHERAN CHURCH, THE CITY

Think Lutherans, think Martin Luther. Obviously. The Reformation. The break with Rome. The birth of Protestantism. Cut out the Latin. No more confessing. Do away with the incense, etc., etc. Okay. So what was left after Luther had swept all that away? What do Lutherans believe and what form does their worship take?

Well, one of the most revolutionary things Luther said was that God was accessible to everybody, without the need for a priest to mediate. And what was even better was that salvation was available to everyone too, through Christ, whatever your position in the world, and you could get it by faith alone. The scriptures held the key to everything.

Lutherans kept baptism and communion services but they made them much simpler. And whichever service it is, congregational singing and preaching always play an important part in a Lutheran church. Their clergy wear vestments for services and their churches have altars but otherwise they tend not to have much decoration. That doesn't mean that they have to be unattractive. St Anne's Lutheran Church in Gresham Street was originally designed by Christopher Wren and is gorgeous. ⑥

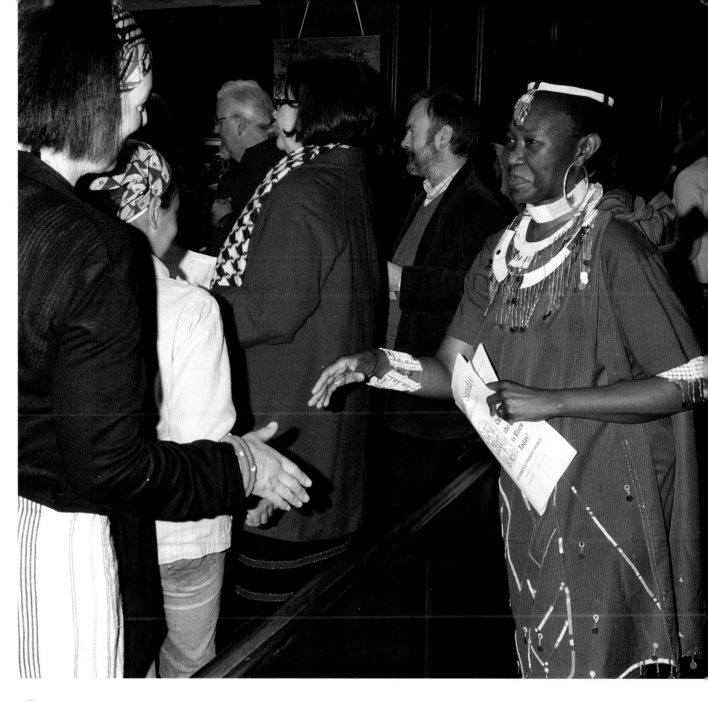

At the Easter Sunday service in this Wren church where a
Lutheran congregation then worshipped, there were people
from Britain and northern Europe, as you'd expect. But
many other countries were represented. Both the Far East
and Africa had large contingents and the biggest group of all
was from East Africa. There were some colourful and exotic
dresses being worn by the ladies and, to my amazement,
some of the anthems sung by the choir were in Swahili.

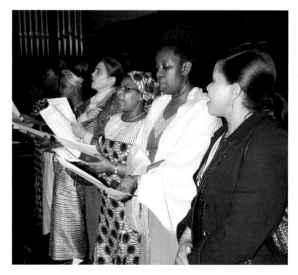

RATHAYATRA HARE KRISHNA FESTIVAL, HYDE PARK

Hare Krishnas? Ah yes, an ancient Indian thing. Wrong. 1966. New York City. It's true, though, that the movement's beliefs are based on traditional Indian scriptures. All the thoughts and actions of its followers are aimed at pleasing Lord Krishna. This stops them from eating meat, fish or eggs, having illicit sex, gambling, getting drunk or using stimulants like coffee, tobacco or other drugs.

You sometimes see groups of them reciting the Maha Mantra in public:

Hare Krishna Hare Krishna
Krishna Krishna Hare Hare
Hare Rama Hare Rama
Rama Rama Hare Hare.

Every June, the movement organises the Rathayatra Festival of Chariots simultaneously in lots of places round the world. In London, three huge, colourfully decorated wooden chariots containing statues of deities are pulled by hand from Hyde Park to Trafalgar Square. **21**

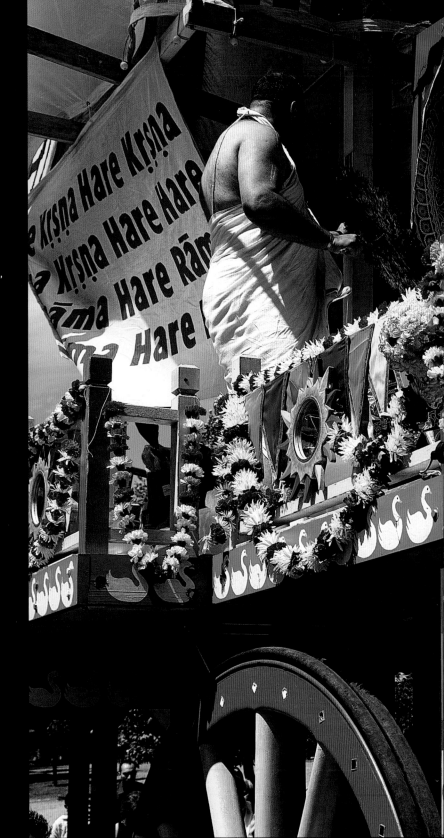

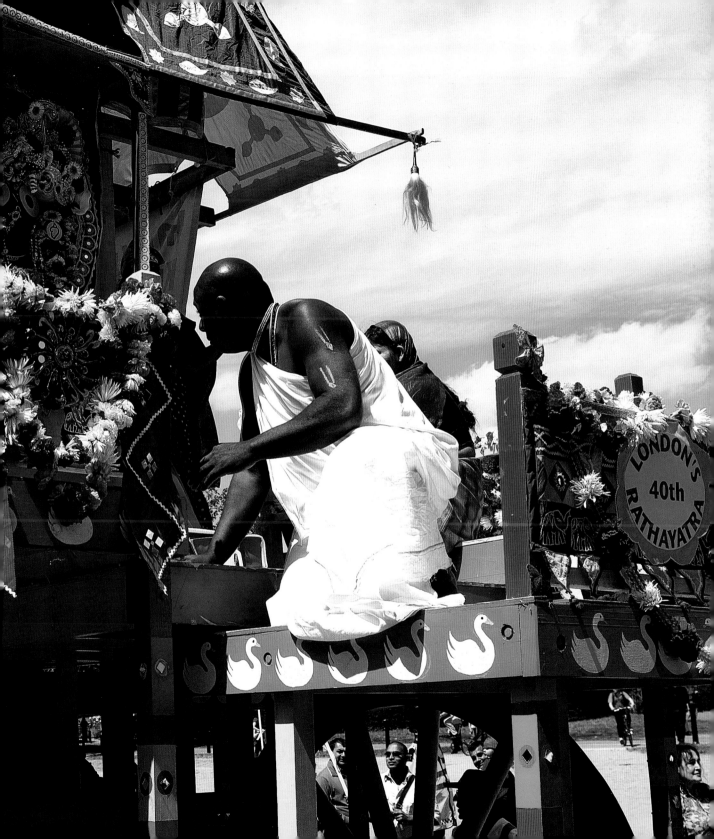

DIWALI, BAPS SHRI SWAMINARAYAN MANDIR (THE HINDU TEMPLE), NEASDEN

If you've not been told what to expect, your first sight of the BAPS Shri Swaminarayan Mandir, popularly known as 'the Hindu Temple', will be a big surprise. You're cruising along among the ordinary run-of-the-mill houses of Neasden, the same old suburban landscape for miles now, when above them rises this huge and magnificent structure in white marble, flags streaming out from its many spires or *shikhars*. It's a building from another continent, you might say from another culture, entirely.

Now it's part of our culture. People of Indian, and especially Gujerati, origin have settled in large numbers over a great swathe of north-west London. And, as a result, India's principal religion, Hinduism, has taken root there. The Hindu Temple was built by BAPS Swaminarayan Sanstha, a Gujerati spiritual organisation.

Well, it was built by it in the sense that it was the moving force behind the project. Over five thousand volunteers were actually involved in turning plans into reality. It was, and still is, funded entirely by worshippers and donors. The story of its construction is amazing too. Five thousand tonnes of Italian Carrara and Indian Ambaji marble, as well as limestone from Bulgaria, were hand carved by traditional craftsmen in India and then their work was shipped in pieces to London for assembly on site. And that's just the mandir, the main temple.

It was the same story with the haveli, the building alongside, which houses, among other things, the assembly hall. This is made of Burmese teak and English oak, all of which is intricately carved.

Entirely traditional methods were used in the construction of both buildings, which meant that there was no structural steel. Since 2,500 people can fit into the assembly hall when it's fully opened out, this is no mean achievement.

And they certainly need to open it out when Diwali is celebrated at the temple because, over the weekend closest to the actual date of the festival, more than 50,000 people come to worship there. There's the Hindu community of north-west London, of course, but whole families travel from all over the south of England. (2)

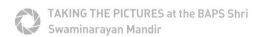

TAKING THE PICTURES at the BAPS Shri Swaminarayan Mandir

This was an event where I was given amazing freedom to go where I wanted and take whatever photographs I liked. I'd been to see the temple's PR team beforehand and they'd ensured that my project was approved and that I had permission to take photographs at Diwali. On the two days of the Diwali weekend, a member of the PR team shepherded me around and made sure that I was always in the best position to take my shots and also that I understood what was going on. So I could go anywhere, both in the mandir and in the haveli. I was the only outside photographer allowed to do that. A huge privilege.

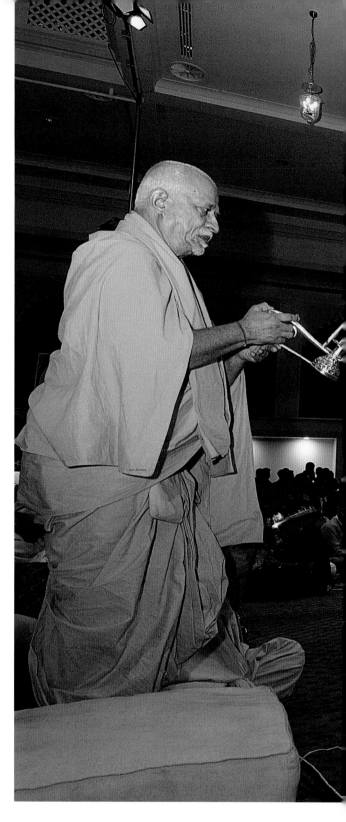

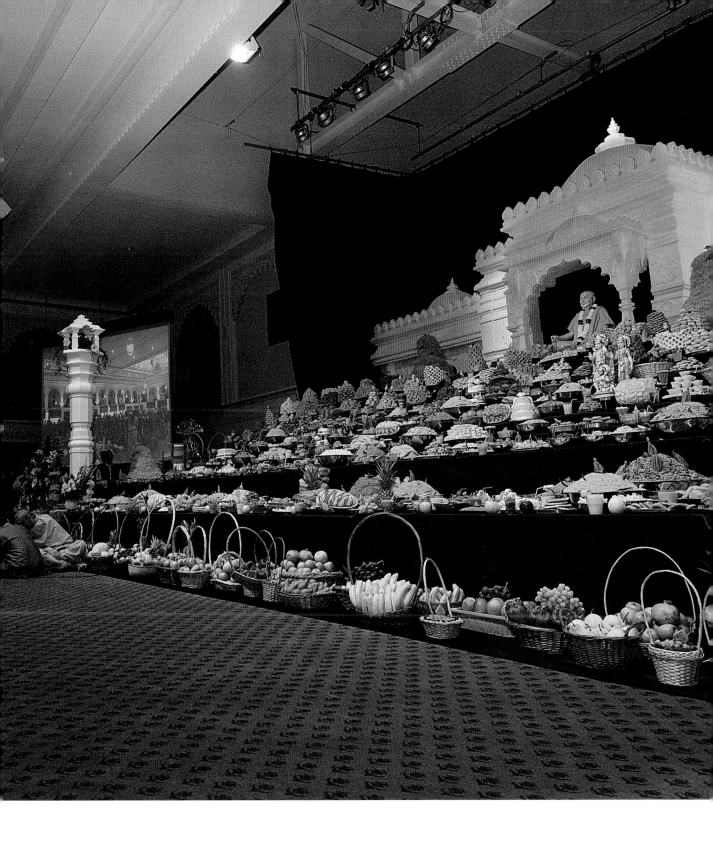

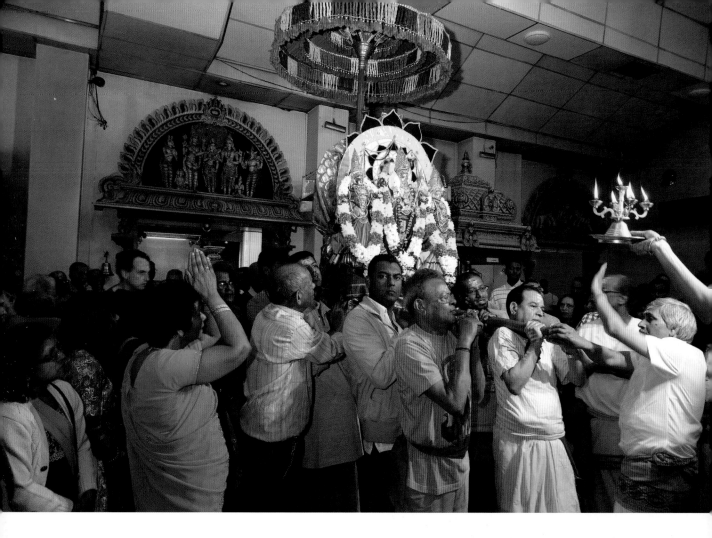

KAVADI CEREMONY, MURUGAN HINDU TEMPLE, HIGHGATE

A Kavadi ceremony honours the Hindu God of War and Victory, Murugan, and what happens in the ceremony stems from a Hindu myth in which Murugan played a leading role. A wise old man called Agastya was given a tough assignment by Lord Shiva. His task was to move two hillocks from the holy mountain, Mount Kailas in Tibet, all the way to south India. This is a good thousand miles. Not surprisingly, after getting part of the way there, he delegated the job to one of his followers called Idumban.

Idumban did well. He was nearing his destination when, reasonably enough, he decided that he'd earned a break. He put the hillocks down to have a rest and that was when things started to get out of control. When he tried to pick them up again, he just couldn't lift them.

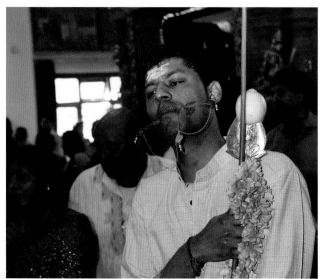

He was trying to work out what to do next when a young man happened to come by. Idumban stopped him and asked for help. Instead of helping, though, the young man, amazingly, claimed that the hillocks were his. They had an argument which became heated and turned into a scuffle, which turned into a fight and Idumban was killed.

The young man, of course, was Murugan in disguise and it was his power that stopped Idumban from lifting the hillocks. But there's a happy ending. Murugan decided to restore Idumban to life and reveal himself. In return, Idumban asked

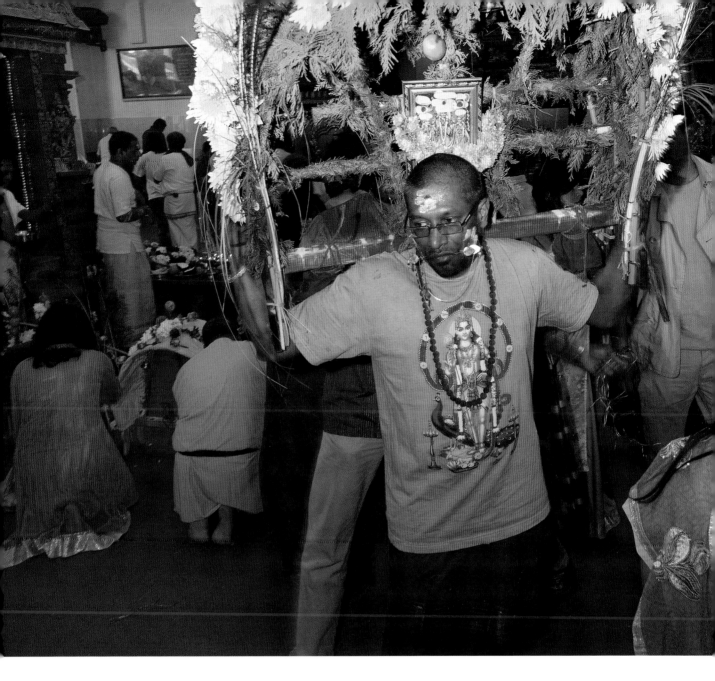

Murugan to ensure that whoever, in future, carried a kavadi – a structure symbolising the two hillocks – on his shoulders to the temple would be blessed.

So what the kavadi usually consists of is two semicircular pieces of wood attached to a cross structure which can be balanced on the shoulders of the devotee. It's decorated with flowers and peacock feathers (Murugan's symbol) and can be extremely heavy.

Devotees generally prepare for a Kavadi ceremony by fasting and then, on the day of the ceremony, with various rituals, prayers and chants at the temple. They also often pierce their cheeks, tongues and other parts of their skin with fine vel skewers, which are then drawn out at the end of the Kavadi ceremony. What's astonishing and has never been scientifically explained is that these skewers produce no blood and don't seem to cause any pain. ①

TAKING THE PICTURES at the Highgate Hill Murugan Hindu Temple

I'd contacted the temple authorities in advance and been told that it was OK to photograph the Kavadi ceremony. I thought that I knew what to expect since I'd photographed a similar ceremony in Mauritius and many of the people who attend the temple in Highgate are of Mauritian origin. But I was unprepared for the size of the congregation and the fervour they showed throughout the whole morning, the noise and the smells of the ceremony and the levels of ecstasy which some of the devotees reached. The individuals whose photographs appear here were kind enough to consent to their inclusion.

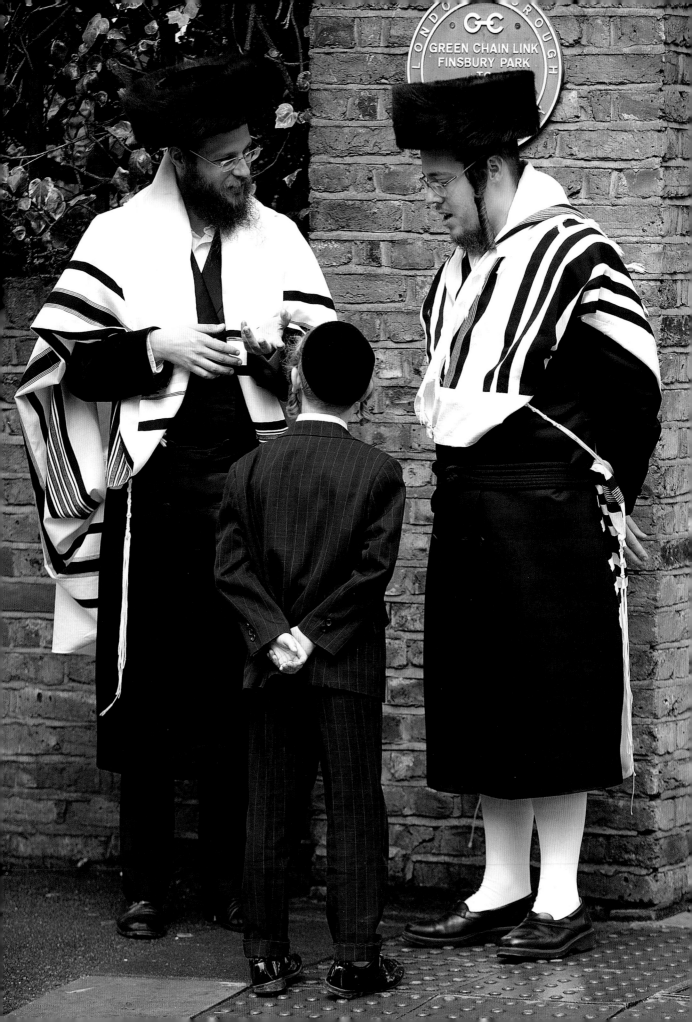

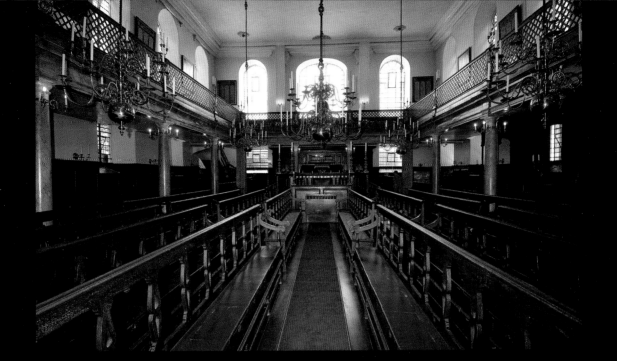

ORTHODOX JEWS, STAMFORD HILL

When you drive through Stamford Hill, it looks as though the large Jewish community there is all just made up of ultra-orthodox Jews. But they belong, in fact, to a significant number of different, mainly Hasidic, streams. And the Hasidim themselves are subdivided into numerous rabbinical dynasties, each taking its name from the village or town in Hungary, Poland or the Ukraine where it originated and each distinguished by some slight variation in religious practice and dress. So within an area of about a square mile in Stamford Hill, there are more than seventy synagogues or *shuls* and each of them is unique. **11**

BEVIS MARKS SYNAGOGUE, THE CITY

The entire Jewish community in England was expelled by Edward I in 1290 and it was only in Oliver Cromwell's time that the first Jews, traders from Spain and Portugal, were allowed to resettle here. At first they had to use houses in the City for worship but in 1699 the present site was acquired and Bevis Marks Synagogue was opened two years later. It isn't actually on Bevis Marks but down an alley off the street, since at that time Jews were not allowed to build on the thoroughfare. The date, 1701, makes it Britain's oldest synagogue. It's also arguably its most beautiful.

Benjamin Disraeli's father was a member of the congregation at Bevis Marks and was, at one point, chosen to be a warden. He said 'no, thank you' and found himself facing a fine for refusing the honour. When he was pressed to pay, he quit the synagogue and, in fact, the Jewish religion altogether. Not long afterwards, he got his children baptised as Christians. Since Jews were not allowed to become Members of Parliament until some time later, it's unlikely that Benjamin Disraeli would have become Prime Minister if it hadn't been for this quarrel. **15**

MITZVAH DAY, JEWISH VOLUNTEERS, FINCHLEY

One of the meanings of the term *mitzvah* in Hebrew is an act of human kindness. Mitzvah Day is the Jewish community's global annual day of social action when many thousands of people give their time, and not their money, and by doing so make a huge difference to a range of people, causes and charities throughout the year. Each November, on Mitzvah Day, a massive number of activities are organised all over London by the Jewish community. **31**

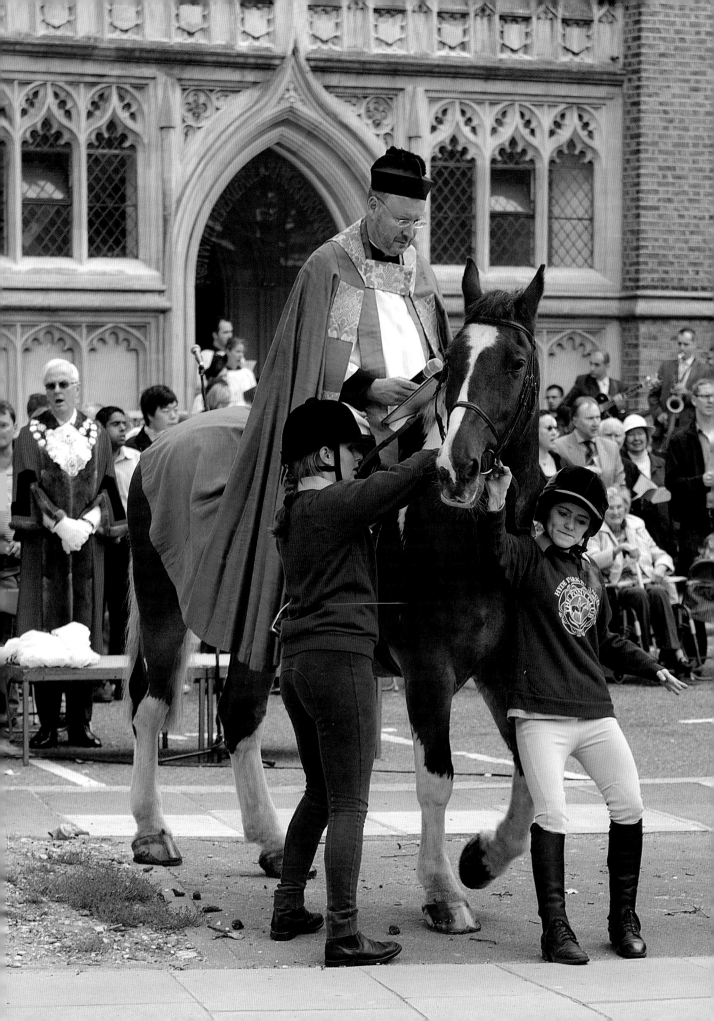

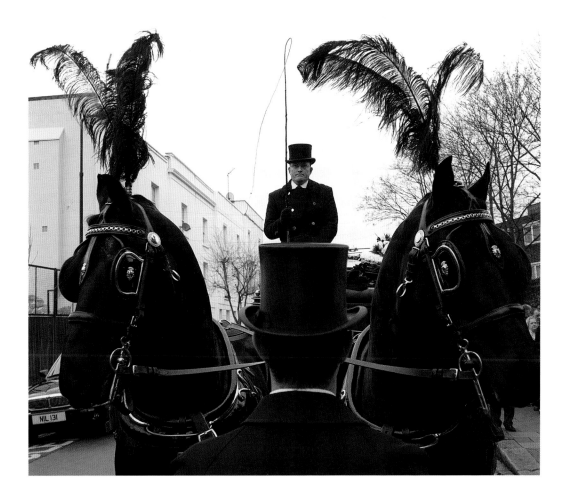

HORSEMAN'S SUNDAY, ST JOHN'S ANGLICAN CHURCH, HYDE PARK

You often see people riding in Hyde Park. Occasionally, it's someone who's confident enough to take a horse out on his own but more often than not it's a group with a riding instructor. Have you ever wondered where the horses are stabled and where the riding schools are based? Answer: in cobbled mews to the north of the park. The area round Sussex Square is distinctly horsey. And St John's Church in the square has recognised this. Once a year it holds a service in front of the church for a congregation on horseback. It's called Horseman's Sunday. The vicar himself is on horseback too, although, as he says, he's no horseman, and he's glad to have his horse held by a couple of young enthusiasts. 13

ANGLICAN FUNERAL, CAMDEN TOWN

But for one thing, this funeral service would probably have gone largely unnoticed by anyone passing by. There was a small gathering of family and friends. It was a nondescript Anglican church in a slightly depressing part of Camden Town next to a railway bridge. There was nothing special about the funeral director and undertakers carrying in the coffin. The family, though, decided to use an ornate glass-sided horse-drawn hearse pulled by a pair of black horses. And not just ordinary horses either. They were Dutch Friesians, known as 'Belgian Blacks'. The coachman and the groom were wearing top hats. It was quite a turnout. The result was a really remarkable send-off for their loved one as far as the family were concerned, and a crowd of people on the pavement outside the church admired the show. 26

EASTERN ORTHODOX CHURCH

The Orthodox Church is one of the three main Christian groups, alongside Roman Catholics and Protestants. It has a lot in common with the other two because it has exactly the same roots, of course, but it developed in the Eastern Roman Empire – capital Byzantium (modern-day Istanbul) – as opposed to the Western Empire – capital Rome. All three believe that Jesus was the Son of God and that he was crucified and rose from the dead. And there are many other areas where Orthodox Christians and Roman Catholics share beliefs. But there are some important differences too. Some of these are theological and others are more about how religious services are conducted and how people lead their daily lives.

The bibles used by the Orthodox and Western Churches are the same, except that the Orthodox one is based on the ancient Jewish translation into Greek instead of the Hebrew one. So the words are different. The key dates in the year are too. After the First World War, most Orthodox Churches switched from the Julian calendar to the Gregorian one. This means that they're thirteen days behind most of us in England, so that, for example, Christmas Day is on 7 January.

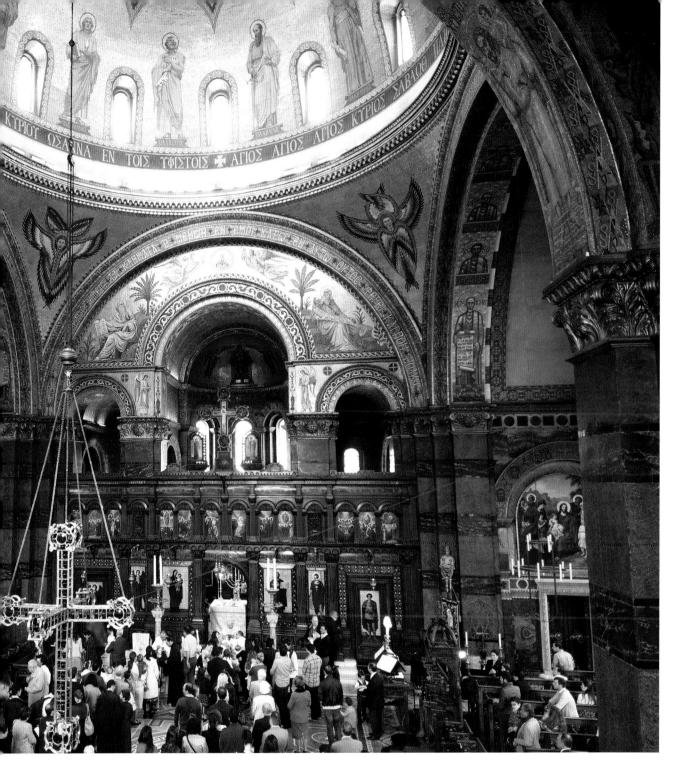

GREEK ORTHODOX CATHEDRAL, BAYSWATER

The Eucharist is an important service in the Orthodox Church, just as Holy Communion, its equivalent, is central to worship in the Western Christian Church. In their different ways they follow Jesus's command at the Last Supper to 'Do this in remembrance of me'. Orthodox Christians believe in transubstantiation. This is the idea that the bread and wine used in the Communion service are actually changed into the body and blood of Christ. So in an Orthodox Eucharist, the prayer of consecration, when the Holy Spirit is called down to make this change, is a crucial part of the ceremony.

Before that, the whole congregation recites the Nicene Creed and, at what's known as the Great Entrance, the bread and wine are carried to the altar. People go to the front of the church and remain standing and then the bread and wine are given to them on a spoon. At the end of the service, bread that's been blessed but not actually consecrated is handed out to everyone, whether they've taken Communion or not, and, as a gesture of fellowship, anyone in the church is welcome to receive some. They don't even ask your religion. 4

Icons are very important in the Orthodox Church. In most traditionally built churches, the altar or sanctuary is separated from the main body by a solid screen, which is called an iconostasis and which is like a wall of icons. Three doors lead through this screen. The one in the middle is the Holy Door and the icons on either side of it show Christ and Mary. Then, to the left and right of those, there will typically be icons of St John the Baptist and the saint to whom the church is dedicated.

In the Orthodox Church, you're baptised by being immersed in water three times in the name of the Trinity. Then, after being baptised, you're anointed with holy oil called chrism. This process is called chrismation. The final stage is usually Holy Communion, so that small children, once they've been baptised, are fully communicant members of the Orthodox Church. **3**

 TAKING THE PICTURES at the Russian Orthodox Cathedral of the Dormition of the Mother of God and the Royal Martyrs

I was at the cathedral to photograph a full immersion baptism. Father Nicholas met me and told me that it was a four-year-old girl who was being baptised. I asked, 'Do the family mind a random photographer being there?' Fr Nicholas said 'No'.

When the service started, I realised that I wasn't going to follow any of it because it seemed to consist of a high-speed Russian monologue by Fr Nicholas.

I started taking pictures, trying not to get in the way. Suddenly, Fr Nicholas's monologue stopped and, in the complete silence that followed, everyone swung round to look at me.

'Oh God,' I thought, 'the family have finally asked Fr Nicholas who the hell I am and they want me out of here.'

'We've got to the part of the service,' said Fr Nicholas in English, 'where we drive the Devil out of the church.'

'And the spot where you're standing is where the Devil is.'

I moved hurriedly off to the other side of the crypt, Fr Nicholas gave a loud command for the Devil to be gone and the service carried on as if nothing had happened. In fact, throughout the whole service – the opening prayers, the circling round the room while a censer was swung, the stripping of the little girl to her knickers, her full immersion in a special bath as Fr Nicholas made the cross and said blessings over her and then her finally being dried off, dressed, hugged, smothered in kisses – the family treated me as if I wasn't there at all.

Perhaps they really did think that it was me who was the Devil. And that if I'd been in the church to begin with, which they hadn't ever acknowledged, then I'd been driven out by Fr Nicholas. The whole

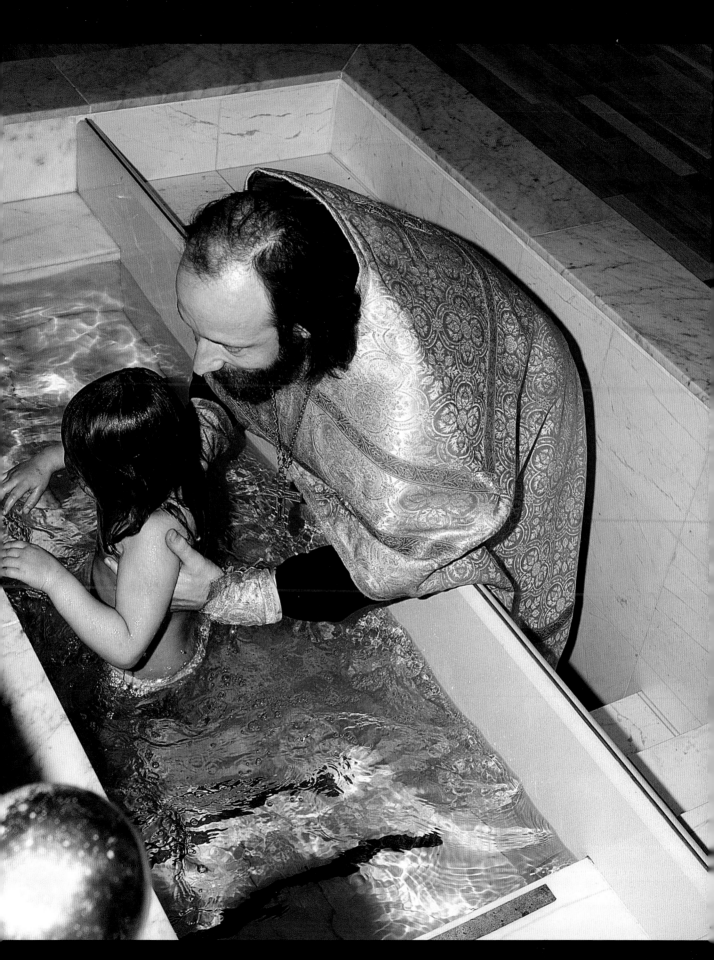

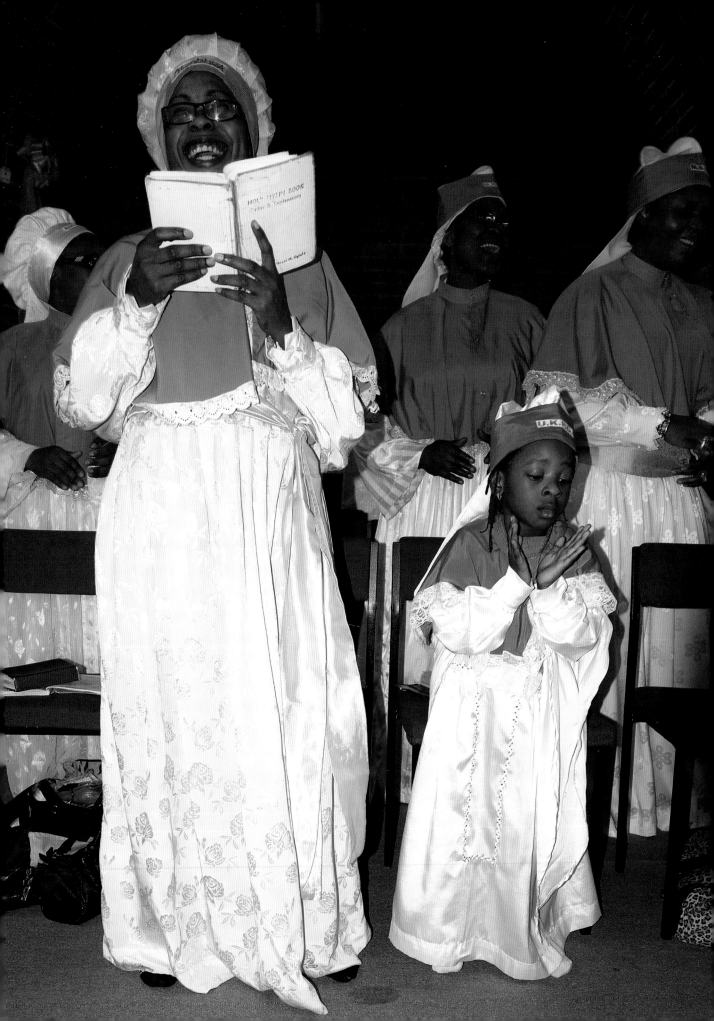

THE ETERNAL SACRED ORDER OF CHERUBIM AND SERAPHIM, WALWORTH

Although they'd already been committed Christians for some time, the Yoruba people of Western Nigeria were, in the 1920s, beginning to find the traditional church services of the Anglican Missionary Society pretty stifling and, well, lame. They wanted to show how much they loved their faith by the kind of communal singing that's now so popular around the world as African gospel. The Anglican missionaries of that time didn't take to it at all. The situation was not helped by the fact that the Yoruba wanted to accompany their singing with clapping, dancing and thumping on drums.

There were other cultural clashes and, inevitably, people began forming their own breakaway prayer groups where they could do Yoruba-style Christianity, with as much enthusiastic music-making as they wanted. Various early movements finally came together in 1930 under the leadership of Moses Orimolade, who is known as Baba Aladura (which means 'Father Who Prays'), with the name The Eternal Sacred Order of Cherubim and Seraphim. The order now claims to have about ten million members and 1,500 branches round the world.

The Cathedral of the Mount of Salvation is in Walworth, where many Nigerians have settled. During the four-hour, sing-yer-heart-out service that I photographed, I noticed a plaque on the wall saying that it used to be the church attached to the St John's College Cambridge Mission. I couldn't help wondering if I was seeing history repeat itself. In 1920s Nigeria, the Anglican Missionary Society gave way to the Yoruba version of Christianity. And in present-day London, the St John's College Cambridge Mission was replaced by the Eternal Sacred Order of Cherubim and Seraphim. ⑤

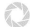

TAKING THE PICTURES at the Cathedral of the Mount of Salvation

I'd arranged by phone with Apostle Michael Charles to photograph a Sunday service but he wasn't around when I arrived. It was clear that no one else expected me. I was asked to sit and wait on a sofa in an anteroom. Time passed. A clock ticked away on the wall.

After an age, three small boys dressed in ankle-length white robes and white hats burst into the room. One of them came over to my sofa and the other two went and sat on the sofa opposite. It wasn't long before they'd jumped up. One of them snatched another's hat off and threw it across the room. It was game on. Hats were thrown backwards and forwards. The boys shrieked with excitement and flung themselves around as if they were goalkeepers and the sofas were goals. Not wanting to be a player, I moved to a nearby chair. The clock ticked on. Was the service going on next door?

Finally, Michael arrived and led me into the cathedral where, to my relief, the service was just starting. He asked me to kneel with everyone else whenever prayers were being said but otherwise he encouraged me to move around freely and to take whatever shots I wanted. I stayed for an hour and a half. The music was fantastic. The singing really lifted your spirits. Almost everywhere that I pointed my camera, I found smiling faces, clapping hands and swaying bodies.

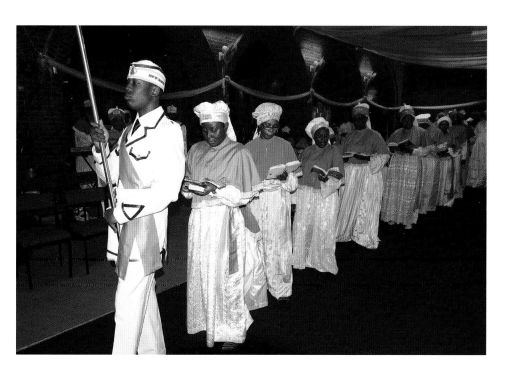

TAKING THE PICTURES at the Vaisakhi and Nagar Kirtan ceremonies

The authorities at the Gurdwara Sri Guru Singh Sabha had given me permission to photograph the Vaisakhi and Nagar Kirtan ceremonies. When things got underway, it became clear that the only other people who'd been given the same permission were an English TV crew. So while the huge crowds who lined the streets were held back by the stewards, the film cameraman and I were able to move about freely among all the men representing the Panj Pyare and the other people taking part in the procession and to go right up to the lorry float carrying the sacred scripture.

VAISAKHI AND NAGAR KIRTAN CEREMONIES, SOUTHALL

Vaisakhi

Vaisakhi is the Sikh New Year festival. It's also the ceremony which celebrates the founding of the Sikh community known as the Khalsa in 1699. In the 21st century the ceremony is still shaped by what happened on the day when the Khalsa was founded.

Guru Gobind Singh, the tenth of the ten Sikh Gurus and their spiritual leader at that time, had called Sikhs together in the city of Anandpur Sahib to celebrate the New Year, and they'd come in huge crowds from all over India. At this massive gathering, the Guru raised his sword and asked everybody who was prepared to give his life for his faith to come forward. There was a shocked silence. No one moved. The Guru repeated his request. Still nothing. He asked again. Finally, one man did come forward. The Guru took him into a tent and, a after a short time, came out alone, his sword covered in blood. The Guru made his request again, another man stepped up and exactly the same thing happened. This went on until five men had given their lives for their faith in this way.

Then, dramatically, the Guru emerged from the tent with all five men still alive after all. The Guru declared that these five Sikhs were the Panj Pyare, the Five Beloved Ones. He said that they would be the embodiment of the Guru himself. These Panj Pyare were the first members of the Khalsa which, in time, became the body responsible for secular affairs in the Sikh community.

In the modern Vaisakhi ceremony, five men represent the

Panj Pyare. After prayers in the gurdwara, the Sikh temple, they emerge carrying swords and parade with them through the streets. They wear saffron yellow tunics with blue cross-belts, long white scarves and orange turbans.

OVERLEAF Nagar Kirtan

Guru Gobind Singh was the last living Guru. The eleventh Guru is Guru Granth Sahib, the Living Perpetual Guru or the sacred scripture of Sikhism. On certain special occasions, this sacred scripture is taken out of the gurdwara and paraded through the streets of a community, accompanied by music and singing. This is called a Nagar Kirtan.

When it's combined with a Vaisakhi ceremony, the Panj Pyare, the Five Beloved Ones, are in the procession with their swords and there are five men dressed the same and carrying yellow flags which bear the Sikh emblem. The Guru Granth Sahib follows behind on a highly decorated lorry float, guarded by priests from the gurdwara. Everybody goes barefoot and so the whole route is swept for them by a small army of Sewadars and then, just behind them, flower petals are scattered all along the route by another small army of ladies. And then, of course, there are the drummers and other musicians banging and blowing for all they're worth. Not surprisingly, progress is very slow but no one minds. Throughout the day, food stalls all round the area hand out free food to everyone. **7**

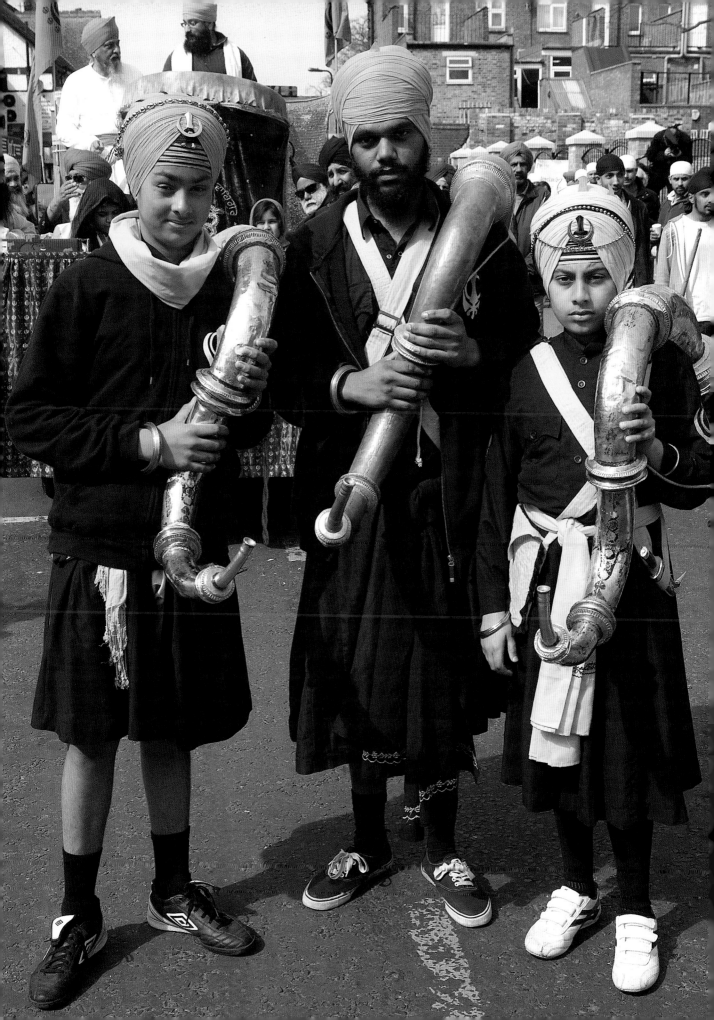

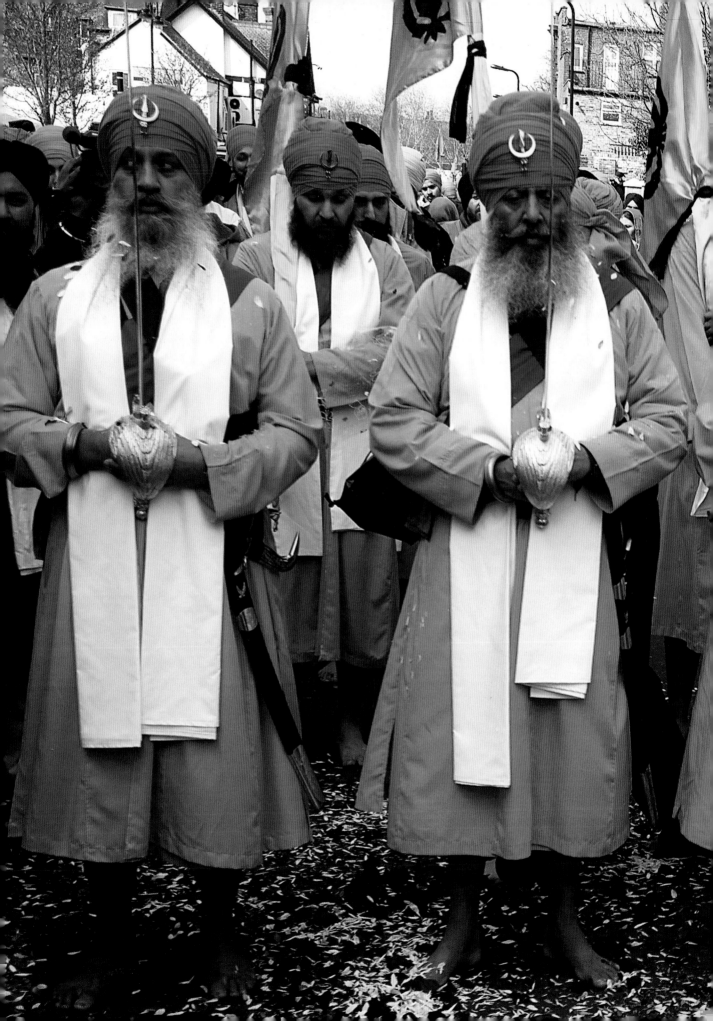

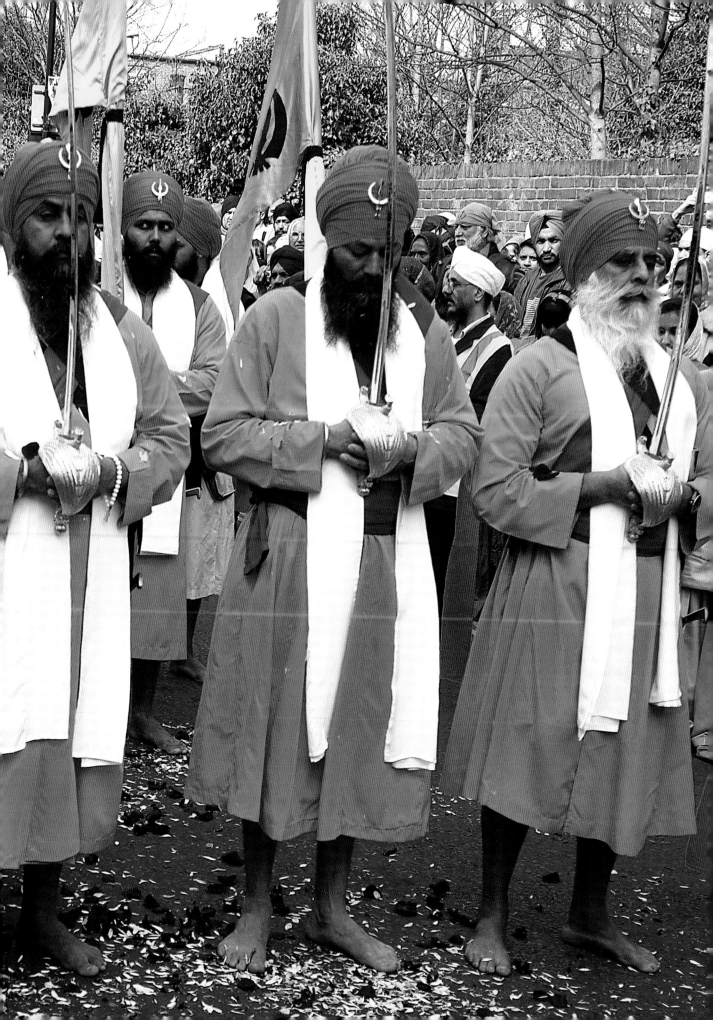

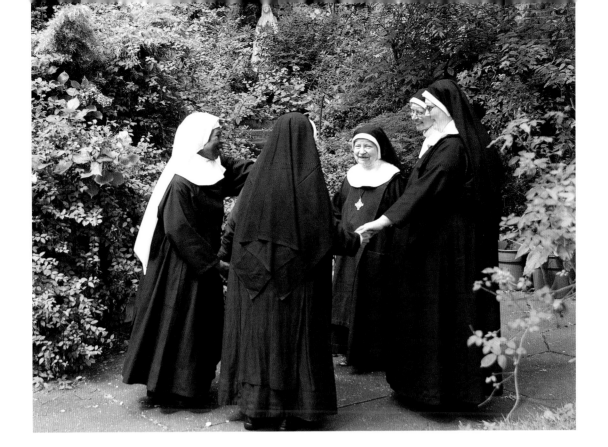

ROMAN CATHOLIC NUNS, TYBURN CONVENT, MARBLE ARCH

If your taste ran to public executions – and many people's did – then, for hundreds of years, the go-to place in London was Tyburn near Marble Arch. And if you went along to a hanging during the Reformation, there was a good chance that you'd have seen a Roman Catholic martyr meeting a horrible death – and it was truly horrible since they were cut down from the gallows before they died and were then disembowelled and had their hearts cut out. More than a hundred died there during that bloody period and, ever since then, Tyburn has had particular significance for Catholics.

In 1901 a French nun called Mother Mary St Peter was forced to close her Catholic religious centre in Montmartre and leave France. She came to England, determined to set up a new monastery in London. Symbolically, she chose Tyburn as her site in memory of its Catholic martyrs. The monastery is still there today and it's the home of the Benedictine Adorers of the Sacred Heart of Jesus of Montmartre, or the Tyburn Nuns as they're known for short.

It may have 'Tyburn Convent' written on the wall below the first floor windows, but I'm willing to bet that not one in a thousand of the people who pass by there every day on the busy Bayswater Road has any idea that a community of nuns lives behind the façade of this grand red-brick residence overlooking Hyde Park. And even less that they have a private, enclosed back garden where they can enjoy a bit of peace and quiet.

THE 2010 VISIT OF THE POPE, WESTMINSTER

When Pope Benedict XVI visited Britain in September 2010, enormous crowds flocked to see him wherever he went. Westminster Cathedral was, naturally, one of his stops and, after celebrating Holy Mass inside the cathedral, the Pope came out through the great doors onto the piazza at the front of the building and blessed the thousands of waving, cheering pilgrims of all ages who'd been waiting patiently in Victoria Street and the surrounding area for the service to end. 27

TAKING THE PICTURES at the Tyburn Convent

When I wrote to the Mother General of the Tyburn Convent asking for permission to take photographs of the nuns there, I expected to get a polite reply saying that they would prefer not to participate in the project. As it was, the Secretary General to the Mother General wrote back asking me to go to the convent to explain in more detail what the project was all about. This visit led to the Mother General kindly agreeing that I could indeed photograph at the convent.

When I went back there on a second visit, this time with my camera, I was escorted to the garden, a study room, the Martyrs' Altar and the room where the nuns assemble before going into the public chapel next door for a service. I was introduced to everyone as I went round. The nuns were full of information and were utterly charming. And I was encouraged to take as many photographs as I wanted.

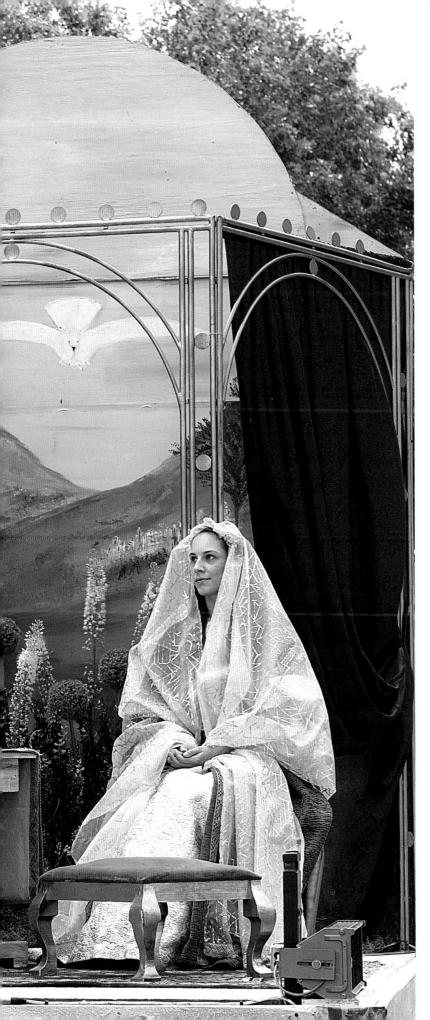

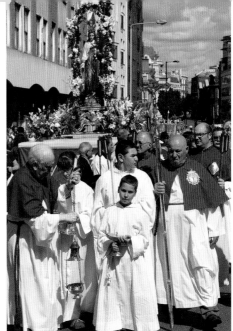

PROCESSION OF OUR LADY OF MOUNT CARMEL, CLERKENWELL

St Peter's Church in Clerkenwell was founded in the mid 19th century as a church for Italians. Anyone who's been to Italy knows that Italians have a tradition of parading the statues, icons and paintings from their churches through the streets on special saints' days. Being an Italian church, St Peter's began to do this in the 1880s. They called it the Procession of Our Lady of Mount Carmel. The thing was, no Catholics had made a public demonstration of their faith like this since the Reformation. So it was a brave thing to do. Well, nobody stopped them and the parade has taken place every year since then.

These days, it's a big event. The statue of Our Lady of Mount Carmel is the main star, of course, with priests and choirboys in close attendance. Then come wave after wave of adults and children on foot dressed as biblical characters, a painting of Mary and the infant Jesus carried by two ladies, Jesus himself and John the Baptist on a lorry float and some gentlemen with a statue of San Antonio on their shoulders. Angels make several appearances, including in a tableau where the Archangel Gabriel is visiting the Virgin Mary. The Three Kings are unmistakable, with their crowns. And towards the rear, Jesus appears again, this time on foot and dragging his cross along. Big crowds line the streets and, in nearby alleys, stalls sell Italian food of all kinds. 12

There's a red-brick building opposite a service station on Willesden Lane, down near the junction with Walm Lane, which used to be a Welsh Calvinist chapel and primary school. It looks as though it still is one too, except that it's got ornate Chinese signs and gilded statues of deer above the entrance. And that's because it's another one of London's buildings which has been converted from one religion to another. It's now the True Buddha School.

But when you go inside, it's not set up like a regular school, with desks and so on. In fact, once you get past the entrance hall, you find you're in a big, high-ceilinged hall and in front of you, where the teacher's desk and whiteboard ought to be, the whole end wall is banked high with statues, vases and other kinds of ornaments. All gold. This is impressive, and especially if they've got the spotlights turned on. What you've stumbled on, behind the Calvinistic chapel exterior, is a Buddhist temple, lifted straight out of the Far East and deposited in Willesden. There are more than thirty statues up there at the front, including a 10-foot Amitahbah Buddha, and it's worth spending a bit of time to take in all the details.

The building is a school as well, though. And what they teach there is Tantric Buddhism, which is the form of Buddhism found mainly in Tibet. It makes use of mystical diagrams (called mandalas) and formulas (mantras) to which only gurus (or lamas, as they're called in Tibet) can give you the meaning. There are some mandalas on the walls here. And on special occasions, as when these photographs were taken, the lamas at the school lead the community in chanting mantras. **8**

TAKING THE PICTURES at the
True Buddha School

I'd met Master Lian Sang on an earlier visit to the school and he'd told me about the Autumn Ceremony at the end of September, when a large number of people come to the school over a three-day period. He'd said that this would be a good time to take photographs and he was right. The hall was packed. The wall at the far end, with its Buddhas, mandalas, vases, flowers, and so on, was brightly lit. There was incense in the air. Everyone in the hall, led by the twelve brown-robed lamas at the front of the temple, was chanting mantras from the sheets that they had been given as they came in. On and on, all afternoon. Interrupted only by the thump of a drum and the clang of a bell every now and then.

I was made enormously welcome by everyone and repeatedly told to wander wherever I wanted and take any pictures that I liked. It didn't matter that people were intensely engaged in what was obviously a profound religious experience, chanting *mantras*, standing, kneeling, standing and kneeling again as they did so.

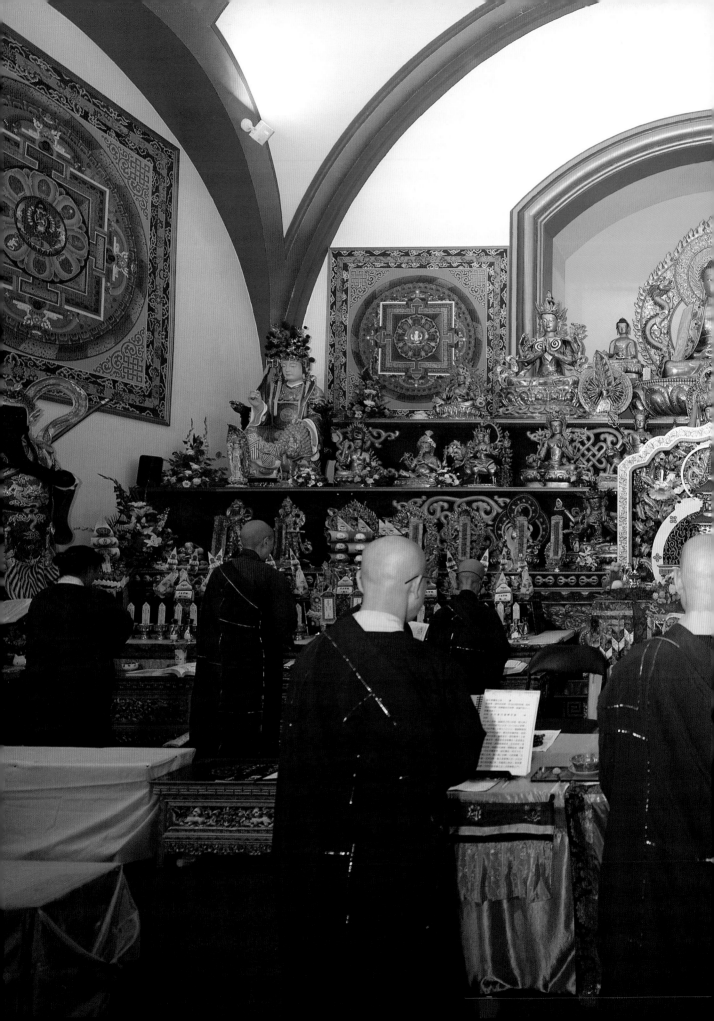

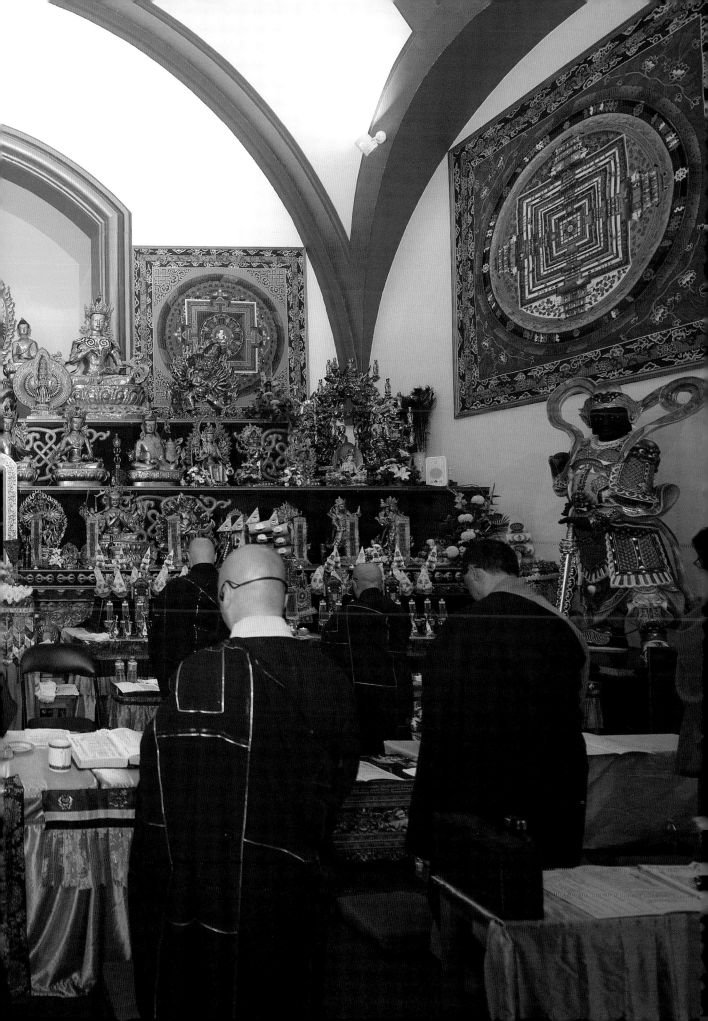

JAIN TEMPLE, HARROW WEALDSTONE

Jainism is a very old Indian religion. It's not clear exactly how old, but a man called Mahavira, who is credited with giving Jainism its modern-day form, lived in the 6th century BC. Jains believe that animals and plants, as well as people, have souls and that all of these souls are equally important. The welfare of the planet, in fact of the whole universe, is therefore one of their key concerns and they try to keep their use of the world's resources to a minimum. Consistent with this, they're vegetarians.

Another of Jainism's main beliefs is reincarnation. And their aim is to escape, through the way in which they live their lives, from this continuous cycle of birth, death and rebirth. They do this by applying the three guiding principles of Jainism, which are sometimes called the 'three jewels': right belief, right knowledge and right conduct. This is a religion of self-help; there are no gods or supernatural beings. In fact, there are not even priests. In addition to the three jewels, Jains live by five vows, the most important of which is non-violence. The others are non-attachment to possessions, telling the truth, not stealing, and sexual restraint. 19

 TAKING THE PICTURES at the Jain Temple

When I took my shoes off in the entrance to the temple, I discovered that this was not enough. Jains will not allow any leather in their places of worship. So off came my belt too. And my camera bag had to be left in the cloakroom because it's got a leather strap. I was a bit worried about my watch strap, also leather, and a few small leather patches on my camera strap but my hosts very tactfully decided not to notice these items and I was allowed to take them into the temple itself.

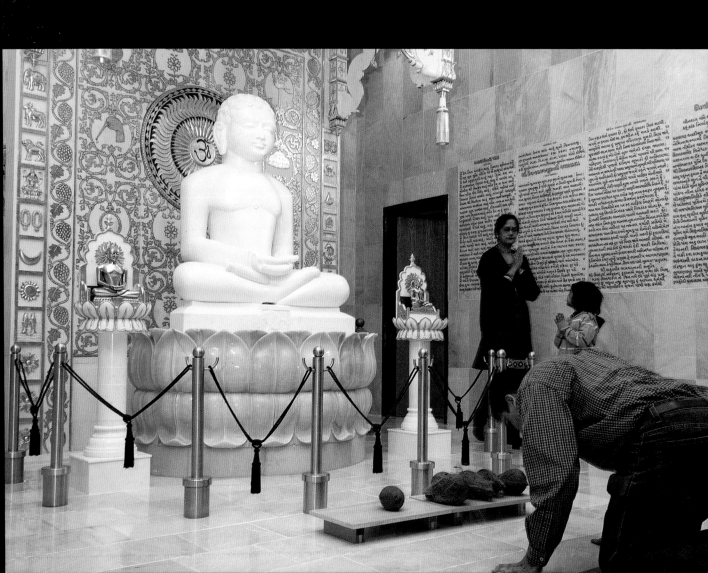

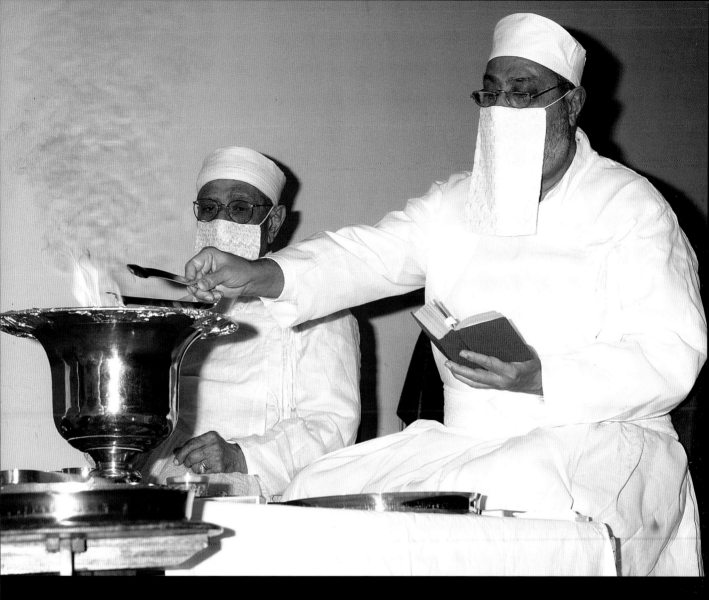

ZOROASTRIAN CENTRE, RAYNERS LANE

Zoroastrianism is one of the world's oldest monotheistic religions. It was founded by the prophet Zoroaster (or Zarathustra) in Persia about 3,500 years ago, and for about a thousand years during the time of the three great Persian empires it was one of the most powerful religions in the world.

After Persia fell to the Arabs in the 7th century, many Zoroastrians fled to India and the religion took root there. Its followers were known as Parsis (or sometimes Parsees), meaning Persians, and their descendants still keep the faith alive in India today. Although they account for only a very small proportion of India's population, it's not surprising that Zoroastrians would be represented in the migration of people from India to England, and London in particular. And that, from among the large population of Indian origin in north-west London, a group of them would succeed – at Rayners Lane – in establishing a place of worship. What could not have been predicted is that they would convert an old Art Deco cinema into a Zoroastrian Centre.

Fire is seen as the supreme symbol of purity in Zoroastrianism. Sacred fires, using sandalwood and frankincense, are kept alive at all times in the fire temples where Zoroastrians traditionally worship. The flame in the temple at Yazd in Iran is said to have been burning continuously since 470 AD. And no Zoroastrian ritual or ceremony is performed without the presence of a sacred fire in a silver urn.

Zoroastrians believe in one God, called Ahura Mazda, whose creation is evident to us as goodness, truth and order. Zoroastrianism has the concept of a Satan, who's called Ahriman and who represents chaos, falsehood and disorder. The conflict between the forces of darkness and light, between good and evil, involves the whole universe, including mankind. It made Zoroastrianism the first dualist religion and it may be no accident that Satan, who hardly makes an appearance in the early books of the Old Testament, begins to be important to the Jews (and therefore, of course, also later to the Christians) only after their Babylonian exile, which put the Jews into contact with dualistic religions such as Zoroastrianism.

The London Melting pot

IN THE EARLY 20th century, Henry Ford's Michigan car factories employed a lot of immigrant workers. Language and citizenship classes were provided at the plants and, at the ceremony when the workers graduated, a symbolic scene was enacted. Everybody went up onto a stage wearing placards or carrying flags which showed what country they'd come from. On the stage there was a giant wooden kettle marked 'Melting Pot', which they walked into. When they came out on the other side, the placards or flags were gone and instead they were carrying the Stars and Stripes. They were now Americans.

This was all well and good but, in reality, changing your identity was not so simple. Every immigrant group develops a new evolving

personality and lifestyle at its own pace and any attempt to speed that process up is bound to fail. For hundreds of years, the same thing has happened time and time again when a wave of new immigrants has arrived in a country, whether it's the United States, Britain or anywhere else. Take Poles arriving in Britain, for example. These immigrants create a transitional society, which is neither completely Polish nor completely British. Its main purpose is to help the people in that society to deal with the problems which they all face and to achieve the ambitions which brought them to Britain. This transitional society is very fluid. It's constantly changing and evolving as its members learn more about Britain. The parental generation

struggle to cope with the change. Their children have more opportunity to learn, at school and on the street, for example. And they're more open to new ideas. So they're much quicker to assimilate.

But assimilate into what? If it's London that an immigrant group has come to, then there are dozens of other transitional societies all around them at various stages of evolution created by immigrant groups from other countries. This means that the picture is changing all the time. More significantly, the underlying society which they came to join – call it the host society for want of a better expression – is itself being continuously reshaped by these influences.

As immigration into England has increased in recent years, it's become harder than ever

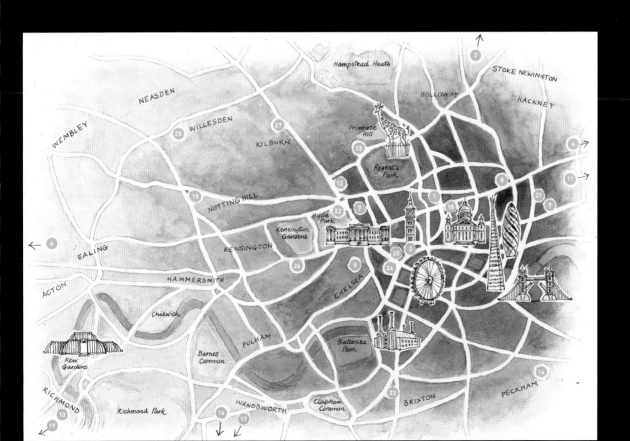

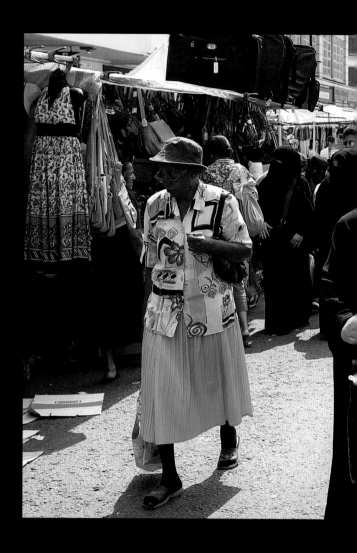

The London Melting pot

for Englishmen to answer the question: 'Who are we?' London, as always, is a special case. It's been absorbing immigrants for a very long time but the rate at which it's had to do so in the last ten years has increased significantly. The 2011 Census revealed that the percentage of people in London who were born outside the UK was 37%. And only 45% of the city's population classified themselves as 'white Britons'. London is arguably the most diverse city in the world. Against that background, how does a Londoner answer the same question: 'Who am I?' And how can an immigrant tell when he or she has been here long enough to become 'a Londoner'?

This chapter contains photographs of lots of people wearing clothes which, not that many years ago, would have attracted stares in

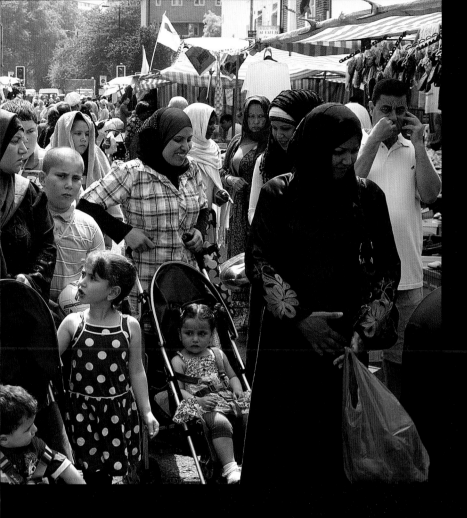

London. They would have been dismissed as
'foreigners' or something worse. Perhaps a more
curious person might have asked them where
they came from. Now, they attract no attention at
all. They're just accepted as part of the everyday
scene. And people generally don't ask, 'Where
are you from?' because it's seen as a bit stupid,
verging on rude. The answer more often than not
is 'London'.

So all through this chapter, I'll say
whereabouts in London I took the photographs
and what was going on at the time. I might
describe my conversation with the people and
one or two other things about them and say
something too about the place or event where I
found them. But I won't tell you whether they or
their parents or grandparents were born abroad

or in this country unless they specifically gave me
that information. I certainly won't try to label them
as Jamaican or whatever it might be, because I
have no idea whether they regard themselves as
more Jamaican than English or the other way
round. How can you tell something so subtle in a
few minutes' chat? And they might be tempted to
say, with some justification: 'It depends what for.'
The fact that they might have been wearing a
costume made from the colours of the Jamaican
national flag at the time when I photographed
them definitely doesn't mean that they still have
to pass through Henry Ford's giant kettle.

What I am sure of is that the vast majority of
the people in this chapter live in London, although
I couldn't say how permanently. And, on that
basis, I count them as People in London.

PREVIOUS PAGES ROMAN ROAD

Roman Road likes to advertise itself as the heart of the East End. That part of London has, for hundreds of years, been the place where successive waves of new immigrants have first settled when they've arrived here. The diversity which has resulted from this history is clearly imprinted on the Roman Road Market. **4**

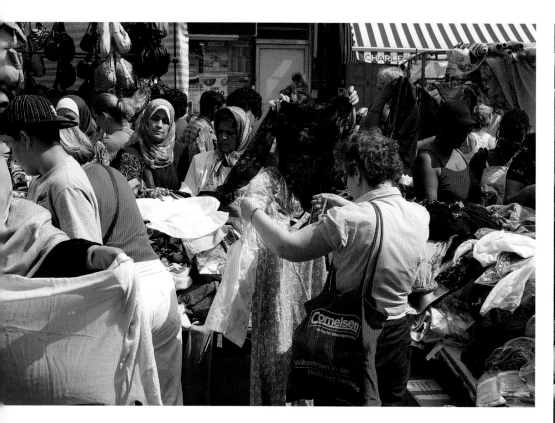

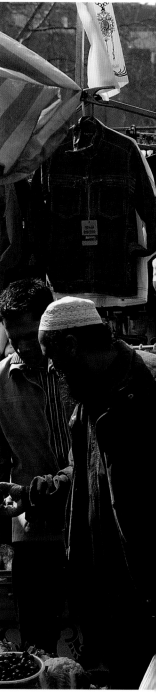

CHURCH STREET, MARYLEBONE

Church Street runs between Edgware Road and Lisson Grove. This corner of the Borough of Westminster was predominantly white until twenty or thirty years ago. Now, there's a very broad ethnic mix in the area. You can see this in the market which operates there on Fridays and Saturdays, both in the faces of the people and in the goods on sale. **12**

Look west from Whitechapel Market and you see the Gherkin. It seems close but it might as well be on another continent. That's the City, the well-ordered world of offices and suits where English is the *lingua franca*. This is the multi-ethnic bustle of colourful market stalls where Bengali is spoken and English is only a fall-back language. The two worlds never meet, even though they're less than a mile apart. 9

CHINESE RESTAURANT, SOHO

Peking Duck is a very popular and easily recognised dish, and so Chinese restaurants often feature ducks in their windows. This chef was busily working away just inside the door but he kindly agreed to come outside for a moment so that I could take a picture of him standing in front of his restaurant in Soho. 1

NAW RUZ CELEBRATION, WEST WIMBLEDON

Naw Ruz is the Iranian New Year and it falls on the first day of spring, which is 21 March. It's a festival day for Bahá'ís, too, and they meet to pray, enjoy some music, dancing and other entertainment and to have a New Year's Day feast. I was there to photograph this Bahá'í celebration (check out the Faith in London chapter) and this little girl caught my eye. Her mother told me that this was traditional Russian dress. 16

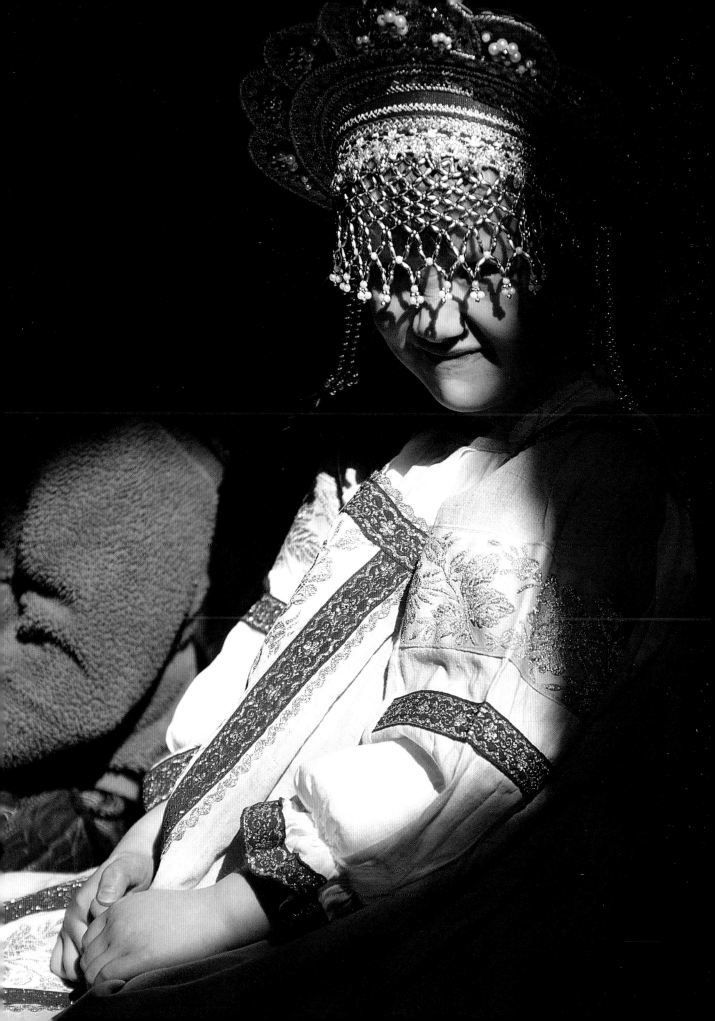

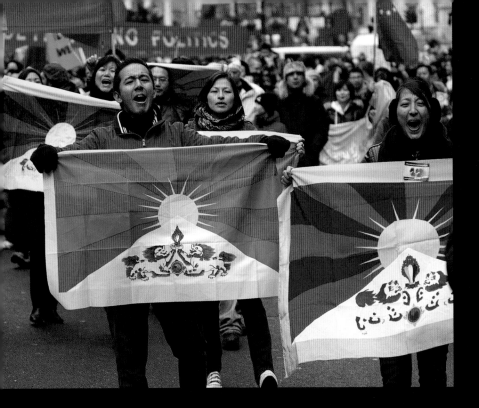

PROTESTS ABOUT POLITICAL EVENTS OVERSEAS

IN TIBET

Just before the Olympic Games were held in Beijing, the Olympic torch was paraded through London escorted by a Chinese guard of honour. One of the stops that it made was in Downing Street and very large crowds gathered in Whitehall to see it. This triggered widespread demonstrations against the Chinese presence in Tibet. The Tibetan flag, which was the focal point of the protests, was everywhere that day. 20

IN EGYPT

At the start of the Arab Spring and before President Mubarak fell, demonstrators gathered outside the Egyptian Embassy to call for his removal. You can see how hastily these demonstrations were arranged by the makeshift nature of the banners that the protesters were holding up. These protests were very tame affairs compared with the momentous events in Tahrir Square around the same time. 7

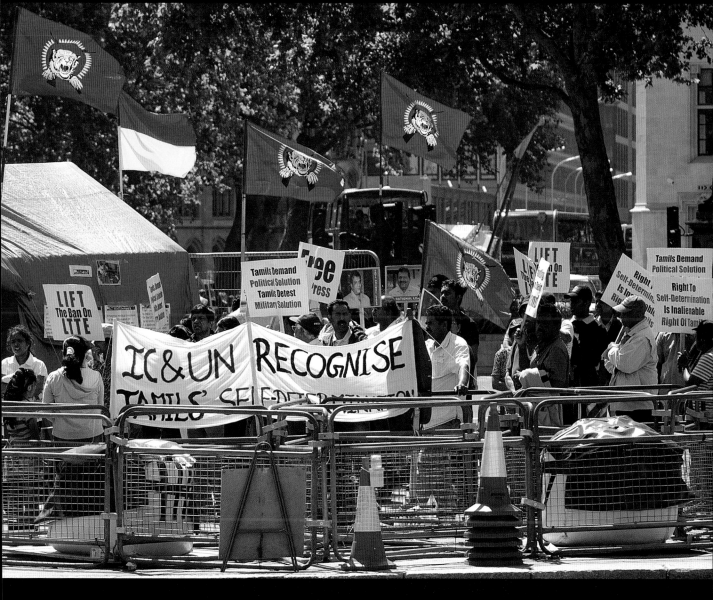

IN SRI LANKA

A group of Tamils were camped in Parliament Square for quite a lengthy period in 2009. Their flags had tigers on them. The separatist militant organisation the Tamil Tigers had been banned by the Sri Lankan Government and the protesters wanted this ban lifted. More importantly, though, they were campaigning for what the Tamil Tigers had been trying to achieve through violent means, which was an independent state for Tamil people in the north and east of Sri Lanka. Their banners said that they were opposed to violence and wanted to reach their goal by a political process. **24**

**REFUGEE WEEK UMBRELLA PARADE,
VICTORIA EMBANKMENT**

The organisation Refugee Week arranges regular umbrella parades in cities all over the country. The one round central London in June 2011, which this photograph shows, had special significance. It marked the 60th anniversary of the UN Convention on Refugees. The umbrellas symbolise shelter for people whose lives are in danger and who seek asylum. And the bright colours were chosen to represent the diversity of the refugees. **2**

❝ A LONDONER TALKING

Hussein Allidina was aged sixteen in 1972 when his parents and he were forced, on less than 24 hours' notice, to leave Uganda by Idi Amin's regime and come to Britain. They spent over a year in different refugee camps round the country before eventually being settled in Hackney. Hussein talked to me about the family's experiences immediately after that.
RICHARD SLATER: Did you get into a school at that point?
HUSSEIN ALLIDINA: Well, I was past sixteen and so I couldn't go back into school ... so I was taken to a local college ... Hackney College.
RS: What was the ethnic mix in Hackney at that time? How did you adjust to living in Hackney? It can't have been easy.
HA: It wasn't actually, because, first, we were placed in a very old council flat. It was very dingy and dark and depressing.

And secondly, my college, where there was all sorts of ethnic mix. West Indians. Indians. Greeks. Turkish people. A good mix. But for me, it was a complete new thing. Different languages. Different ways of dealing with things. And I had quite a hard time because being black Asian, it was very difficult to mix with the Asians. And then the blacks wouldn't accept me. And so I was a right mess for a while.

RS: And I imagine that Greeks and Turks were hostile towards each other at that stage.

HA: Yes, there was the Cypriot War going on. They didn't like each other. That was going on too.

RS: So the whole atmosphere must have been very difficult to cope with generally.

HA: Yes, I found it very difficult to study, to settle down. Plus I had to cope with things at home. Mum and Dad. My father became ill as well. He was in hospital very regularly. And so there was me trying to help Mum and Dad. And also looking after myself and coping with this whole new situation in London.

RS: Were your parents able to work despite health problems?

HA: Yes, my father believed in not taking charity or anything. He always said work hard and make your own living. So they went round looking for jobs. And eventually, they went to the Job Centre and they were sent for some retraining. So my father, from being a businessman, he started retraining as a machinist. Gents' clothes. And so did my mother. They joined a clothes factory, which sent them somewhere to train. To be able to sew, you know, men's clothes. And once they were trained, they found jobs in the local rag trade and they worked together.

MARBLE ARCH

The stretch of Edgware Road from Marble Arch up to Marylebone Road has a distinctly Middle Eastern feel to it. Many of the shop signs are written in Arabic and that's the language that you hear spoken. The food in the restaurants and supermarkets is mostly Middle Eastern. There are lots of pavement cafés and they open late into the evening. The smell of hookahs is everywhere. 22

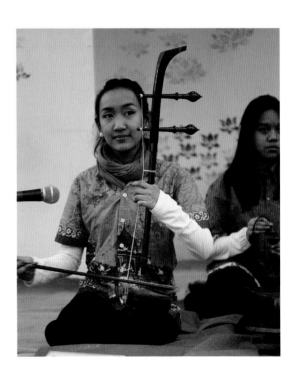

EID, NEAR THE LONDON CENTRAL MOSQUE, ST JOHN'S WOOD

Eid al-Fitr is a big day of celebration in the Muslim calendar. It's the last day of Ramadan and so the month of fasting has come to an end. It's traditional for everyone to wear new clothes and this proud father (just look at his face) told me that his daughter had indeed put on her beautiful sari for the first time that day. I asked him whether this was the traditional dress of any particular country and he said yes, Bangladesh. 13

THAI BUDDHIST TEMPLE, WIMBLEDON

The annual Floating Flower Festival at the Thai Buddhist Temple in Wimbledon attracts five thousand visitors if the weather's fine. People launch their flower lanterns on the temple's pond and then have a picnic in the grounds. There's lots of food available from the stalls set up in the car park and you can listen to a Thai orchestra while you eat. 17

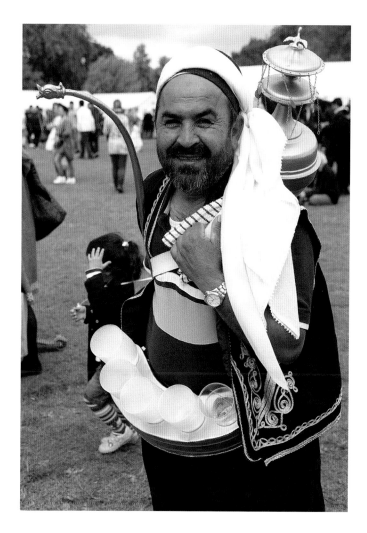

ANATOLIAN CULTURAL FÊTE, CLISSOLD PARK

The Anatolian Cultural Fête gives a lot of people an excuse to put on national dress and to dig out traditional old-fashioned appliances. If you asked this vendor for a drink, he'd take a glass from the rack at his waist, hold it underneath the spout and lean forward so that the lemonade in the urn on his back came out. He was obviously enjoying himself enormously. ③

PROCESSION FROM ITALIAN CHURCH, CLERKENWELL

It's very much to its credit that the Italian Church in London can persuade teenagers and children to dress up in biblical costumes and parade through London's streets, where they might easily be spotted by more cynical classmates and friends. But significant numbers of them turn out every year and give every appearance of enjoying themselves. 18

STOCKWELL TUBE STATION

Sometimes you come across people in the street who look so intriguing that you just have to ask them if they'd mind being photographed. This guy said yes. But once I'd taken his picture, he didn't want to talk and, even if he had, I don't think I'd have been able to understand him because he had a broad West Indian accent. So he's still an enigma. Why has he got the dangly stuff on his belt? What does 24 mean? Or is it two and four? What about the medallions round his neck? And why was he wearing three hats? **23**

VAISAKHI AND NAGAR KIRTAN SIKH CEREMONIES, SOUTHALL

These ceremonies are a big deal for the Sikh community in Southall. Many of the area's streets are closed to traffic for the day as a massive procession crawls slowly round. Look at the Faith in London chapter to see some pictures of it. From early in the morning, stalls all round the area hand out free food to everyone. No bus is going to be stopping at this shelter for the rest of the day, so it's a useful place to sit and enjoy a plate of curry and rice from one of these stalls. **6**

LAST NIGHT OF THE PROMS, ALBERT HALL, KENSINGTON

In the queue outside the Albert Hall for the Last Night of the Proms, everybody had Union Jacks, George Cross flags, red, white and blue dresses, face paint and the other stuff that you usually associate with football fans walking up Olympic Way before an England game at Wembley. The chanting and singing that you get at Wembley was missing: *Land of Hope and Glory* is apparently confined to the inside of the Albert Hall. **26**

ST PATRICK'S DAY PARADE, WILLESDEN GREEN

Since these two pages are all about being proud of your national colours, these people definitely qualify. They were enormously excited to be showing them off in the St Patrick's Day Parade and dead keen to be photographed. 25

TWICKENHAM RUGBY STADIUM

I said in the introduction to this chapter that it's often difficult to be precise about a person's nationality but this woman is definitely South African. She was wearing the country's flag round her shoulders. Her hat said 'SA Rugby'. She had the national colours painted on her cheeks. She was supporting them in a rugby international against England. And she told me very clearly that she was South African. Oh, and she had a strong accent too. 18

Both these photographs were taken on the day when the Bromley by Bow Centre had a party to celebrate the Olympic Games being on its doorstep.

The biggest community in the area is of Bangladeshi origin but there's also a significant one whose roots are in Somalia and this is the group to which the children (*below*) belong.

The women (*left*) have been in London for many years but were born in Eritrea and are proud of their origins. The headband which one of them is wearing is in the colours of the Eritrean flag. The cup of coffee which is being poured out has been made in the traditional Eritrean way, after roasting the beans on the little stove which you can see at the front. **11**

NEAR BRICK LANE

I ran into Pious – he told me his name as soon as we got talking – one Sunday morning near Brick Lane. We had a few laughs. Pious likes a laugh. I asked him if I could take his picture and told him that he had the most wonderful face. This made him laugh even more. So the picture came out well. **21**

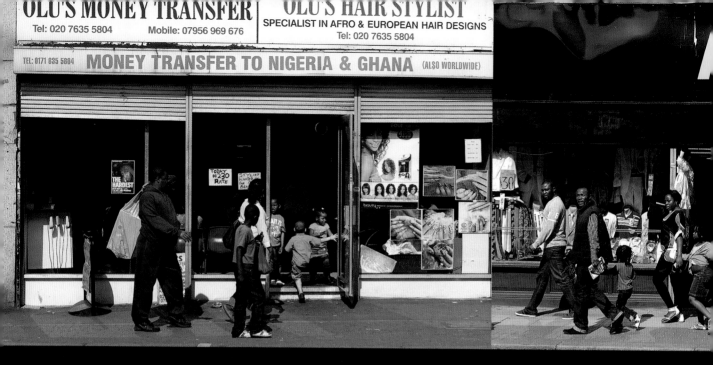

LOCAL HIGH STREET SHOPS

ALL ABOVE PECKHAM

It's quite hard to pin down where Peckham is. It's a big and loosely defined area. The people living there have their origins in a large number of different parts of the world. West Africa, especially, is strongly represented and although there are people from many other countries too, the shopping streets sometimes look distinctly West African. **14**

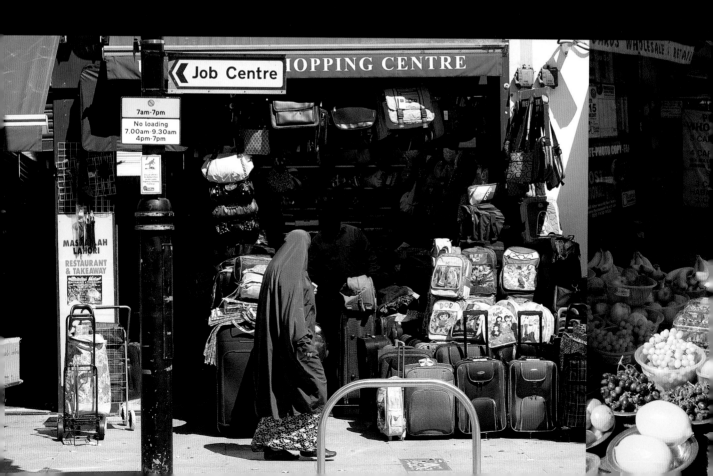

SU

BELOW LEFT AND MIDDLE SOUTHALL

Southall has a very diverse community, with its strongest roots in India and Pakistan, especially the Punjab. The shops on Southall Broadway and South Road have a strong flavour of those countries. And it's common for people visiting the local market for the first time to say that it's just like Delhi. **6**

BELOW KILBURN

Kilburn was always very strongly associated with Irish immigration. The pubs in Kilburn High Road used to have collecting boxes for the IRA. Now its community also has its roots in the Caribbean, India, Pakistan, Bangladesh, Somalia and many other countries. It has become, in fact, one of London's most diverse areas and Kilburn High Road has changed to serve the needs of this new population. **27**

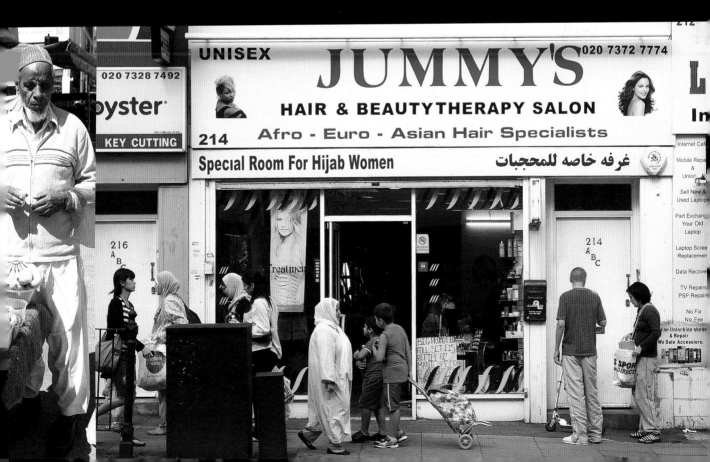

2 FULLER COMFORT PILLOWS

BOW bounce-back spiral fibre filling provides shape retaining...

Bow and the area round it has an extremely varied ethnic mix. But the English that you hear is very much East End London, whatever the skin colour of the person speaking. Have you noticed the shirt that the boy in charge of this market stall is wearing? He wants the world to know that he's an England supporter. 4

SUPER BOUNCE

2 FULLER COMFORT PILLOWS
bounce-back spiral fibre filling provides shape retaining comfort

THE Styler DUVET

10.5 TOG KING

luxury

SUPER-BOUNCE 2P

Pair of Lined
Curtains
& Tie-Backs
£9·99
66"x72"

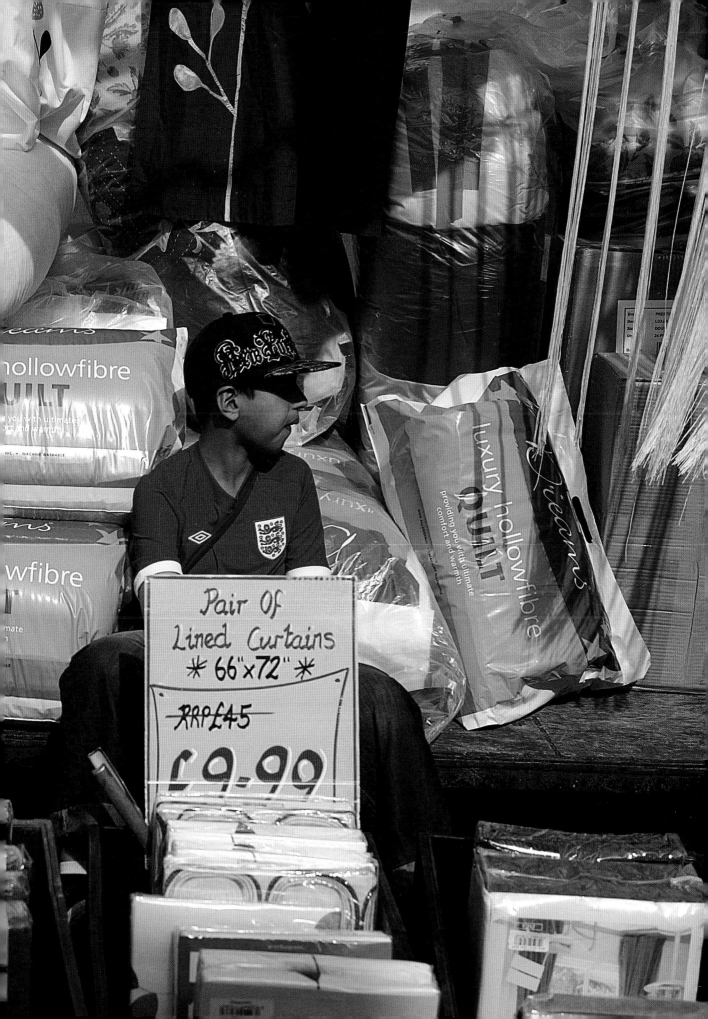

SCOTTISH COUNTRY DANCERS, KNIGHTSBRIDGE

The Royal Scottish Country Dance Society's London branch has regular evening get-togethers in the hall at St Columba's Church of Scotland. Everyone is welcome, whether they're an experienced dancer or not. And, although a lot of the men do wear kilts, you're allowed in – and you can dance too – without one. ⑤

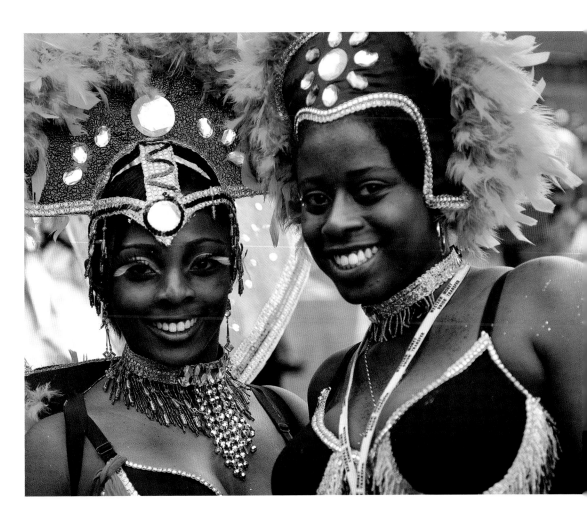

NOTTING HILL CARNIVAL

It's traditional at the Notting Hill Carnival for people from the West Indies to make a big thing of which island they or their parents or their grandparents were born on. One of the ways to do that is to have an outfit in the national colours. The fantastic headdresses and costumes (and even the eye make-up) in this photograph are in the colours of Jamaica. You see these colours a lot, as well as the red, black and white of Trinidad. ⑮

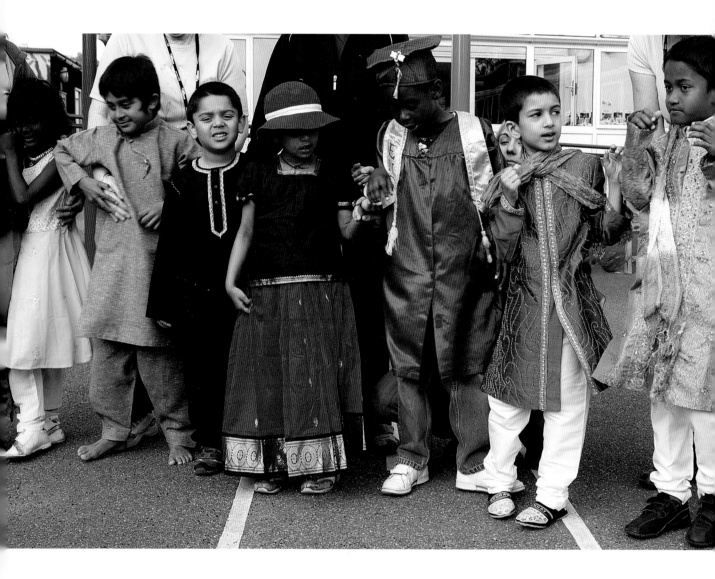

LINDON BENNETT SCHOOL, HANWORTH

Lindon Bennett School is a smallish state primary school
in Hanworth with about a hundred children. All of them suffer
from severe, profound and multiple learning difficulties and
some of them have physical disabilities too. These hundred
or so children have about twenty different mother tongues
between them and English is that mother tongue for only a
quarter of them.

I arranged with the headmaster that, on the day when I
went to photograph the children, they'd wear the national dress
of the country where their family had its roots. They were very
excited by this and it made for a memorable day. 19

CENTRAL FOUNDATION BOYS' SCHOOL, OLD STREET

The situation of Central Foundation Boys' School near the East End means that it has always provided an education for the sons of the different waves of immigrants who've settled in that part of London. This pattern continues today and the boys at the school come from a very wide range of national and ethnic backgrounds. **8**

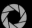

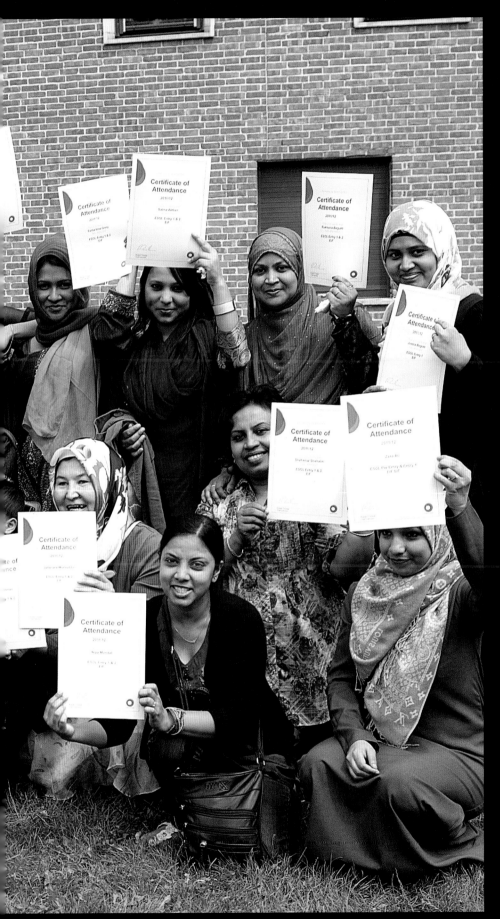

TAKING THE PICTURES at the Bromley by Bow Centre

Have you ever been to Bromley by Bow? Probably not. Have you ever been past it or near it? Probably. Especially if you went to the 2012 Olympics. Because it's right next door to the Olympic Park. But despite that, the community was pretty much untouched by all the razzamatazz.

This is the deprived community where the Bromley by Bow Community Centre operates. It's hard to describe in a few words what it does because it does so much. For example, people of all ages go there to learn things. At a basic level, the Centre might simply help new immigrants to acquire some English. They give people the skills that they need to get a new job and they actually help them to find work. They have courses in how to manage your money. They teach art and design. They give advice on welfare and financial questions. And there's an affiliated Health Centre too.

Once a year, there's an Adult Learner Day Certificates Picnic in the Centre's park. Did I mention that they have a park? Right next to their building. The women in this photograph had attended an English class. All but one were fairly recent immigrants from Bangladesh. Everyone had passed and, perhaps even more impressively, they'd all been to every single lesson right through the year. Quite justifiably, they were hugely proud of this achievement and, as soon as they'd collected their certificates, they came over and asked me if I'd take their picture. So here they are, waving their certificates in their excitement.

Celebrating London

ONE OF THE STRONGEST impressions made on me in the course of the five years that I've been taking the photographs in this book is how much energy Londoners put into all the seasonal festivals, parades, celebrations and parties that dot the year and how much enjoyment they get in each other's company at these events. They happen all the time. You'll find one every week if you pick up a copy of *Time Out* or browse their website, and more often than not it costs nothing to go.

You quickly discover at these events that everyone's out to have a good time and so they're happy and chatty. There's a real let's-have-a-party atmosphere. The stereotyping of Londoners as cold and unfriendly is nonsense.

This chapter features an eclectic mix of these events, which together span a year. There are quite a few big street parades. The one with the most flamboyant costumes is the Notting Hill Carnival in August. But just a few weeks after that, in September, the Mayor's Thames Festival stages a parade along the Victoria Embankment which can boast some pretty amazing outfits too. New Year's Day also has its own major event now. The thing that marks it out is the marching bands and cheerleaders from North America. When it comes to the oldest parade in town, there's no contest. The Lord Mayor's Show in November has been happening since the time of Bad King John.

This show can lay claim to the 'Best Coach' prize too. But these days the Queen uses a coach to get from Buckingham Palace to the Trooping of the Colour on Horseguards Parade in June, so that claim might be challenged. There are no coaches at all for the St Patrick's Day parade round Willesden Green in March but there are certainly marching bands, complete with bagpipes.

A couple of special days in the year are celebrated with running races. On Shrove Tuesday, in February, the competitors have to run with frying pans, flipping pancakes as they go. The shots I took were at Tower Hill. And on Bastille Day, in July, there's a race for waiters and waitresses in a street near Borough Market where they have to balance food and wine on a tray. At Easter, you get not a race but a hunt. For Easter eggs, of course. More than two hundred very special ones, 2½ feet high, scattered round central London and then gathered together in Covent Garden for Easter week.

On May Day I followed a strange procession, called Jack in the Green, on the streets of Deptford and Greenwich. I was back again in Covent Garden for the traditional Harvest Festival service at the Actors' Church, where London's Pearly Kings and Queens get together. The busiest streets in London at Halloween are in St John's Wood because of the American School

there. And although I'd never heard of the Floating Flower Festival in November, I was astonished to find that about five thousand people came to the event at the Thai Buddhist Temple in Wimbledon.

Some special one-off celebrations occurred while I was photographing for this book. There was the hullabaloo round the Olympics and the Paralympics in the summer of 2012. And, in the same year, the 70th anniversary of the London Blitz saw a service at St Paul's Cathedral and a fly-past by a Lancaster bomber and a Spitfire.

Remembrance Sunday is the lead-in to the winter season and Christmas follows soon after. Then there are plenty of ways for Londoners to celebrate and enjoy themselves. I picked out the carols under the Norwegian Christmas tree in Trafalgar Square, ice-skating in front of the Natural History Museum and an event called Santacon, which is a good-natured cross between a flashmob and a pub crawl, involving hundreds of people all dressed as Santa Claus.

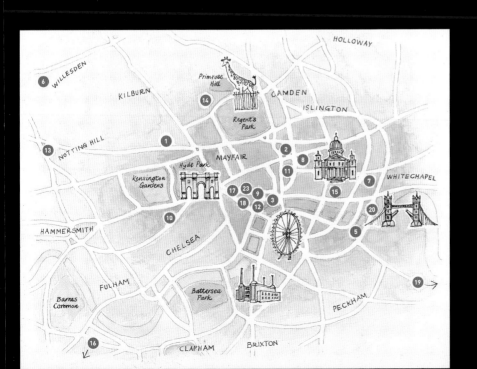

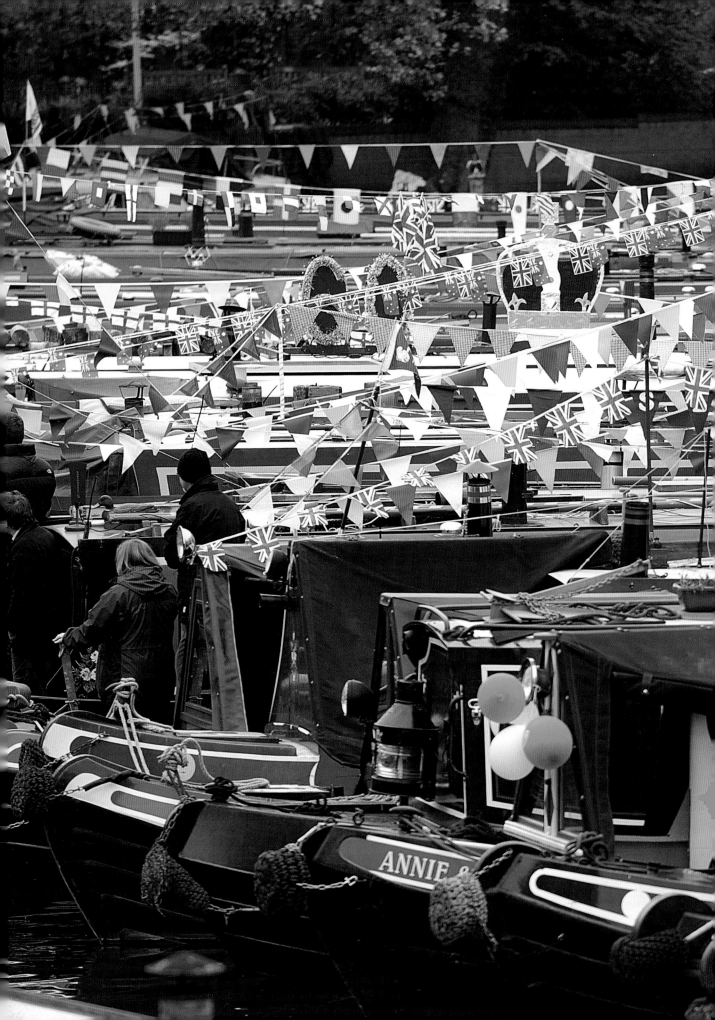

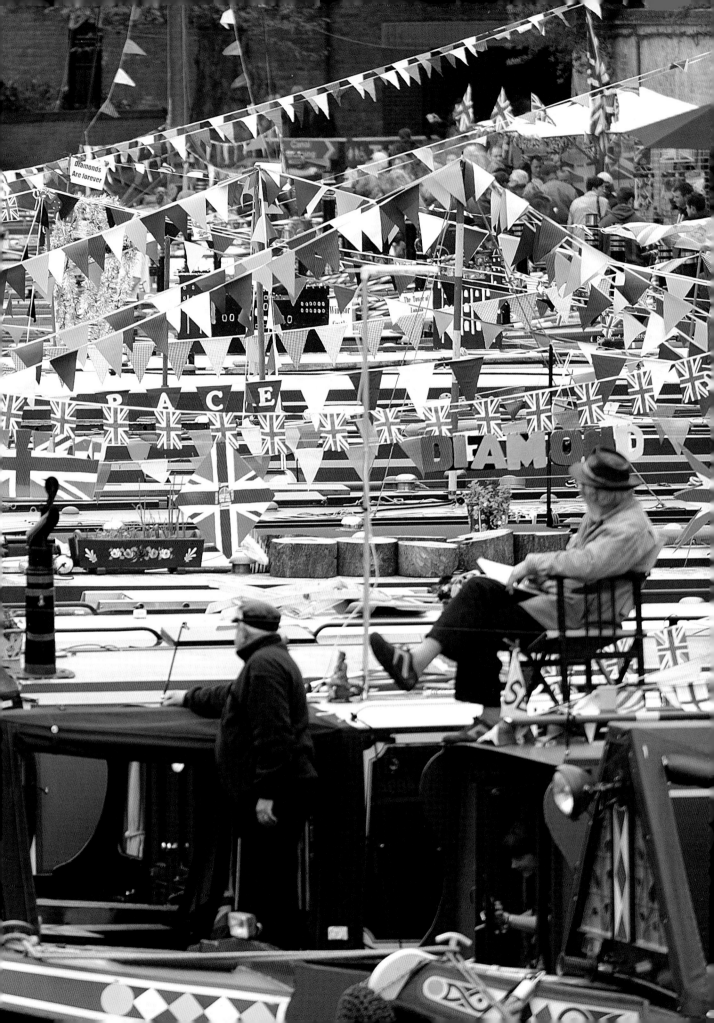

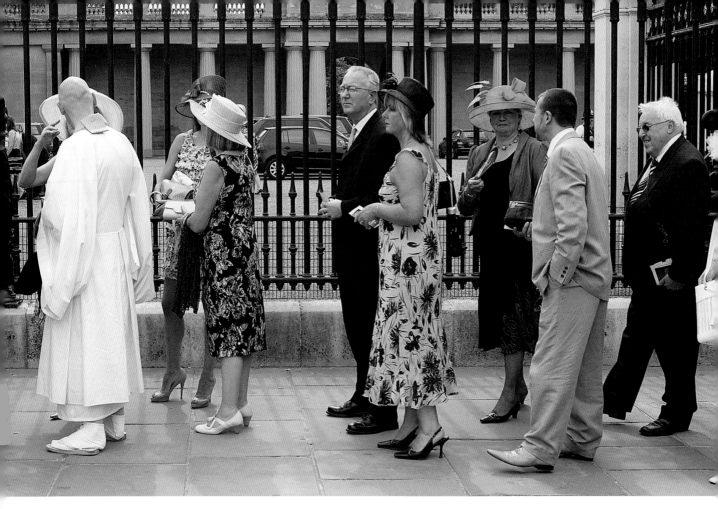

PREVIOUS PAGES

CANALWAY CAVALCADE, LITTLE VENICE

If canal boats are your thing – or if you just want something fun to do on the first May Bank Holiday weekend – then you should head down to Little Venice. You can always see boats there, of course, moored along the Regent's Canal next to Blomfield Road and Maida Avenue. But during the Canalway Cavalcade, the whole of the Little Venice basin is full of them. They lie there side by side, noses to the quay, bunting fluttering overhead, dozens and dozens of them. Their owners are here to show them off and so they're usually on board, posing at the tiller or sitting in deckchairs on the roof.

There are bands, Morris Dancers, a Punch and Judy show and other children's activities, a bar (real ale, naturally), food stalls, people selling clothing, jewellery, handbags, ceramics, toys, art, crafts, you name it.

It's been happening for over thirty years. This is London. We go out and enjoy ourselves on a May Bank Holiday. A bit cold? Raining? Who cares about the weather? It's an extra day off. So lots of people – and many who are not canal boat nuts at all – come to the Canalway Cavalcade and they have a great time. **1**

BUCKINGHAM PALACE GARDEN PARTY

It's exciting to get an invitation to a Buckingham Palace Garden Party even though there are an astonishing 8,000 guests at every one. Who are all these people? Well, they come from every imaginable walk of life. The invitation system is set up to ensure that. The way it works is that a whole lot of different organisations submit their recommendations. Central and Local Government and the Armed Forces, obviously, and Lord Lieutenants in the Counties, charities, societies for all kinds of things, religious bodies, and the list goes on. The people who eventually come together in the Palace garden really are a cross section of the community. Meetings with the Queen and the Duke of Edinburgh are not prearranged. They move along 'lanes' towards the tea tent and just stop when they feel like it. So, if you're feeling brave, you should position yourself somewhere along one of these lanes.

And there is that all-important question: what should you wear? For men, as always, the answer is reasonably easy. The official advice is morning dress or lounge suits but it's also perfectly acceptable to wear your national dress or, if you're a member of a religious order, your robes. Ladies are told that it's a special day and they should wear afternoon dress, usually with a hat. Does that leave things a little too vague for some ladies to be completely comfortable with their frock on the day? And that great new English social occasion question comes up: are fascinators OK? Fortunately, the Palace has specific guidance on this and the official line is yes. **17**

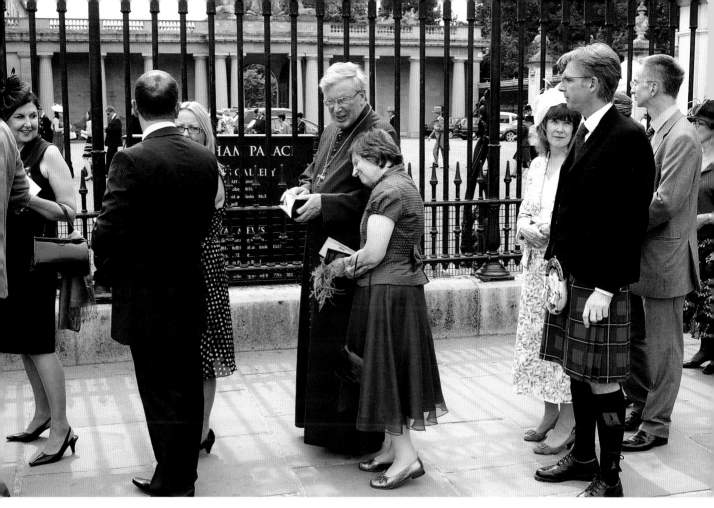

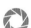 **TAKING THE PICTURES outside Buckingham Palace before a Garden Party**

I hadn't been there a minute before the police (there were a lot of them) wanted to know who I was and what I was up to. Fair enough. Once I'd shown my ID and explained, it was fine and they let me take plenty of photographs.

They were checking every guest's invitation at the Main Gates of the Palace and so the queue was very slow moving, which gave me plenty of opportunity to ask people if they minded having their pictures taken. At one point, a tall, distinguished-looking gentleman in red robes came along and went to enter the gate without queuing. All the same, I had time to ask him if I could photograph him.

'Certainly,' he said.

When I'd taken the shot, I carried on pushing my luck. 'Do you mind my asking,' I said, 'why you're dressed all in red?'

'Not at all,' he said. 'I'm the Dean of Westminster.'

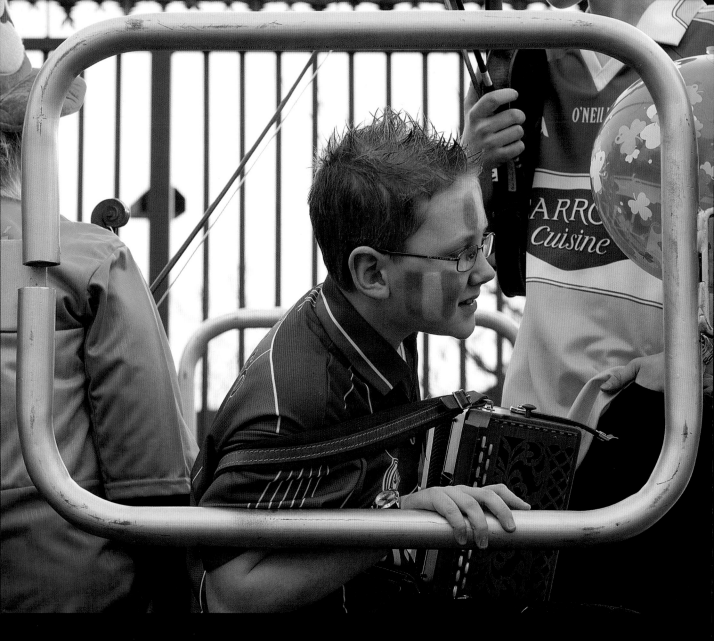

ST PATRICK'S DAY PARADE, WILLESDEN GREEN

Willesden and its near neighbour, Kilburn, had always attracted Irish settlers and, when America imposed restrictions on immigrants in the 1920s and 1930s, what had been a trickle became a stream. Then, after the Second World War, it turned into a flood. There had always been lots of Irish in the building trade and, in the late 1940s and 1950s, they poured into the area's cheap lodging houses. The 1966 Census showed that almost 20% of Willesden's population had been born in Ireland.

The ethnic mix has become a good deal more exotic since then, but there's still a healthy Irish contingent and so it's natural that Willesden Green should be the place for a St Patrick's Day Parade. The place has an appropriate name too, because this event's very green. I mean literally green, as in the colour, not as in environmentally friendly. Though it could be that too. I couldn't say. But green is definitely the colour. It's everywhere. On people's shirts, blouses, skirts, hats, coats, banners and flags. On their faces. And in their hair. The bags on the bagpipes are even green. And what else do you associate with Irish clichés? Yes, you've got it. There are shamrocks all over the place and you see Guinness mentioned everywhere too.

I was surprised to see that the pipe and drum band had come down from Birmingham for the occasion. Haven't we got one in London? Anyway, when the parade got going, they made a great noise and marched forward bravely and all the assorted green-clad hordes, on foot and on lorry floats, on bikes and in buses, came following on behind. And in no time at all, sure, the *craic* was great. 6

Lent is the period of forty days before Easter in the Christian calendar. Jesus disappeared off to the desert for that number of days and, partly to mark his fasting there and partly to prepare for the commemoration of his death at Easter, Christians give things up during Lent. It might be alcohol or chocolate or going to parties or some other indulgence. The word Lent, by the way, comes from an old English word meaning lengthen. This is the time of year when the days are getting longer.

Lent starts on Ash Wednesday and the day before it is Shrove Tuesday. A big day. Because this is the day when you have to cleanse yourself of sin by repenting of your past misdeeds. And it's also your last chance to have a blowout before Lent. The first bit is where the name Shrove Tuesday comes from. Shrive is another old English word. It means to confess your sins and receive absolution. At a time when all this was taken rather more seriously than it is now, having to face confession might have taken the edge off the best bit of the day, the part from which the day's nickname comes. Pancake Day.

There are some foods that Christians used not to eat during Lent. Meat, fish, fats, eggs and dairy products were the main ones. So, before the days of fridges, you had to eat up all that sort of stuff on Shrove Tuesday. (Question: what's the French for fat, in the sense of cooking fat? Answer: *gras*. And that's why they call it *Mardi Gras*. Fat Tuesday.) People worked out hundreds of years ago that pancakes were a great thing to cook on Shrove Tuesday because they used up eggs, fats and milk. The only other thing you needed was flour. And so, from then on, pancakes were being eaten everywhere on Shrove Tuesday.

But that still doesn't explain why people race through the streets flipping them in their pans. You can believe this or not, as you like. It's up to you. But the story goes that, in 1445, a woman was busy cooking pancakes in her kitchen thinking that she had plenty of time left before she had to go to church for the confession bit. But she'd got the time wrong. The pancakes were nowhere near finished when the bells started to ring, meaning that she had to get to church right away. So she ran out of the house in her apron, still carrying the pan with the pancakes in it, and raced all the way to the church. 20

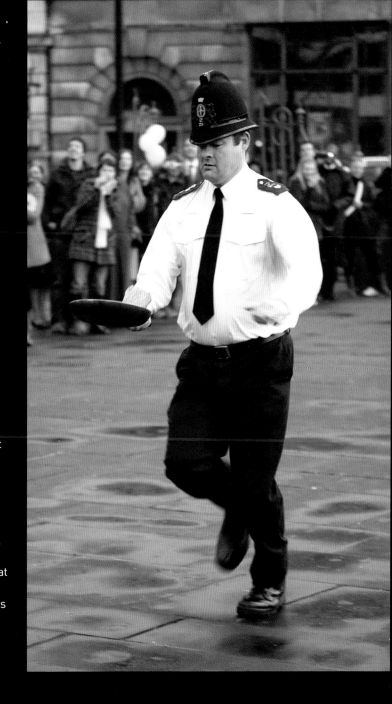

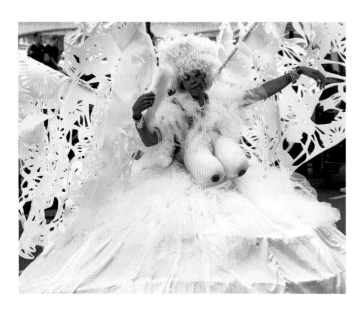

MAYOR'S THAMES FESTIVAL, VICTORIA EMBANKMENT

The parade along the Victoria Embankment which is part of the Mayor's Thames Festival takes place just a few weekends after the Notting Hill Carnival. And, guess what? I happened to see a few of the same people there as I'd seen up in Ladbroke Grove at the first event and wearing identical outfits too. Well, you can't blame them really. It must take hours to make those costumes and they should get all the wear that they can out of them.

But the Mayor's Thames Festival is much more than a street parade. When it first started, it lasted only a weekend. Then it grew to a week and, in 2013, to ten days. In 2014 it was a whole month. As the name would suggest, everything's very much focused on the river, with events in all the seventeen boroughs that the Thames runs through. And there's an incredibly varied programme. Creative commissions, exhibitions and installations, live performances, lots of things happening on and about boats, talks about the Thames' geography and ecology, walks and a photography competition. **3**

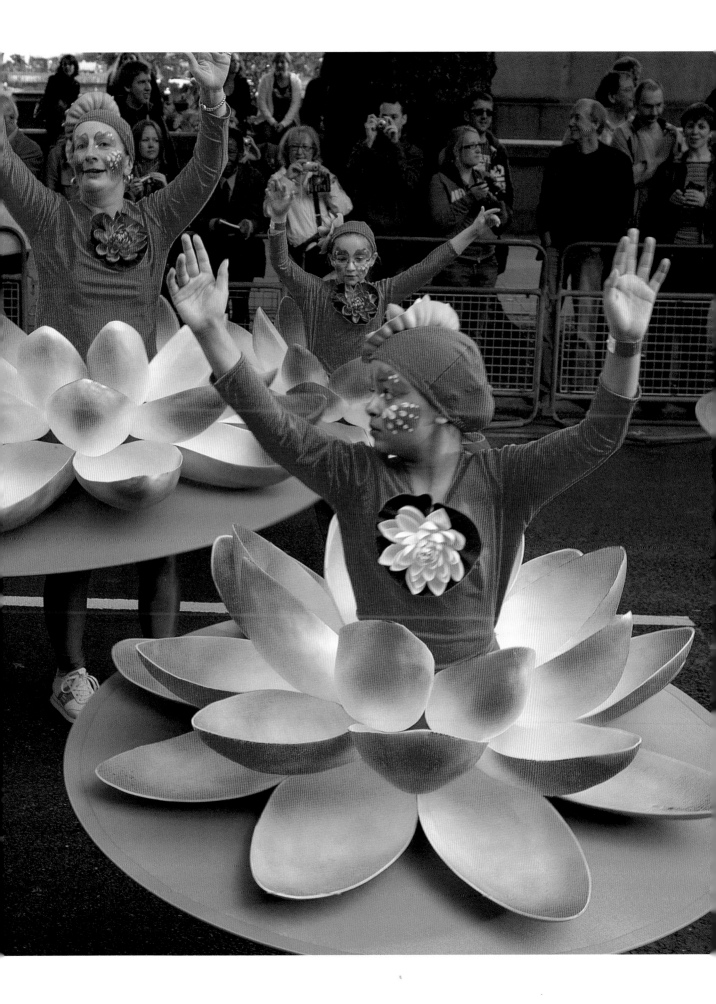

70TH ANNIVERSARY OF THE BLITZ, ST PAUL'S CATHEDRAL

The Luftwaffe's Blitz on London started on 7 September 1940 and continued for eight devastating, terrifying months. That Saturday afternoon hundreds of planes appeared, flying in formation up the Thames, and the bombing began. It was the first night too of the fires, burning out of control, that would soon become familiar. Almost 30,000 Londoners lost their lives in the course of those months. Vast areas of the city were reduced to rubble and the face of London was changed forever. The aim of the German high command was to destroy civilian morale but, in point of fact, it had the opposite effect. The appalling adversity brought people closer together. Londoners think of the Blitz with pride as an ordeal that they survived with courage and dignity.

Seventy years on, this critical period in the city's history was commemorated with a series of events. As so often when we want something to be stamped in the national consciousness, St Paul's Cathedral was the focal point. A service was held there. And then there was a fly-past by a Lancaster Bomber and a Spitfire, the roar of their engines breaking the silence and startling birds from nearby buildings. Then, evocatively, the silence was broken again by the sound of an RAF band marching through the gap between the steps of the cathedral and another Spitfire incongruously parked there. **15**

? DID YOU KNOW these facts about the London Blitz?

On 12 September 1940 an unexploded bomb buried itself under St Paul's Cathedral, close to the south-west tower. This was a serious threat to the foundations. It took three days to get it out and when it was exploded on Hackney Marshes, it made a crater 30 metres in diameter. After that, all the buildings round the cathedral were flattened during the Blitz, one after another, but St Paul's survived.

People were advised officially not to use Tube stations as shelters. But despite that, thousands of people slept in the stations every night for weeks. You were OK in the deepest stations but actually still at risk in the ones near the surface because high-explosive bombs could penetrate at least 15 metres. Even though you couldn't hear the bombing in the deep stations and might have felt safe there, they were pretty unpleasant places. There were no toilets or washing facilities and the ventilation was very poor so that the air was rank. And there were fleas, lice and rats everywhere.

Although food was rationed, there was quite a bit of it at this stage of the war. The problem was cooking it because gas and electricity supplies kept being cut off. In fact, one day water spurted out of the gas stoves in Pimlico. So people shared their facilities or improvised field kitchens in their gardens, or even in the streets.

In peacetime, 1,850 fire pumps were enough to fight fires in the whole of Great Britain. By the end of December 1940, there were 2,000 pumps in the City alone and the City fire brigade had 20,000 auxiliary firemen as well as 2,000 regulars.

Bomb blasts sometimes had extremely odd effects. A girl in Poplar was taking a bath when her house was hit. The bath was blown upside down with her inside it and she survived completely unhurt because it acted as a shelter against the tons of rubble which fell on her. The rescuers were absolutely astonished to find her there. Being found stark naked by them was embarrassing, but a small price to pay for the miracle.

CHINESE NEW YEAR, SOHO

The Chinatown in London is very small beer compared to its equivalents in the countries which have had more Chinese immigration than we have. In San Francisco, for instance, about ten thousand Chinese people live in the inner-city area where the Cantonese first settled during the 1849 Gold Rush. They have nearly a hundred restaurants there, catering to even the most exotic Chinese tastes. But, small though it is, London's Chinatown still puts on a good show for Chinese New Year.

There are masses of red and gold lanterns and banners strung overhead. You can buy Chinese foods, toys, knick-knacks, clothing, and any number of medicinal cures with Chinese writing all over the boxes and bottles. But there's no need to be concerned about what's inside them or what you might be putting inside you because you can have a free consultation with someone in a white coat. You may need something to cure indigestion, since lots of the restaurants in the area are offering special deals on Chinese New Year feasts. Twelve courses for a knock-down price, 'including famous Peking Duck'. And, to entice you in, you can see rows of glazed roast ducks in the window. All this attracts thousands of people. The area inside the traditional Chinese gates to Chinatown is packed and just walking from one end of Gerrard Street to the other takes hours. **2**

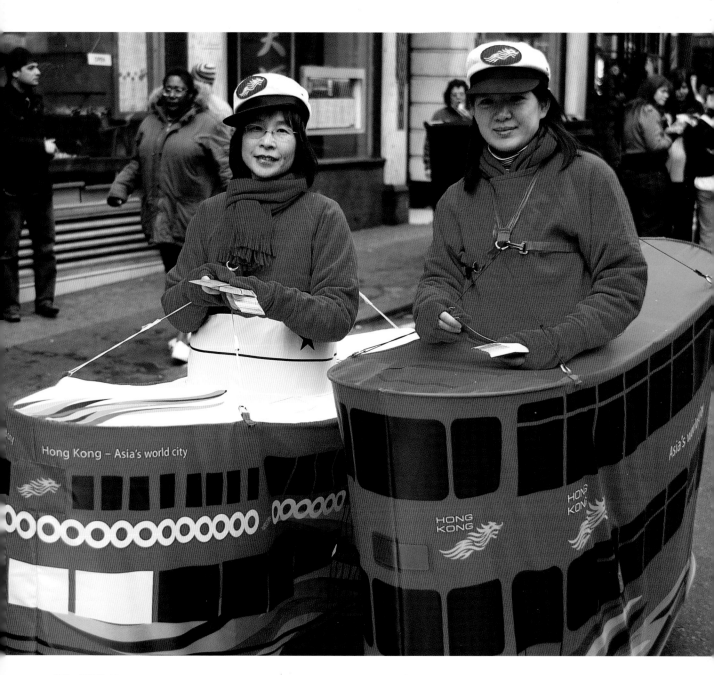

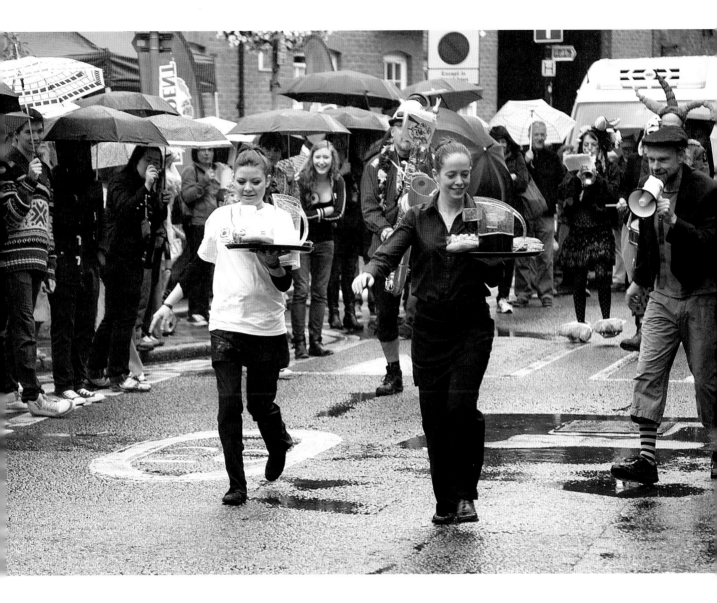

BASTILLE DAY, WAITERS' RACE, BOROUGH MARKET

Borough Market has become a Mecca for foodies. You can hardly move for the crowds on the days when it's open. All those people are there for a good reason. The food's terrific. An event which takes place nearby on Bastille Day, which is 14 July, is very much in tune with the market and is also lots of fun. It's a race for waiters and waitresses. The competitors have to run while carrying the traditional French round tin tray on which there are a baguette sandwich, a slab of Camembert, a jug of wine and some glasses of wine too. It's quite a challenge to cover 50 yards without dropping or spilling any of that. **5**

TAKING THE PICTURES on Remembrance Sunday in Whitehall

Obviously there were going to be a lot of people there. But not, I thought, at the early hour that I'd got to Westminster Tube Station. I was wrong. There were already big crowds inside the station and, when I came out onto the street, I began to realise that I'd underestimated the difficulty. It took me some time to get down Bridge Street to the traffic lights and the corner of Parliament Square. I'd had this idea that I'd try to blag my way along towards the Cenotaph and maybe even, with the long lens that I had in my backpack, take a shot of the Queen laying her wreath. I'd been very naïve. No one could get more than ten yards along Parliament Street in the direction of Whitehall without an invitation. So I walked round the corner into Parliament Square. Edged would be a better word, since the pavement was by now full. It was clear that this little bit of Parliament Square was where I was going to do my photographing.

I'm not normally reticent about asking people if I can take their pictures. But the solemnity of this occasion and the facial expressions of many of the veterans in the crowd made me reluctant to approach a lot of them. It obviously just wasn't right to intrude. You could see that this day meant a great deal to them. Some, though, were kind enough to see what I was trying to do and to say yes to me.

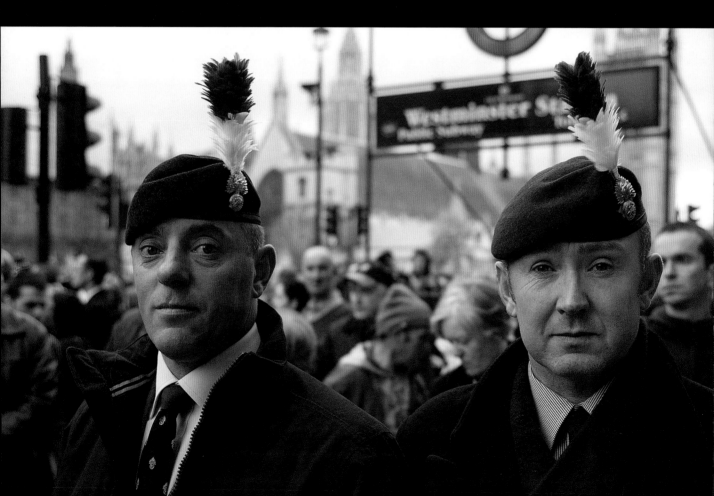

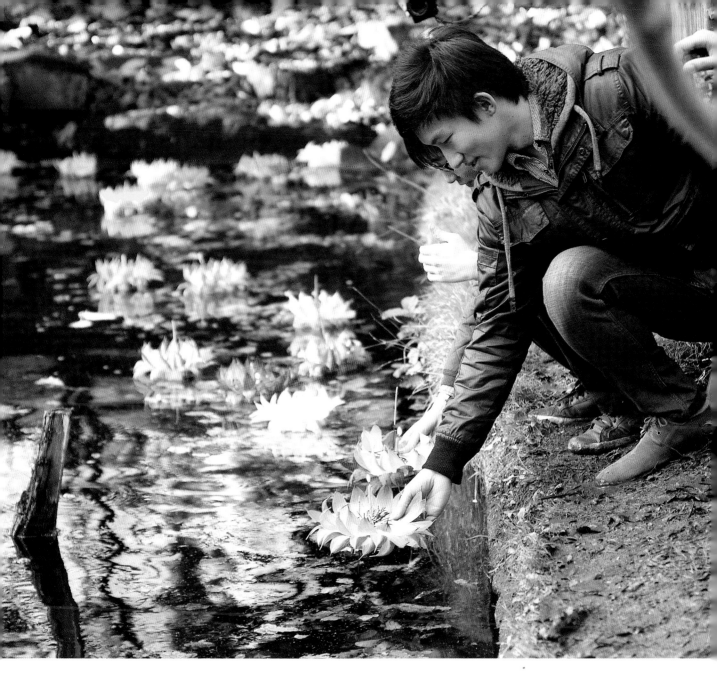

FLOATING FLOWER FESTIVAL, THAI BUDDHIST TEMPLE, WIMBLEDON

When I filmed a video interview with Phrakru Lom, one of the resident monks and meditation masters, at the beautiful Thai Buddhist Temple in Wimbledon, he tipped me off. 'You should come to the Floating Flower Festival in November,' he said, 'it's a big deal. We get about five thousand people if it's a fine Sunday.' I couldn't believe what I'd heard and asked him to repeat that number. But, sure enough, there certainly was a large crowd when I went to photograph it. There were people everywhere, launching their lanterns on the temple's pond, picnicking round the extensive wooded grounds on the hot (I mean heated as well as spicy) Thai food that they'd bought at the stalls in the car park, listening to the Thai orchestra playing on the stage and cruising round buying the Thai products which were on sale.

The main reason why people go, though, is in the name of the festival. In Thai, it's Loy Kratong. *Loy* means to float and *kratong* means lantern or little vessel in the shape of a lotus flower. And this is the festival, celebrated all over Thailand at full moon in the twelfth lunar month, on which people float candle-lit lanterns in rivers and on canals, lakes and ponds.

What's the idea of floating these lanterns? The first reason for doing it is to thank the Goddess of Water for letting us use water in our daily lives and to say sorry for polluting it. You'll see people pulling a piece of fingornail, a hair or a coin in the lantern with the candle, incense sticks and flowers. What they're doing is letting go of unhappiness or sickness. 16

ICE SKATING, NATURAL HISTORY MUSEUM

Londoners have really gone in for ice skating in recent years and there are now some great places where you can do it, overlooked by some of the city's most famous buildings. The Natural History Museum is one of those, instantly recognisable by every Londoner because we all went there as children to see – and be awed by – the huge dinosaur in the entrance hall. The trees along the Cromwell Road add some extra charm and can sometimes give the whole scene a bit of a Christmas card feel. **10**

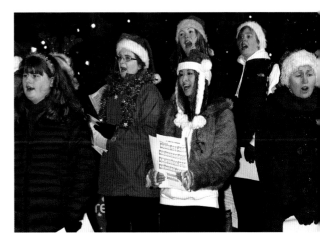

CHRISTMAS CAROLS, TRAFALGAR SQUARE

If you want a heart-warming Christmas experience, you can't do much better than Trafalgar Square. There's an absolutely enormous Christmas tree, given each year to the people of London by the people of Norway as a thank you for Britain's support during the Second World War, which is decorated with lights in the traditional Norwegian vertical style. Underneath it, every evening in the run-up to Christmas, there are carols sung by volunteer choirs from all over the country. Lots of the carol singers, of course, can be relied on to wear Santa or reindeer hats. They're excited to be performing in such an iconic setting and their enthusiasm comes across. **12**

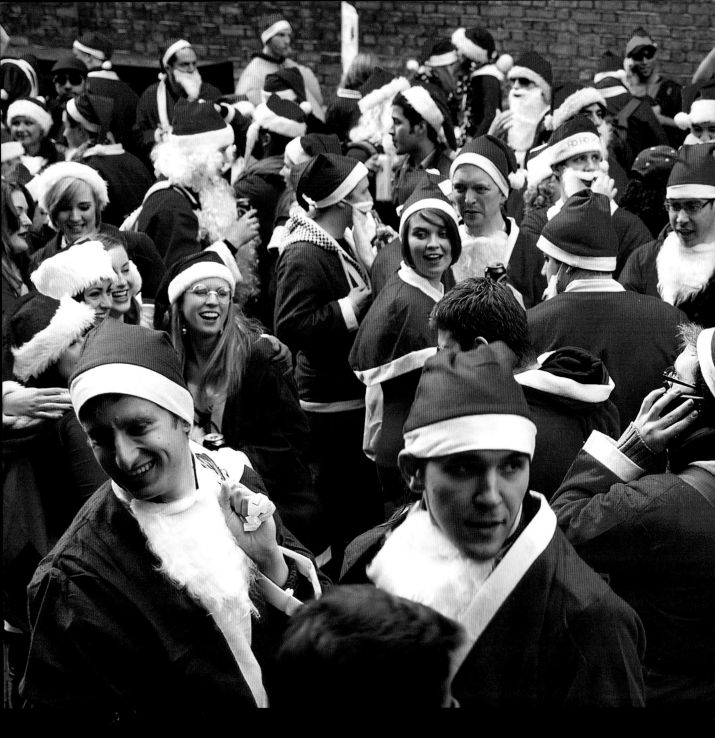

SANTACON, LEICESTER SQUARE

If I'm going to explain what Santacon is, I really can't do better than paraphrase bits of their website (with apologies, of course):

It's a Christmas parade of goodwill and fun created by whoever wants to take part. You don't have to belong to anything or pay any money and it's not religious or political. There's no particular reason to dress up in Santa suits, run around town, hand out gifts, sing songs, have strangers sit on your lap and decide who's naughty or nice. But it's lots of fun and so Santa does it anyway and everyone loves Santa and Santa loves everyone.

There are some rules. Not many but they're important. You've got to wear a Santa suit. Buy one. Make one. Customise one. Be creative. If you don't have any creativity, slap yourself three times and ask your Mum to help you. A Santa hat is not enough.

Be jolly. Be nice. Don't throw things at people or elves. Memorise the answers to these questions that you may be asked:

Q: Who's in charge? A: Santa

Q: What are you protesting about? A: We're not protesting. We're celebrating.

Q: Why?: A: Because it's Christmas.

Q: How did you get here? A: A sleigh and eight reindeer.

Q: Where are you going next? A: I'm only allowed to tell you if you wear this hat and buy me a beer. (11)

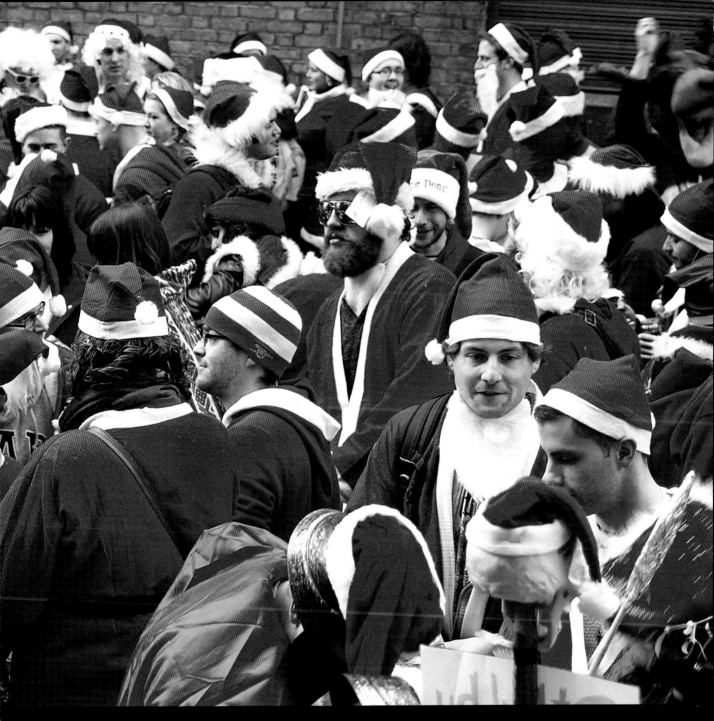

 TAKING THE PICTURES of Santacon

This is the kind of event that you're likely to pick up only if you follow *Time Out London* or something similar on Twitter. Then you'll discover that there are several Santacon groups starting out in different places round London. I chose the one which was going to begin their day by watching the film *Bad Santa* at the Prince Charles Cinema near Leicester Square.

When I arrived outside the cinema there were one or two Santas waiting, like me, for the film to finish. By the time it did end, this number had grown to twenty or so. And then well over a hundred more Santas came pouring out of the cinema, as well as a smattering of elves, dressed in green. Brave people these. They'd have to face a day of Santas pointing at them and chanting, 'Elf, elf, elf.'

I realised that I had a problem. How was I going to get a shot which showed how many Santas there were milling around here? It was the sheer number of them in their red outfits that I was trying to convey in my picture. I needed to get above them somehow. But I couldn't see a way into any of the surrounding buildings. The only possibility was the three steps up to the fire exit of the Prince Charles and what turned out to be a very wobbly rail. Feeling rather conspicuous now, as one of the few people not dressed as Santa or an elf, I clambered up onto the top of the rail and, gripping the wall with one hand and my camera with the other, took my shots.

HALLOWEEN, ST JOHN'S WOOD

Halloween is a bit like pizzas. Italian emigrants took what was a relatively humble snack over to the United States. It was embellished there and then exported back to its homeland in its new Americanised form. It was the Celts who started Halloween (although they called it Samhain) and Scots and Irish who flocked to America in the 19th century took a version of the celebration with them. After a suitable period, back it came, complete with trick-or-treating, fake cobwebs and all that other stuff.

What Samhain celebrated was the end of the harvest season. It was also thought that, on 31 October, the worlds of the living and the dead overlapped. So the dead could come back to life and cause all manner of grief, like making you or your animals sick, ruining your crops, messing up your business, and so on. To try to ward off the living dead and the evil spirits which would also be nosing around, people took to wearing masks and frightening costumes. You can see how we've got from there to where we are today.

The American School in London is based in St John's Wood. As a result, a lot of American families live in the area and, over recent years, a few of the streets there have become the destination of choice on Halloween for people from all over London. It even gets recommended in *Time Out*. From just before dark, no traffic can possibly pass along those streets. They're completely full of families parading up and down in their masks and costumes and trick-or-treating all the houses. **14**

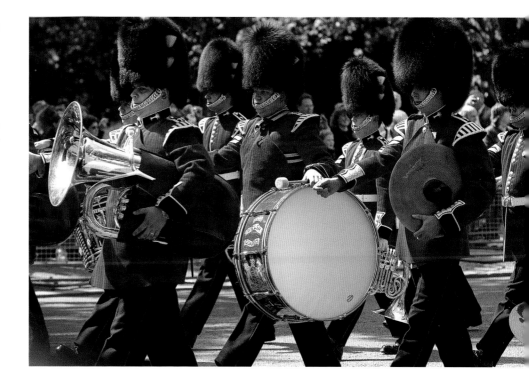

TROOPING THE COLOUR, THE MALL

Everything about Trooping the Colour is very British. First of all, the ceremony is to celebrate the Queen's birthday. But it doesn't take place on her birthday, which is in April. The colour is trooped in June. And what exactly are they doing all that marching about and saluting for?

Well, when the thing first started, probably back in the early 18th century, it had a practical point. The colours, or flags, of the battalions were carried, or 'trooped', down the ranks so that the soldiers could see them and would then recognise them, in the heat of battle and so on. The first English monarch to get in on the act was George II. In 1748 he came up with the idea of making the parade part of his birthday party, and that's been the tradition ever since.

The ceremony takes place on Horse Guards Parade and so the Foot Guards, the Household Cavalry, the King's Troop, Royal Horse Artillery and all the marching bands have to go down The Mall to get there, followed, of course, by the Queen and the other members of the Royal Family. Then, in an echo of the Grand Old Duke of York, they all come back again after the colour has been trooped. **23**

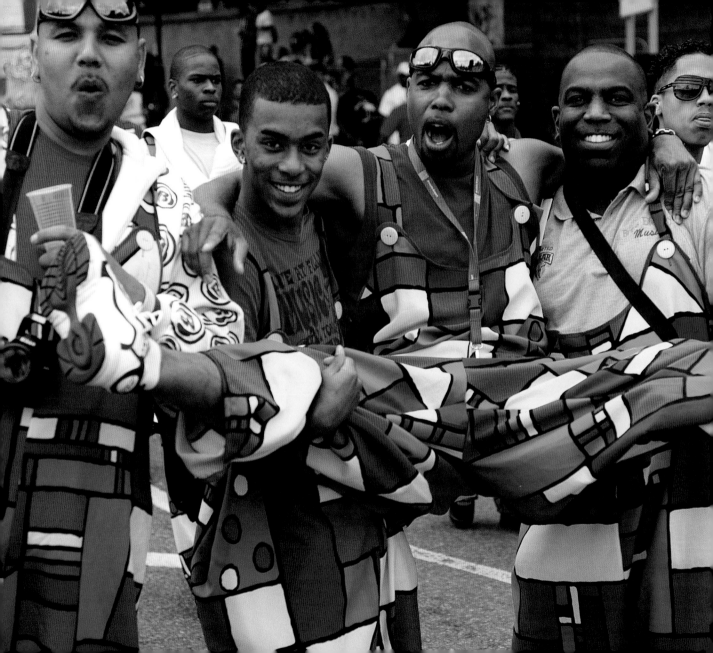

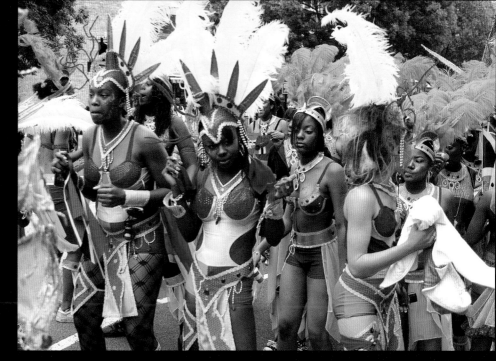

LEFT, ABOVE AND OVERLEAF

NOTTING HILL CARNIVAL

A lot of people are fond of the Hugh Grant/ Julia Roberts film *Notting Hill*, but some local residents certainly aren't. They object to it because it doesn't even mention the biggest thing that happens in that area every year. 'One of the largest street festivals in the world. How could they leave it out?'

But then a lot of those same local residents make absolutely sure that they're in their country houses for the August Bank Holiday weekend. 'The noise, my dear. You wouldn't believe it. The litter. The crowds. And the way they behave.'

It is indeed a huge and daunting event. Over a million people looking for a party. A massive crush everywhere. No signal on your mobile phone. Twenty miles of roads in all. Forty sound-systems booming away. No toilets visible. But there are lots of amazing floats and costumes that people have spent

event is like the Notting Hill Carnival buzz. But you have to know how to enjoy it. Are you a first-timer? Then you need some expert advice. Check this out:

* It's more laid-back on Sunday than on Monday. Things are cranked up a notch or two on Monday.
* Get on a bus to Harrow Road. Heading anywhere near Westbourne Park or Notting Hill Tube station is for amateurs.
* Don't expect too much from the food. It's overpriced and pretty hit-and-miss.
* Don't go in a group of more than three people. You'll get separated and won't be able to find or call each other.
* If you see big groups of kids steaming into crowds, stay cool.
* Don't forget that they're just kids mucking about.

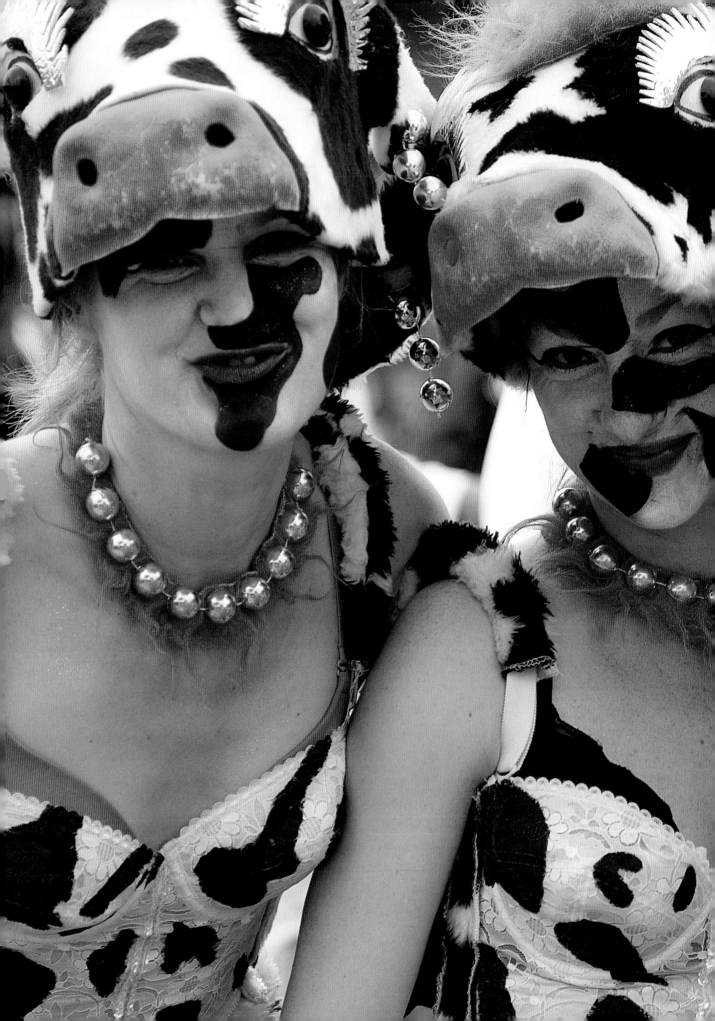

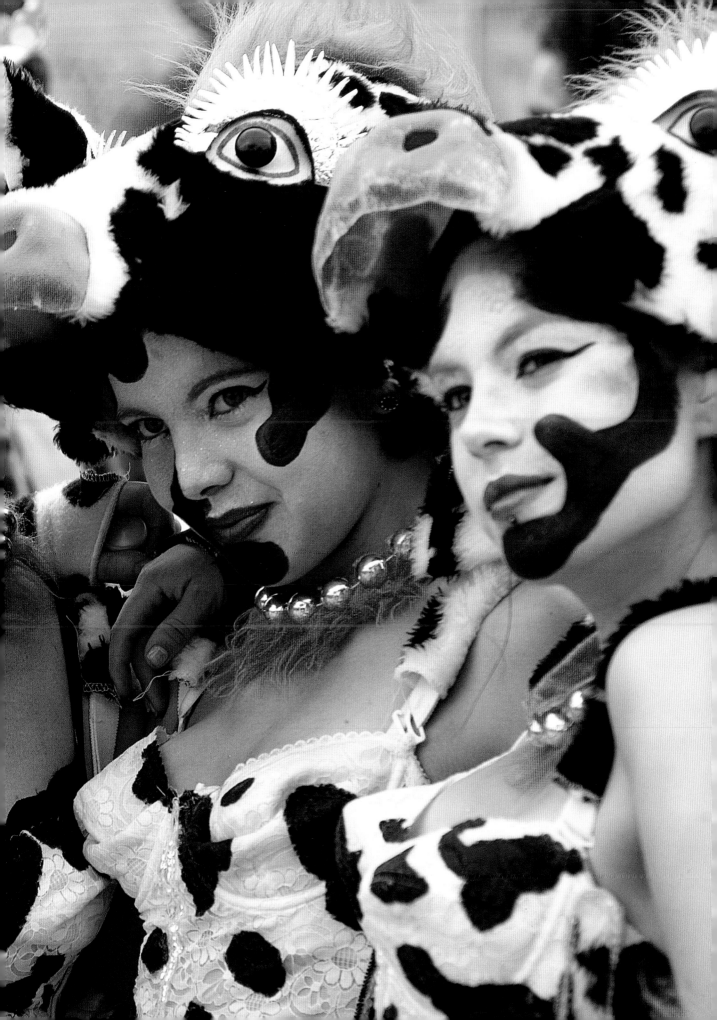

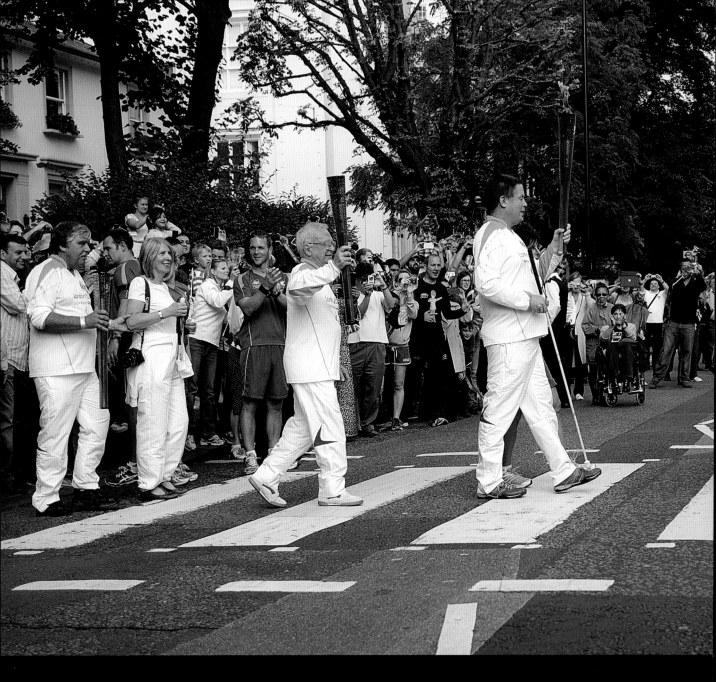

LONDON 2012 VICTORY PARADE,
NEAR ST PAUL'S CATHEDRAL

Londoners have never been in such a mood for a party as
they were at the end of the 2012 summer of sport. The spirits
of the whole country had been lifted by the performance of
our Olympians and Paralympians but, if you were a Londoner,
you felt a special pride in having hosted such fantastically
successful Games and at having seen your city looking so good
on all the television coverage that was going out round the
world. You knew that the backdrops of Greenwich, Horse

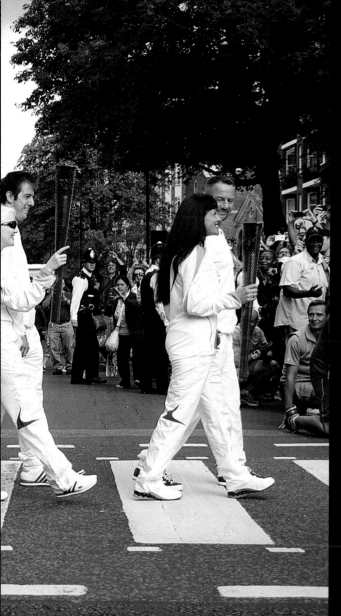

The organisers of the London 2012 Paralympic Games (and the people behind the Olympic Games too, of course) deserve huge credit for the imaginative way in which they arranged for the torches to be carried by relays of different people and the creative route that they worked out. Just take the last day, which was the day when the torches moved slowly through London and finally ended up at the Olympic Park.

There was an 8.30 a.m. stop at the BAPS Shri Swaminarayan Hindu Temple in Neasden. You can see pictures of the Diwali ceremony there in the Faith in London chapter. Later in the morning, there was a stop at the zebra crossing in Abbey Road, made famous by the Beatles. Here, the members of the team carrying the torches waited until a small army of press photographers and television cameramen were in place and then re-enacted that scene on the album cover. This team was made up of people who had all been unemployed at some point in the past. Now they'd trained and qualified as gym fitness instructors, overcoming disabilities like spinal cord injury, blindness and impaired mental health.

Then it was on to London Zoo in Regent's Park. The whole cavalcade (and I can tell you that the torchbearers had quite a supporting cast) stopped at the penguin enclosure – a lot of people's favourite – for the flames to be held aloft. Next, it was down Regent Street and into Piccadilly Circus. And then, eventually, on to the Olympic Park. 14

Guards and Buckingham Palace, for example, simply could not be bettered by any city in the world. And how brilliant to design events so that they could take place at those venues.

So when a victory parade through central London was announced, it was bound to be turned into one massive celebration. The streets all the way from the Guildhall in the City to Buckingham Palace were so full that, in many places, there was no way to get along the pavements behind the crowds. No one knows how many people showed up but it was hundreds of thousands. They arrived early to get a good spot, they chatted and laughed and had fun while they waited and

they cheered and cheered when the athletes finally came past.

Eight hundred competitors paraded on twenty-one floats. Some of them had become national heroes in the weeks before: Mo Farah, Jessica Ennis, Chris Hoy, Ben Ainslie, Bradley Wiggins, for instance. But there were many others not so instantly recognisable and the crowd roared their approval and waved their flags at them too. There were thousands of flags, not only being waved but also modified into dresses. There were wigs, face paint, whistles, giant hands with pointy fingers and vuvuzelas (presumably remaindered after the 2010 World Cup in South Africa). 15

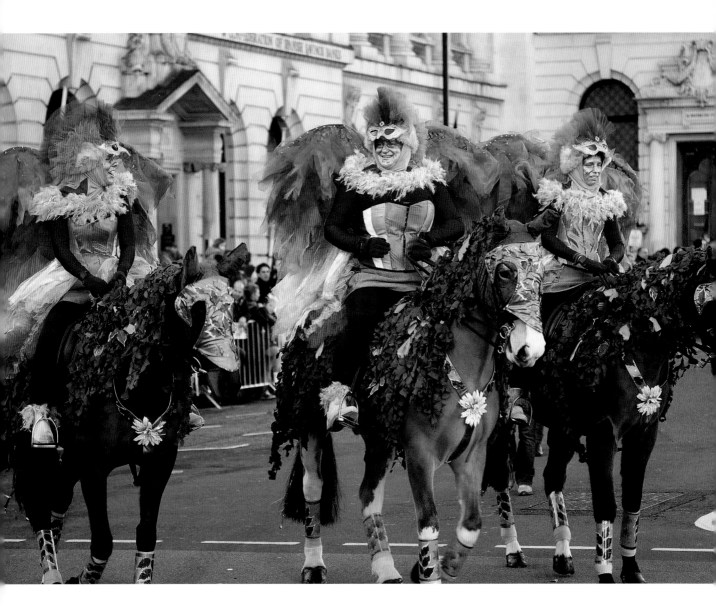

NEW YEAR'S DAY PARADE, PALL MALL

Was it a case of 'Anything you can do, I can do better'? Or just thinking that the West End on New Year's Day was pretty dull and needed perking up? Or some other reason? In any event, the Lord Mayor had been doing it in the City for about six hundred years before his equivalent in Westminster followed suit in 1987 and came up with the idea of a parade in his part of town.

It couldn't begin to compete with the Lord Mayor's Show at the start, of course, but, actually, Westminster didn't do too badly for a beginner. In year one, there were about two thousand performers, most of them marching bands, and a hundred thousand or so spectators. The breakthrough came two years later, when they dreamed up an idea which really distinguished the New Year's Day Parade from the City's show

in November. This was the first time that American cheerleaders made an appearance. Now, 25 years on, they're a major feature, along with their high school and college marching bands. The first concerts were staged back in 1989 too. And the organisers started dabbling with the idea of a Parade Finale Arena.

A few years later, all the London boroughs started to participate and to take a float in the parade. This developed into a competition between them, which results in a prize for charity. It has grown steadily into a major London event, on a par with its historical equivalent a few miles to the east. These days, there might be three-quarters of a million people lining the streets if the weather's good and the TV audience round the world is an amazing 300 million. **9**

LORD MAYOR'S SHOW, THE CITY

Everyone knows that King John signed Magna Carta and that he was a Bad King. But he had some good ideas too. And one of these was to make the newly elected Lord Mayor come out of the safety of the City and down to Westminster, where he had to swear loyalty to the Crown. It was a bit of a pain in those days, of course, involving river barges. All the same, King John insisted and so did his successors, with the result that the Lord Mayor has been making this journey ever since. In due course, horses replaced the barges but, in 1711, an unfortunate mayor fell off and broke his leg. After that, coaches were hired. The City got richer and richer and, in 1757, the astonishingly ornate State Coach which is used today was commissioned.

Over the years, the 3½-mile trip took on a life of its own.

As early as the Middle Ages, a great deal of rowdy pageantry accompanied the stately person of the mayor. Sometimes it wasn't altogether peaceful. Well, no doubt people had got a bit tanked up as the day wore on and tempers had frayed, leading to swords being drawn. But, for the most part, it was all in good fun. That's the way it is today and it's bigger than ever. If you like big, then listen up. This is the information on the 2013 Lord Mayor's Show.

Over 7,000 participants. 21 bands. 150 horses. 23 carriages, carts and coaches. Hundreds of other vehicles. Vintage cars. Steam buses. Tanks. Tractors. Ambulances. Fire engines. Unicycles. Steamrollers. Giant robots. Helicopters. Ships. Penny-farthings. Beds. Bathtubs. And around half a million people on the streets watching. ⑦

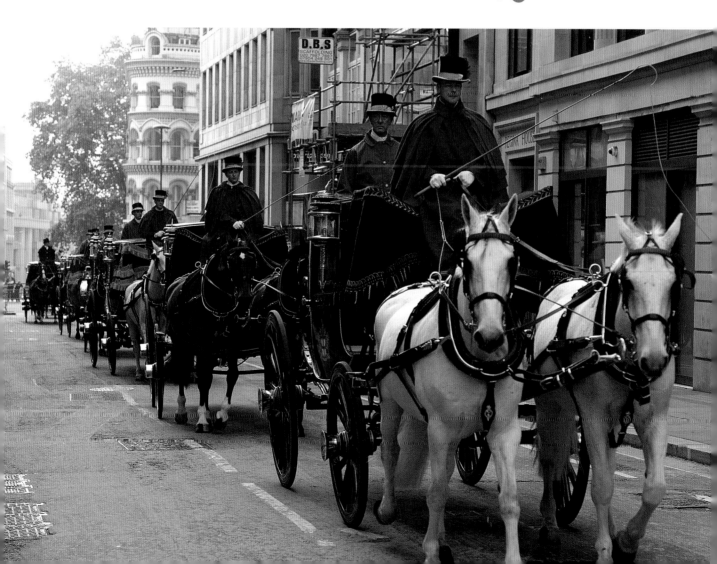

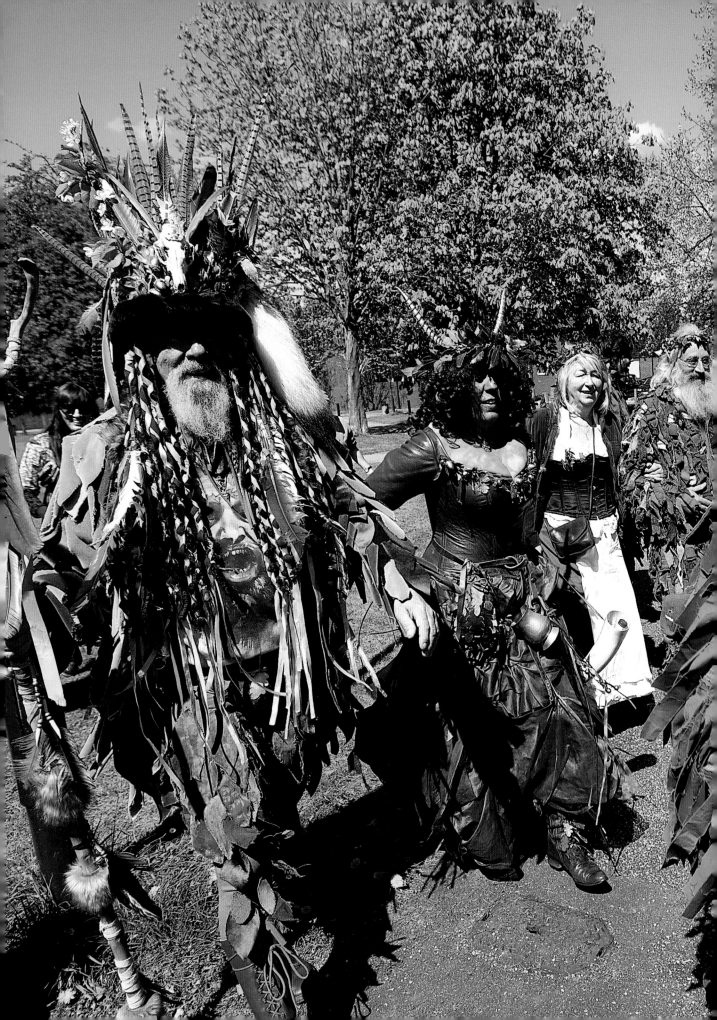

DEPTFORD JACK IN THE GREEN PROCESSION, MAY DAY

Here's something bizarre. A straggling column of musicians, bosomy women, top-hatted men, green-faced, leaf-wearing beardies and fancy-dress merchants. At the front is a 10-foot-tall cage covered with flowers and branches and inside that there's a man. He's the Jack in the Green.

The procession happens on May Day and it goes from pub to pub in Deptford and Greenwich. The musicians play at each stop and as they walk too. Anyone is welcome to tag along.

What's it all about? You have to go back to the 17th century for an answer. In those days, milkmaids went out on May Day with the things that they used in their job, like pots, cups and spoons, piled up on their heads and decorated with garlands. Why? No doubt for a laugh to start with. But soon people were throwing them money. And then other trades thought that they'd copy the idea.

At this point, a character with a brilliant name enters the story. Thankfull Sturdee. He was a press photographer with the Daily Mirror in the early 20th century and, as a local resident, was interested in anything out of the ordinary happening in Deptford. Around 1904, he took a photograph of the Deptford Jack in the Green and added a caption saying several interesting things. First, that the people in the shot were Fowlers Troop of May Day revellers; and secondly, that Jack in the Green was an old practice kept up regularly in Deptford until twenty years before, when the police stopped it.

The Fowlers Troop and the Jack in the Green tradition were revived in the 1980s by the Blackheath Morris Men. **19**

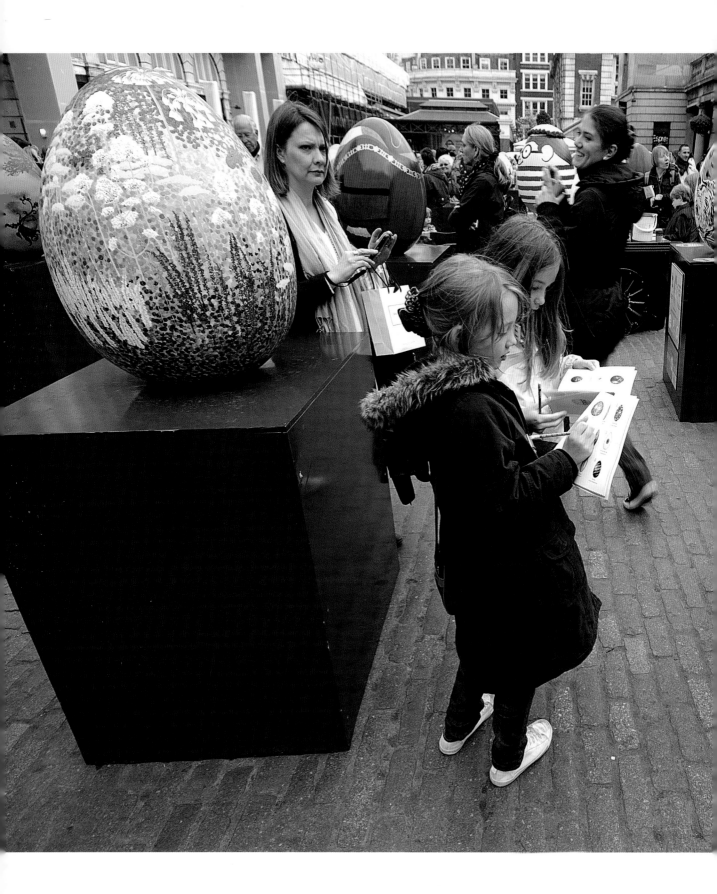

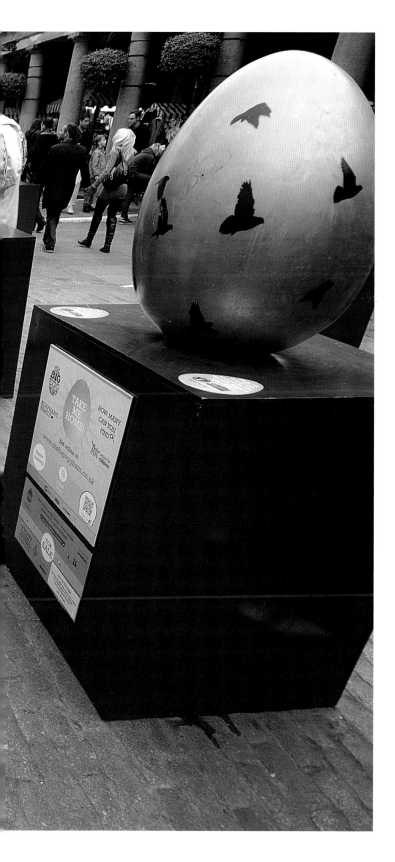

THE BIG (EASTER) EGG HUNT, COVENT GARDEN

Londoners had got used to having painted baby elephants round their streets in the summer of 2010 because of the Elephant Parade which is pictured in the Street London chapter. And there'd been a few oddball cows in their own Cow Parade about ten years before that. So they weren't very surprised when 2½-foot-high eggs started appearing in February 2012. In fact, most people's first reaction was that they looked great. Beautiful, even. But what were they all about?

Well, it was not too difficult to work it out, even without Googling them. Eggs? And Easter wasn't too far away. Yes, this was the (Fabergé) Big Egg Hunt. Fabergé had got a different artist, architect, fashion designer, etc., to produce each one, with the result that there was more variety in the 200-plus eggs scattered round central London than you would have thought possible. Each egg contained its own code word. When you texted a code word to the number you were given, you entered yourself in the competition to win the Diamond Jubilee Egg which was on display at Fabergé's shop in Grafton Street. (Remember, this was the Queen's Diamond Jubilee year as well as the Olympic Summer.) Most of the charges for the texts were collected as donations to charity.

Then, for Easter week, all the eggs were brought together in Covent Garden and you could see them all just by strolling round the piazzas. You could still do your bit for charity by buying a booklet which showed a little picture of every egg and told you who'd designed it. If you were really keen, you could race round ticking the eggs off in your booklet and then get a certificate stamped saying that you'd seen the lot. There were lots of kids doing this on the Sunday when I took this photograph, and who's to say that there weren't some nerdy adults doing it too? **8**

HARVEST FESTIVAL, PEARLY KINGS AND QUEENS, COVENT GARDEN

St Paul's Church in Covent Garden was built by Inigo Jones in 1633. There can't be many churches in London that more tourists look at. Most of them, though, probably don't notice it because its eastern façade with its lovely portico now serves as the backdrop for the acts of the Covent Garden street entertainers. The crowds watching the acrobats and unicyclists don't look beyond their tricks. This is not a new phenomenon, though. Pepys records a Punch and Judy show there. By the way, it's this very portico which features in the first act of Shaw's *Pygmalion* (and therefore also of *My Fair Lady*). St Paul's has been associated with the theatre community for a long time and it's known as 'the Actors' Church'.

The entrance to the church is through a small garden at its western end. Outside that entrance on the second Sunday morning in October, there's always a remarkable sight. A large group of Pearly Kings and Queens come together from all over London for the Harvest Festival service in the church. They, too, have a long and close association with Covent Garden. And some of their predecessors appear in *Pygmalion* and *My Fair Lady* too.

The reason is that the Pearly tradition started among the costermongers – the original barrow boys – of London's fruit and vegetable markets. An orphan called Henry Croft, who worked as a sweeper in the markets in the 1870s, adopted a fashion among the costermongers and took it to new extremes. The flash boys sewed smoke pearl buttons down the seams of their bell-bottom trousers and on their jackets, waistcoats and caps. Henry used the same smoke pearl buttons but he didn't limit himself to the seams; he smothered his clothes in them. But not because he wanted to show off. Henry had also noticed a very attractive characteristic among the costermongers: they looked after anyone in their community who was ill or fell on hard times. Henry wanted to raise money to do good too. He thought that people would notice him if he wore a suit that was covered in smoke pearl buttons and that they'd be more likely to open their wallets and purses. And he was right. Soon he became well known for his charity work.

Henry's friends among the costermongers decided to follow his example and raise money for charity in the same way. Before long, there were twenty-eight Pearly families. It was all very territorial. Each London borough had a family and there was one for Westminster and one for the City too. And it's not only the tradition of the smoke pearl buttons which lives on. 21st-century Pearly Kings and Queens may not be pushing barrows round Covent Garden but they do still spend a huge amount of time raising money for good causes. 8

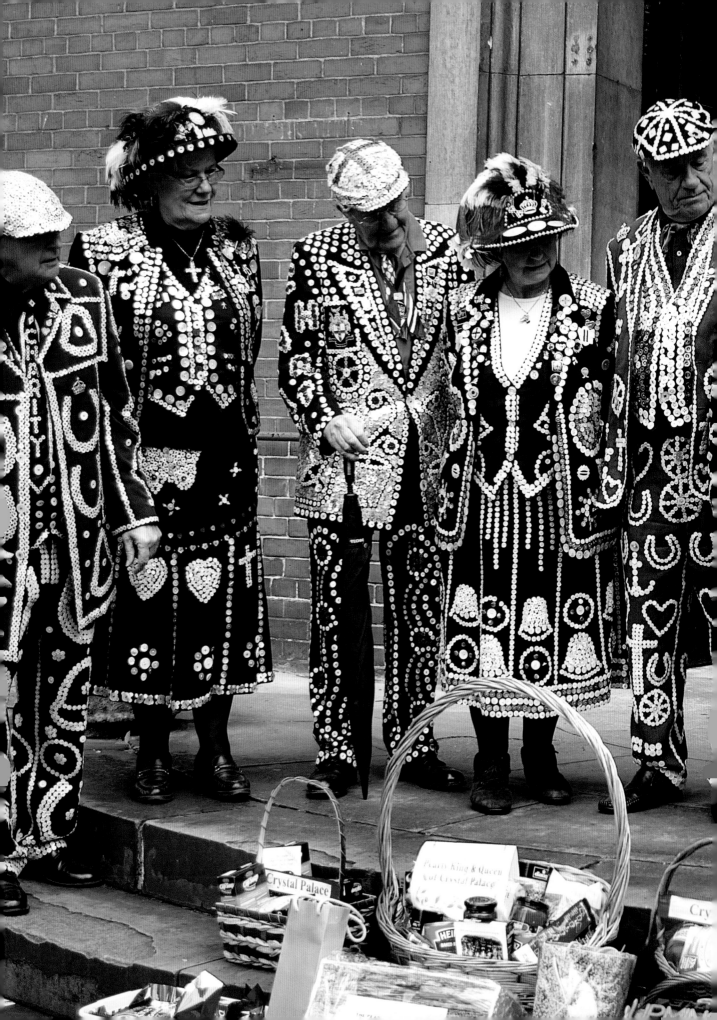

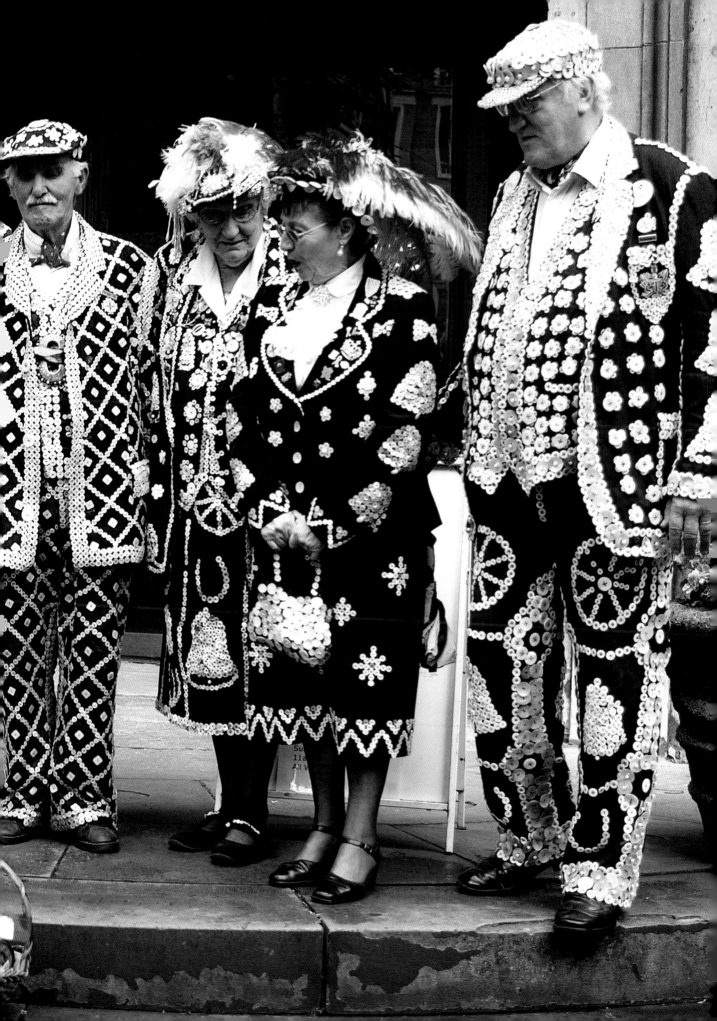

Street London

WHEN YOU WALK round some parts of London, you know what you're likely to come across. In Covent Garden, for example, you're almost sure to see some really professional street entertainers in front of the Actors' Church there. The only question is what kind of act will be on when you arrive. And all round the rest of the marketplace, there'll be buskers, living statues, jugglers and other performers. Covent Garden's not the only place like that. Down on the South Bank near the London Eye, it's exactly the same scene.

London's got some really talented street entertainers. There are some amazing street artists working here too, some of them with big international reputations. Where in London do you go to see street art? Your best bet is Shoreditch. Not much of it survives for very long because it's always being painted over but there's lots around if you're prepared to spend time walking the streets looking for it.

I'm often asked: 'How do you find out about all the things that you photograph?' Quite a lot of the pictures in this chapter are the result of reading *Time Out* and keeping track of various London 'What's On' lists and Twitter feeds. This is how I heard about the concert by Strange Fruit United Bellringers at Canary Wharf, the Royal Ballet on the big screen in Trafalgar Square and the Michael Jackson tribute flashmob in Liverpool Street. It's hard to say how I got to know about things like the 'I'm Yours, Play Me' pianos and the Elephant Parade which appear in this chapter too. Maybe someone mentioned them to me or I read about them in the paper or I just happened to spot them on my travels.

The demonstrations related to the meeting of the G20 leaders in London and the Occupy protest certainly did get extensive coverage in the newspapers. As far as Occupy was

concerned, I could pick my day to go down and photograph the camp in front of St Paul's Cathedral because, famously, it was there for several months. The Put People First demonstration took place at a specified time on a particular day and followed a set route. What I had to do was to work out where to station myself to get the best photographs. For the G20 Financial Fools' Day protest outside the Bank of England, it was easy deciding where to go. As you'll read below, the problem was getting away from it.

It's very rewarding when you're out with a camera and, quite unexpectedly, you stumble across somebody or something that you know at once will make a great photograph. Examples in this chapter are the environmental campaigners, called dirtybeach.TV, whom I came across building sand sculptures at low tide under the Oxo Tower, a graffiti artist spraying a wall in Haringey and a lady with a stall in Portobello Market, who happened, just for a few seconds, to be perfectly framed by the silverware that she was selling.

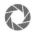 **TAKING THE PICTURES** at the
Michael Jackson tribute flashmob

Michael Jackson died on 25 June 2009.
It was early morning London time. Word
began to spread during the day that there
was going to be a spontaneous Moonwalk
flashmob in his memory that evening.
Around that time, there was a very popular
TV commercial for T-Mobile which featured
a huge crowd of people line-dancing in the
concourse of Liverpool Street Station. And
so Liverpool Street Station was fixed as
the venue for the Michael Jackson tribute.
I decided that I had to head down there with
my camera.

Just as I got to Liverpool Street, the
City police looked at the number of Michael
Jackson fans who were already in the
station concourse. And at the problems that
the regular Friday night commuters were
having getting past them to their trains.
'This won't do,' they said, and announced
that the flashmob was cancelled. I don't
know if they expected some trouble after
that but, to the credit of the hundreds of
Michael Jackson fans who'd come to
celebrate his life, there was absolutely
none. All the same, they weren't just going
to head off home quietly either. Word
spread that we should move out into the
street. And that's what happened. Liverpool
Street became a seething mass of people
raving away to Michael's hits relayed over
an improvised network of different sound-
systems that suddenly materialised from
nowhere. And the police stood around on
the outside of this happy crowd, apparently
perfectly content to let it all happen. Some
of them even looked as though they were
enjoying themselves.

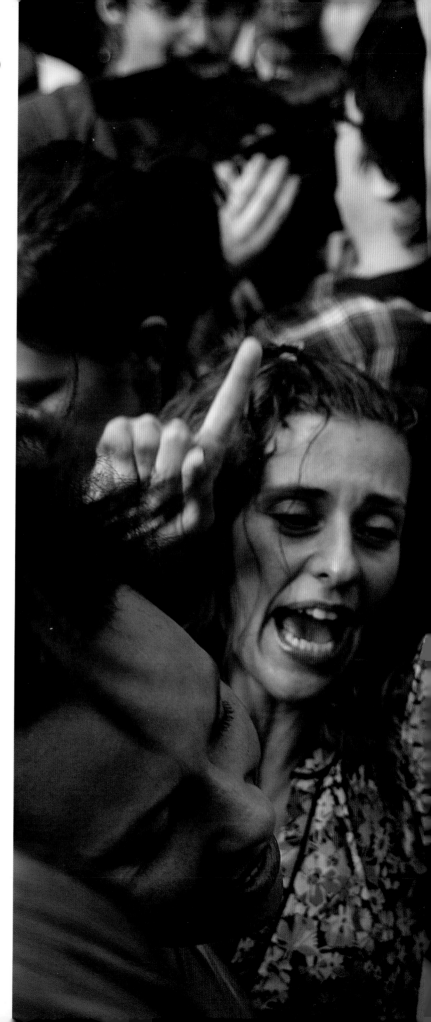

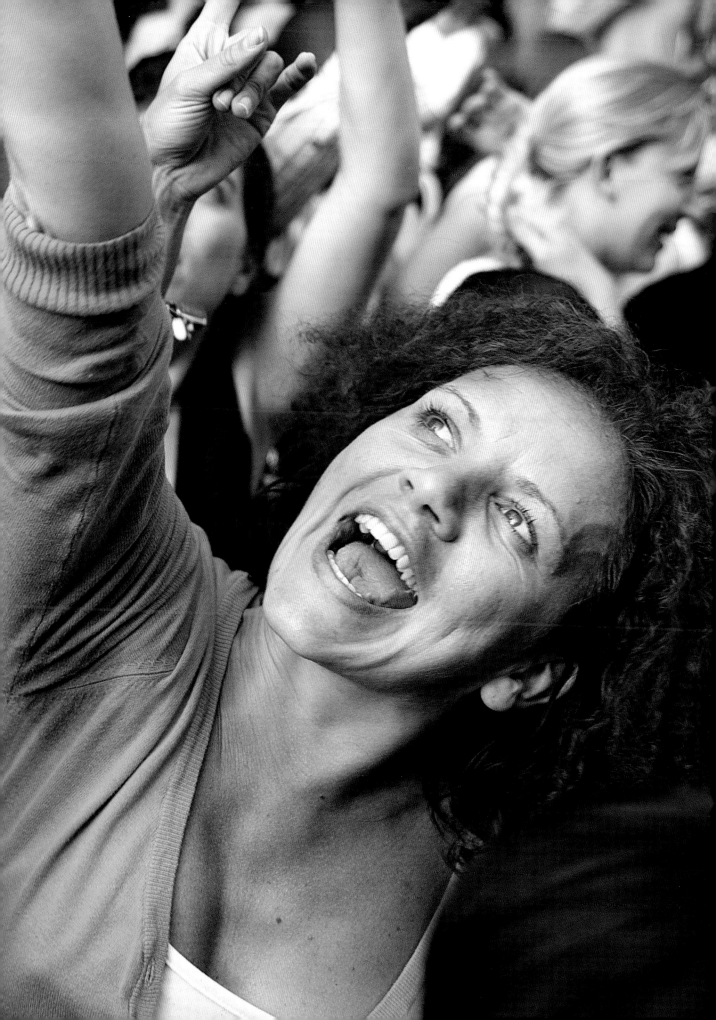

POLE ACROBAT, COVENT GARDEN

This is Rueben DotDotDot, who also performs under the name Reuben Kuan. The pole that he's balancing on is 15 feet high. It's being kept vertical only by the straps that you can see and these are being held by four nervous men dragged out of the audience as 'volunteers' by Reuben a short while earlier. He's balancing on one hand and holding his bowler hat in the other.

And he's swivelling round, talking as he goes into the mini-microphone taped to his cheek. Below him are the very hard cobbles of the Covent Garden piazza. You won't be surprised to hear that a big crowd of people have stopped to watch this spectacular act, gathered all round the piazza and on the balcony above.

Reuben combines street entertaining all over the world – he spends a good bit of the year in Australia – with private shows (sometimes for big corporates) and appearances for some of the best-known circus names. He was in Cirque du Soleil's *Saltimbanco* show. **7**

ACROBATS, SOUTH BANK

The London Eye is one of our biggest tourist attractions. During the summer months, the crowds round it are so large that it's hard to get along the South Bank. And as you go east from the Eye, you often still run into big groups of people blocking the path. What they're doing is clustering round the entertainers who perform here. This, along with Covent Garden, is one of the places where the biggest audiences – and the biggest purses – are likely to be. And so the acts queue up to put on their shows.

They follow in quick succession, one after another. But they never have a ready-made audience because, when an act finishes, it passes round the hat and the large crowd which was watching it disperses in seconds. So quite a bit of time has to be spent attracting the audience at the start of each new show. The main showman for the act launches into his patter but he wouldn't be heard over the general din if his voice wasn't amplified and he has to have a tiny wireless microphone taped to his cheek. This stays attached to him for the next half-hour while he's going through his break-dance routine or forming part of a human pyramid or whatever else his act is. It's worth putting a quid or two in the hat, isn't it, for a guy who can crack jokes while spinning round on one arm or doing a hand-stand on top of two other men's heads? **11**

ARTIST PAINTING MILLENNIUM BRIDGE, SOUTH BANK

Johnny Morant is a figurative artist who spends a lot of his time outdoors in London painting the built environment. He focuses on patterns and structures defined by shadows, reflections and contrasts. It's obvious, therefore, why this scene appealed to him. The Millennium Bridge offered intriguing pattern and structure. And the trees on the South Bank, the Thames and St Paul's in the background provided plenty of shadows and contrasts. 16

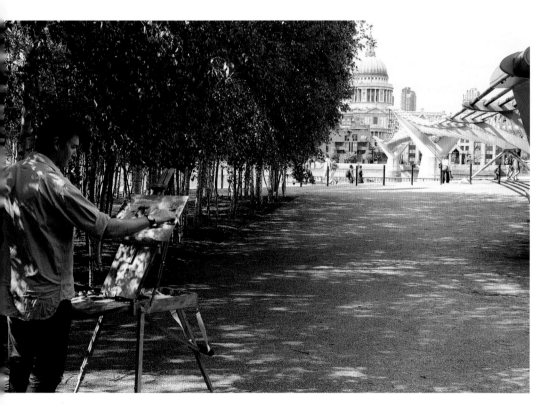

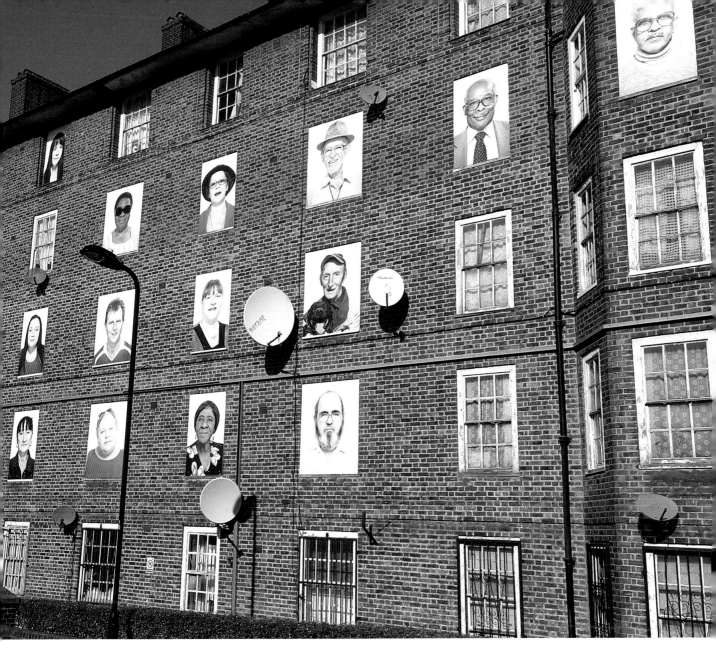

I AM HERE ART PROJECT, HACKNEY

It's hard to think of a public art project which makes a bigger visual impact than this one. The building is Samuel House, on Regent's Canal. So everyone who goes along the busy towpath between Kingsland Road and Victoria Park sees it. And you can't help noticing those giant photographic portraits in the windows. So what's the story behind it?

Well, Samuel House is on the troubled Haggerston and Kingsland Estate, which had been falling apart since the early 1980s. Very little repair or maintenance had been done and a lot of the flats had been left empty. No new tenants had been accepted since 2004. Instead, flats had been boarded up. In 2007, more than 70% of the people living on the estate voted in favour of knocking down the current buildings and putting up new ones on the same site. A massive wholesale redevelopment of this kind was eventually agreed on. As part of this, all the current residents would be offered a flat in the new buildings and, while the construction work was going on, they'd be rehoused somewhere else.

Suddenly, in 2007, bright orange boards were fitted over the windows of the empty flats on the estate. These ugly blotches made it seem even more run-down. At this point, a group of artists stepped in. Some of them lived on the estate and had heard people passing on the Regent's Canal towpath commenting on its decayed condition. Their plan was simple and beautiful. Replace the horrible orange boards with huge photographs of people from the estate. A lot of the people who are featured in the pictures are still living there but some of them have moved on. The effect is the same, though. To remind anyone going past that this is more than just a building; that this is home to a large community of people. And to raise a broader question, too. How much account do we take of the social issues when we come up with plans for the demolition of large-scale residential property in inner-city areas? ⑩

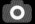 BEING THERE WITH A CAMERA ... at the G20 Protest

Do you remember this demo? It was very violent and a lot of damage was done, especially to RBS's branch near the Bank of England. And it was at this protest that Ian Tomlinson died after being pushed to the ground by a policeman.

We need to put it in context. It happened in April 2009. So the global financial crisis was still very fresh in the memory. The UK Government had bailed out several banks, including RBS. Bankers were being blamed all over the world for the economic problems that were affecting everyone. The City was seen as the place where a lot of the evil had been done. And now the leaders of the G20 nations were meeting in London.

The protest started peacefully enough. Everyone seemed to be up for a good time. There was a lot of joking as we walked down Moorgate and into Princes Street. The good mood continued for a while in front of the Bank of England. But soon this space began to get very crowded. And new people, who'd obviously come to stir things up, began to arrive. I noticed that the Bank of England's parapet above us was full of police, who were filming and photographing everyone in the crowd. Some of the troublemakers were obviously prepared for this because they were wearing hoodies and had their faces covered by scarves.

The chanting, which had been going on all day, began to get more aggressive. And, in places, the crowd was so dense that it was very hard to move through it. I reckoned that I'd taken enough photographs and that it was time to leave. But when I went back to Princes Street, I found lines of policemen three deep and was told that I couldn't get out that way. Try Threadneedle Street, they said.

But I found, after twenty minutes of fighting my way there, that the crowd was at its thickest in that direction. And when I finally reached the policemen stationed in Threadneedle Street, I realised that I'd got myself into a really dangerous situation. The protesters at the front here were constantly surging forward against the rows of police, who were carrying riot gear and wielding batons. And the police were pushing back against the crowd, making people stumble and fall. There was a lot of swearing and yelling. This was the place where Ian Tomlinson would be pushed over that evening. It was obvious that I had to get back out of there as quickly as possible.

My best bet, I thought, might be Lombard Street. Once again, though, I found three lines of policemen blocking my way. I asked a sergeant if I could get past, please. No, he said.

No one's leaving. I said that I'd just been there to photograph the protest but he was unmoved. His orders were to let no one through. So I found myself kettled.

I was there about an hour more. A large group of people formed, all wanting to leave. In that time, two people approached the same sergeant and said that they worked in a bank 50 yards down the road. They said that they'd just come out in their lunch break and they'd like to go back to work. He asked them why they weren't dressed in suits like proper City workers and they said that they'd been advised by the police not to wear suits today. No go, he said. If you came in, you stayed in. One woman did get out: on a stretcher, because she fainted.

Eventually, a timid girl of about eighteen spoke to the sergeant. She said that she was an art student who'd been given the assignment of photographing the protest. She'd finished. Please could she leave? Amazingly, he said yes. I jumped in at once. That, I said, was my case exactly. Couldn't I leave too? Slowly, reluctantly, he nodded. I didn't need any more encouragement. I was lucky. Everyone else was there for five more hours.

OCCUPY PROTEST, ST PAUL'S CATHEDRAL

The Occupy protest was not meant to be outside St Paul's Cathedral. What the protesters had really wanted to do was set up camp facing the Stock Exchange in Paternoster Square. But the authorities had got wind of their plans and the police had sealed off the square. As it happens, St Paul's is right next to Paternoster Square. Nobody stopped the protesters from pitching their tents in front of the cathedral and so, almost by default really, that's where, in October 2011, everything kicked off. This chance was to cause problems for the Church.

The campers got a boost to start with when a Canon of St Paul's, the Reverend Giles Fraser, announced from the cathedral's steps that he was happy for people to 'exercise their right to protest peacefully'. But not everyone in the Church agreed. Six days later, the Dean closed the cathedral and asked the protesters to leave. They said that they wouldn't go without a court order and five days after that, the Dean announced that the cathedral would reopen. The next day, Giles Fraser resigned, saying that he thought there could be violence in the name of the Church. A few days later the Dean resigned as well, shocked by the reaction to the Chapter's decision to evict the protesters by force if necessary.

It took a while for the legal wheels to turn but, when they did, eviction orders started to appear. One by one, the movement was thrown out of all the sites that they'd gradually occupied in and around the City. The camp in front of St Paul's was eventually cleared on 28 February 2012.

What exactly were they protesting against? Well, one of their problems was that there wasn't a single clear message that the public at large could grasp. When I went to take photographs, I spent some time at the St Paul's camp and came away quite confused because each person I spoke to told me something different. But over the period of the camp, the main causes that they were fighting for seemed to boil down to these: the lack of affordable housing; social injustice; corporate greed; and the undue influence of corporates and lobbyists on government. **1**

PUT PEOPLE FIRST DEMONSTRATION, VICTORIA EMBANKMENT

The G20 meeting in London just before Easter 2009 prompted not only the violent protests outside the Bank of England where I was kettled, and which I've written about above, but also an entirely peaceful demonstration named 'Put People First'. As I said, the backdrop to that G20 meeting was the recent global financial meltdown. According to the organisers of 'Put People First', this showed that the world had been following a dodgy financial model. The economy it had created was fuelled by ever-increasing levels of debt. Even before the banking collapse, they said, the world was faced with poverty, inequality and (adding a rather different topic) the threat of climate chaos. Three key things were needed: fair distribution of wealth, decent jobs for all, and low carbon emissions. So they encouraged Londoners to take to the streets and say all this as loudly as possible ahead of the G20 Summit. They hoped that their demo would challenge the G20 leaders to 'put people first' in their plans for the future.

The result was an impressive turnout and an unusually varied and colourful array of banners, placards and flags. **5**

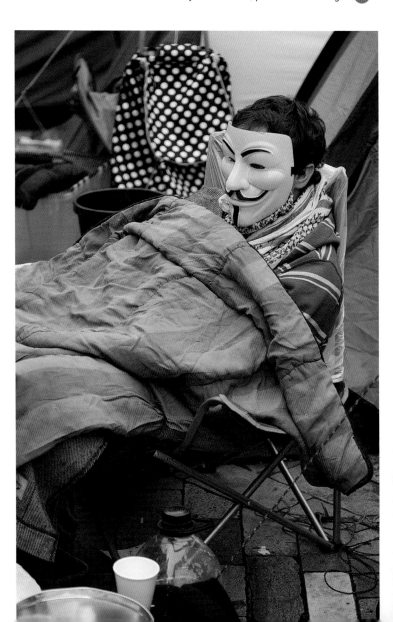

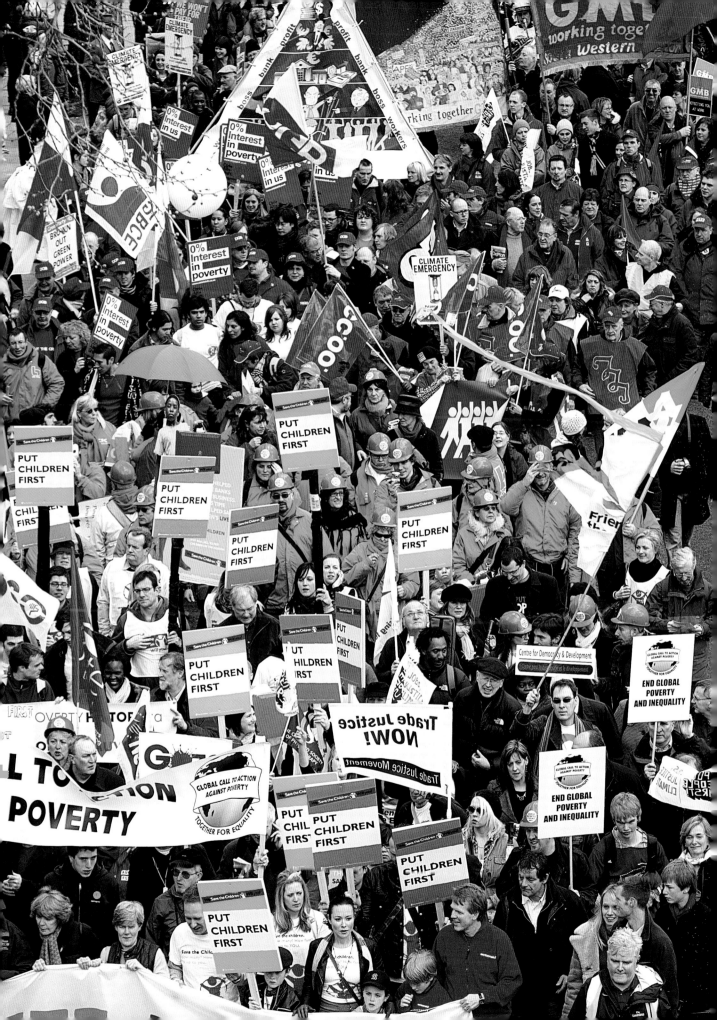

London Underground managed to get the law changed in 2001 to make licensed busking legal. That opened the way for the Tube's highly successful scheme.

Musicians have to audition to get licences and auditions only take place occasionally. There were some in 2010 and then again in the spring of 2013. The panel of judges consists of music industry professionals, people from London's music scene and Transport for London staff. Any kind of musician is welcome to apply. Pop, classical, folk, world music, anything.

In the spring of 2013 there were thirty-seven busking pitches in twenty-five different stations. The licensed buskers – about two hundred of them are active – get shifts at these pitches. And the audience? Well, four million people use the Tube every day.

John Albert's favourite pitch is at Bank station. A couple of record producers passed him there regularly and liked his music so much that they and some other commuters pressured him into making a CD. It's called *Blue Notes from Underground* and it includes *Georgie* by Willie Nelson, *Whiskey* by Champion Jack Dupree, *Stormy Monday* by T-Bone Walker and some of John's own original tracks.

Another Tube busker, Duncan Kane, was chosen to be one of the artists to perform at the BAFTA Awards ceremony in 2006. He played film themes.

Every year there's a search for London's newest busking star. In 2013 it was launched by the Mayor and the singer Misha B. The finalists, who were chosen by industry judges and a public vote, went head-to-head at a concert in Westfield. And the eventual winner got a whole lot of amazing things, including a year's busking licence, recording sessions at a professional studio, a year's course at The Institute of Contemporary Music Performance, coaching from chart-topping songwriters and some music equipment.

Busking
Pitch
Number
1

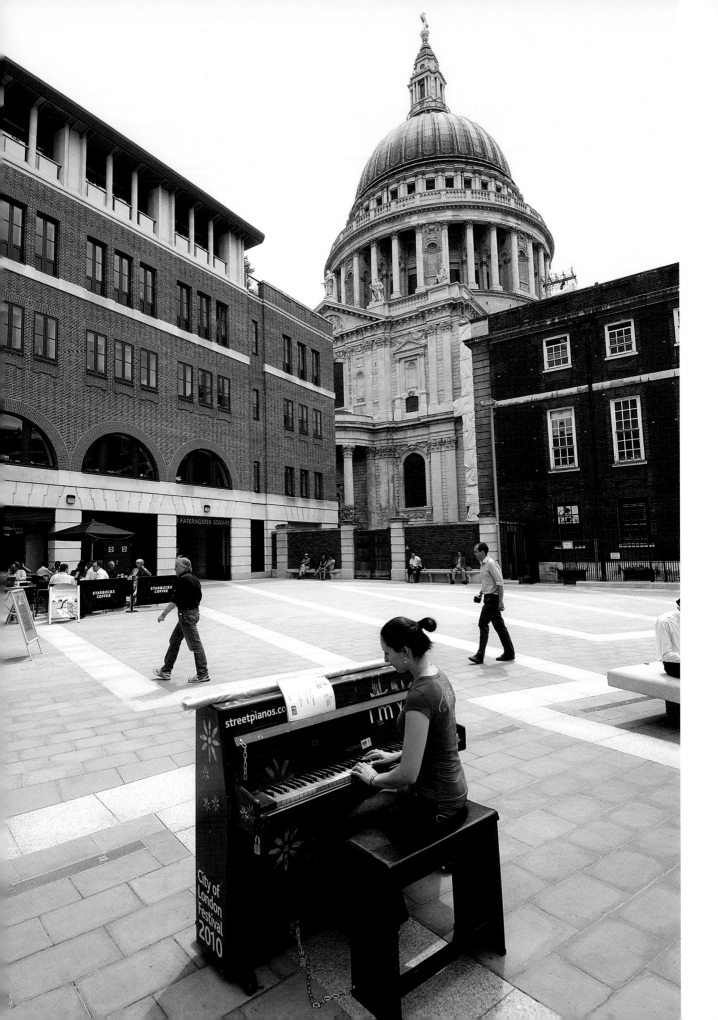

CHINESE MUSICIAN, COVENT GARDEN

This guy hasn't just turned up on a street corner with a flute to play some tunes and earn a few bob. To start with, he's in one of the piazzas at Covent Garden, which is quite a schlep from the nearest parking place. His gear includes a Chinese instrument called a *yang qin*, which is big and heavy enough on its own. But he has brought along a chunky carved wooden stand for it, an amp and a monster speaker too. Oh, and he wants to sell some of his CDs, so he's got a case of them as well. You can't trust the English weather, of course. Add a café-style umbrella to the list, as well as the stand to put that on. It takes two trolleys to move all this stuff from wherever he did park his car to his pitch in the piazza. You can see one of them by his leg and the other behind him. It's got a stack of cases on it and it's next to another stack of the cases that he needs to protect everything from damage in transit. It must take him half the day to get himself set up. You've got to give him ten out of ten for grit and determination.

High marks for musicianship too. The *yang qin* is not straightforward to play. Its closest Western cousins are the dulcimer and zither but I don't suppose that you've been to any dulcimer or zither gigs recently so that won't help you much. A *yang qin*'s strung with sets of strings (between seven and eighteen – they vary in size) on four or five bridges. And you strike these strings with bamboo beaters which have leather or rubber heads. You can see our guy doing that. The instrument found its way to south coastal China in the 17th century as a result of trade with the Middle East. It has a Persian cousin called a *santur*, which I found being played at the Bahá'í Naw Ruz celebration in west Wimbledon that features in the Faith in London chapter. **7**

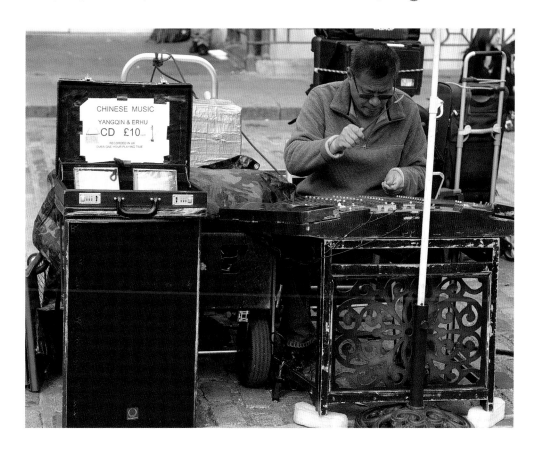

PLAY ME, I'M YOURS PIANO, ST PAUL'S

City workers – and, in fact, people in other parts of London – have got used now to seeing pianos stuck out in the street carrying notices saying 'Play Me, I'm Yours'. There are piano stools and laminated sheet music too, so that there's nothing to stop any passer-by from sitting down and hammering out a tune. Except, of course, that most people are too bashful. Or at least they certainly were when the pianos first appeared as part of the City of London's 2009 Festival. When the pianos came back year after year, people became less shy. They're popular on fine summer evenings and – odd this – the ones stationed near pubs tend to get more use than the ones in churchyards.

The people banging out *Maybe It's Because I'm a Londoner* on these pianos might be surprised to hear this, but they're actually an artwork by a UK artist called Luke Jerram. The first of his pianos was installed in 2008 and he says that over seven hundred of them have now appeared in thirty cities round the world. He reckons that more than two million people have played them. **1**

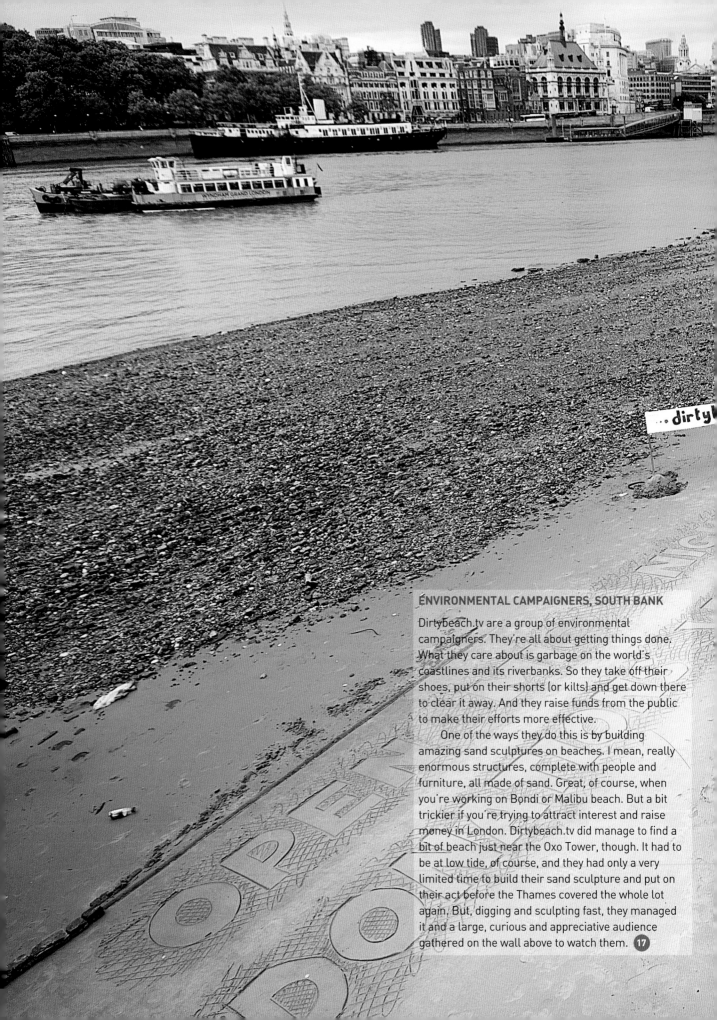

...dirty

ENVIRONMENTAL CAMPAIGNERS, SOUTH BANK

Dirtybeach.tv are a group of environmental campaigners. They're all about getting things done. What they care about is garbage on the world's coastlines and its riverbanks. So they take off their shoes, put on their shorts (or kilts) and get down there to clear it away. And they raise funds from the public to make their efforts more effective.

One of the ways they do this is by building amazing sand sculptures on beaches. I mean, really enormous structures, complete with people and furniture, all made of sand. Great, of course, when you're working on Bondi or Malibu beach. But a bit trickier if you're trying to attract interest and raise money in London. Dirtybeach.tv did manage to find a bit of beach just near the Oxo Tower, though. It had to be at low tide, of course, and they had only a very limited time to build their sand sculpture and put on their act before the Thames covered the whole lot again. But, digging and sculpting fast, they managed it and a large, curious and appreciative audience gathered on the wall above to watch them. **17**

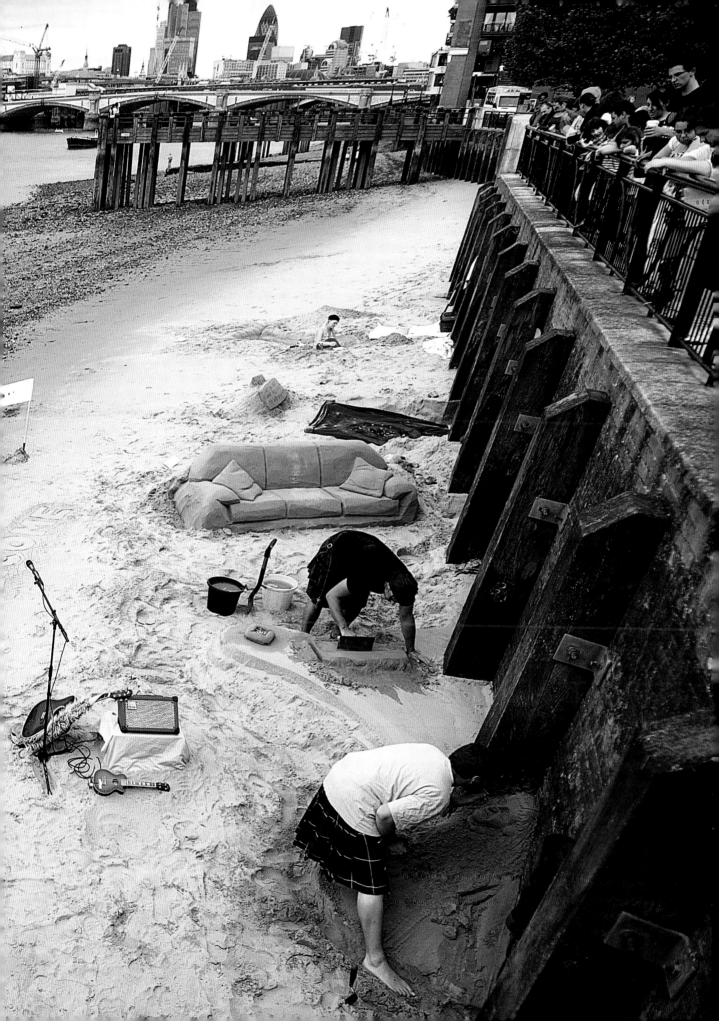

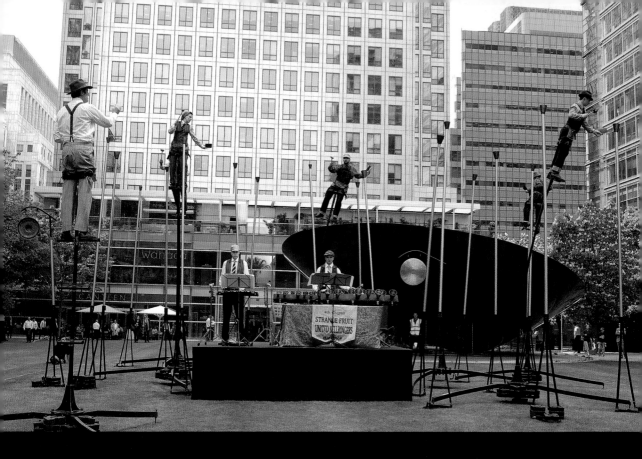

BELLRINGERS, CANARY WHARF

You need a bit of an explanation to understand what's going on in these photographs. First of all, where are we? Answer: Canada Square Gardens in Canary Wharf. That's why there are all those big office blocks. Next, who are the people up those masts? Well, they're called the Strange Fruit United Bellringers.

The guy wearing the braces up the mast on the left is their conductor. The only members of the group who stay on the ground are the keyboard player and the percussionist in the middle. Everybody else is up a mast. The masts have springs at their bases and the musicians can make them sway around by leaning this way and that. You can see some lighter-coloured

poles too. These have bells on their tops. The bellringers make their masts sway between these poles and, as they get near them, they strike the bells with the hammers that they hold. Some of the musicians have small handbells too.

As you can see, the musicians curve their bodies like dancers as they move between the poles, striking the bells. So their performance is not only a concert of unusual and beautiful music played on bells and keyboard. It's also an aeria ballet. They call the show 'Ringing the Changes'. On the day whe I was there, it attracted a large crowd of lunchtime office worke who started out being a bit perplexed by the unconventional arrangements but ending up being enchanted. **8**

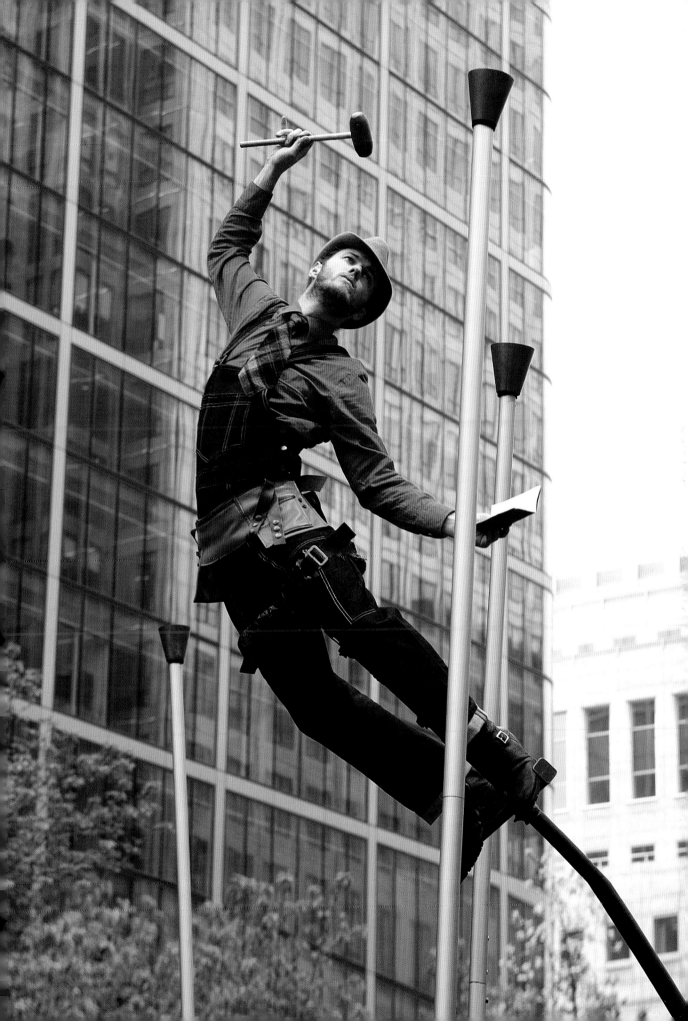

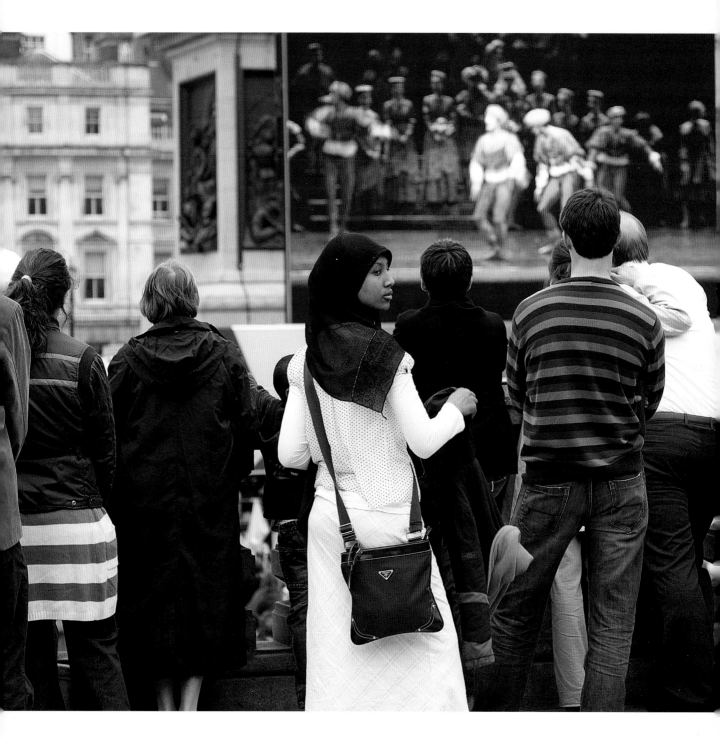

ROYAL BALLET IN TRAFALGAR SQUARE

You don't have to splash big bucks to see the Royal Ballet perform at Covent Garden. Or to see operas there, for that matter. In fact, you don't have to put your hand in your pocket at all. All you have to do is get down to Trafalgar Square on one of the afternoons when they're relaying a performance to the big screen there. And hope for fine weather. Arrive early because a lot of other people will have had the same idea. And take a cushion. Those ballets and operas go on a long time and you've got to sit on the paving stones. You can make it a kind of Londoners' Glyndebourne and take along a picnic.

But keep it on your blanket or in your lap. Fold-up chairs and tables are verboten. Here's the good news, though: you're allowed as much booze as you like, although the rule is that you can't take it outside the square.

The other things that are banned are barbecues (understandable) and dogs (well, they bark, don't they). And don't imagine that you might get carried away by the heavenly music and, in your rapture, jump into the famous Trafalgar Square fountains. They're turned off for the afternoon. 12

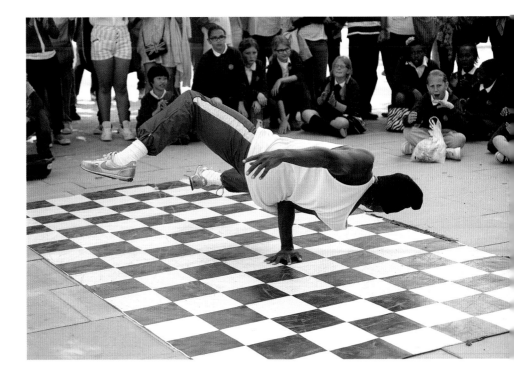

BREAK-DANCER, SOUTH BANK

These four guys might not have been as polished as most of the acts performing on the pitch next to the London Eye but they were cooler than any of them. Their music came from an object which looked suspiciously like a ghetto-blaster and which they simply stuck on the ground behind the pitch. Then, without any announcement of any sort, they launched into their break-dancing routines. Each of them had short bursts that they'd worked out for themselves and then sometimes they'd pair up too. The schoolkids in the crowd were completely awestruck by it all. **11**

SILVER SHOP, PORTOBELLO ROAD

Here's some news to shock you. The antiques market in Portobello Road is no more antique than, allegedly, some of the antiques on sale there. (Please don't anybody bother to sue me.) Although the stallholders would love the tourists who flock to the market to think that this was part of the quaint old London scene, dealers really only started moving to Portobello Road in any numbers when the Caledonian Market was closed in 1948. Its history before that was nothing much to be proud of. The main players for many years were gypsy horse-traders. A battle rumbled on for a long time between the street traders, local shopkeepers and the authorities about the size of the market. That was probably standard stuff for a lot of London's street markets in those days and I don't suppose that Portobello was very different from many others, except, possibly, that it was in a more run-down part of town. Notting Hill used to be a seriously scruffy place. Portobello Market, like the area generally, has made a lot of itself, considering its humble beginnings. **6**

ELEPHANT PARADE, NEAR LONDON BRIDGE

Londoners had got used to seeing painted cows round town some time earlier in the 2000 Cow Parade. So, in concept at least, the Elephant Parade in the summer of 2010 wasn't a surprise. But still, having baby elephants suddenly popping up everywhere caused quite a stir, especially since a lot of them were decorated in bright colours.

There were 260 of them and they were scattered all over central London. Each one was designed by someone different and the range of people who had a hand in the designs was amazing. There were artists with big international reputations and a primary school in Hackney; there were fashion and jewellery designers with household names and tribal artists who are virtually unknown. The result was that the elephants looked incredibly different. You could really appreciate this when they were all herded together at the end of the summer and auctioned for charity. An impressive £4.1 million was raised. The bulk of this went to Elephant Family, a charity which is trying to save the Asian elephant from extinction in the wild. **15**

 TAKING THE PICTURES of a graffiti artist

I stumbled across this guy while doing the Parkland Walk, which runs up a disused railway line from Finsbury Park to Alexandra Palace. It's tree-lined most of the way and overgrown. You can easily forget that you're passing through the north London suburbs. Although it's popular with walkers, joggers and cyclists, there are often stretches when you have the walk all to yourself. Ideal, then, if you want to express yourself with spray paint on one of the bridges over the old track.

I don't think that he heard me coming because he jumped when I said 'Hi' and almost dropped his spray can.

And when I asked if I could take his picture while he sprayed the wall, he said,

'You gotta be joking.'

I pointed out that if he kept his hood up and used his left arm to spray, no one would have any idea who he was.

He said, 'But I'm right-handed.'

I said, 'It's only for a picture. Just hold up the can. You don't actually have to spray. It won't take a moment.'

He said, 'Be quick then.'

And five seconds later, I was on my way.

ABOVE STREET ART BY PHLEGM, SHEPHERD'S BUSH 20

BELOW STREET ART BY ROA, OLD STREET 2

OPPOSITE, ABOVE STREET ART BY ARYZ, OLD STREET 2

OPPOSITE, BELOW STREET ART BY BEN SLOW, OLD STREET 2

London Surprises

THIS CHAPTER is a bit of a hotchpotch. A mixture of things. It could have had lots of different titles but I decided to call it 'London Surprises' and here's the reason why. I've spent a lot of time in the last five years looking for interesting people I could photograph to illustrate the main themes of this book. Tribal London, religion in the city, racial and ethnic diversity and so on. Every now and then, though, I came across something – an event, a place, a tradition – which didn't fit into any of those themes but which was too good to leave out. Even though I was born in London and have lived here nearly all my life, almost all of those things came as a surprise to me. And my guess is that the same will be true for most people who read this book.

Did you know, for instance, that there's an annual church service for clowns in Dalston, which they all attend in their costumes, face paint and so on? That there's a working farm, complete with real fields and grazing animals, overlooked by the office blocks of Canary Wharf? Or that there used to be a prostitutes' graveyard near Borough Tube Station, which is now commemorated with a brass plaque on a gate festooned with ribbons, dead flowers, feathers, cheap jewellery and rag dolls?

Most people have been to Kew Gardens but, sadly, very few by comparison have visited the Chelsea Physic Garden. It's older than Kew, a short walk from Sloane Square and a lovely experience. Everyone knows Greenwich but only a relatively small number of people have looked at the Naval College and the Royal Observatory from across the river at Island Gardens. It's the same fantastic view that Canaletto painted. And I'm prepared to bet that most of you haven't been on the roll-on, roll-off ferry operating a bit further down the river at Woolwich.

Do you like going to the beach? Then have you checked out the one at the Chalk Farm Roundhouse in recent summers? The only snag is that there's nowhere to swim. But you can swim every day of the

year in Hyde Park's Serpentine Lido. If you want to compete for the Peter Pan Swimming Cup on Christmas Day, though, you have to be a member of the Serpentine Swimming Club.

There was a working windmill in London as recently as 1934. Any idea where it was? The answer's Brixton. It's been restored, complete with sails, and you can go and see it, just off Brixton Hill, near the jail. What about a galleried coaching inn? The only one left in London? Well, it's off Borough High Street but it's not easy to find because it's down a nondescript alley.

It used to be normal practice for parishes everywhere to beat their boundaries once a year. In other words, for a party of people to go round and literally beat the boundary stones with sticks. The Church of All Hallows by the Tower, which is right next to the Tower of London, still follows this tradition and you can walk round with the beating party. But when they go out

onto the Thames by boat – part of their parish boundary runs along the middle of the river – you have to stay on the bank and watch them beating the water from there.

Lots of us have been to the Whispering Gallery in St Paul's Cathedral. Some people go further up from there to get the outside view from the Stone Gallery. But hardly anyone climbs the full 528 steps to the Golden Gallery at the top of the dome, where there's one of the best views in London.

Any idea where Big Ben and the Liberty Bell were cast? If I took you to the shopfront, you wouldn't believe it. It looks like an old-fashioned little place in Whitechapel, close to the East London Mosque. They've been casting bells there since 1738. Behind the modest shopfront there are some substantial workshops where bells are still cast regularly. This is one of only two bell foundries in the whole country.

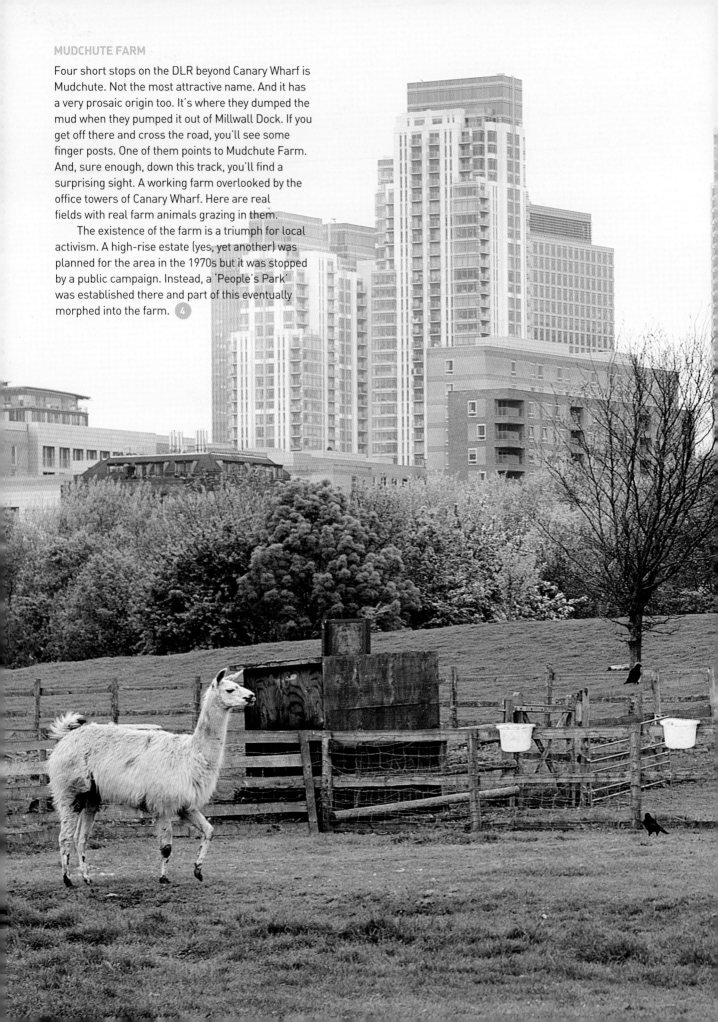

MUDCHUTE FARM

Four short stops on the DLR beyond Canary Wharf is Mudchute. Not the most attractive name. And it has a very prosaic origin too. It's where they dumped the mud when they pumped it out of Millwall Dock. If you get off there and cross the road, you'll see some finger posts. One of them points to Mudchute Farm. And, sure enough, down this track, you'll find a surprising sight. A working farm overlooked by the office towers of Canary Wharf. Here are real fields with real farm animals grazing in them.

The existence of the farm is a triumph for local activism. A high-rise estate (yes, yet another) was planned for the area in the 1970s but it was stopped by a public campaign. Instead, a 'People's Park' was established there and part of this eventually morphed into the farm. 4

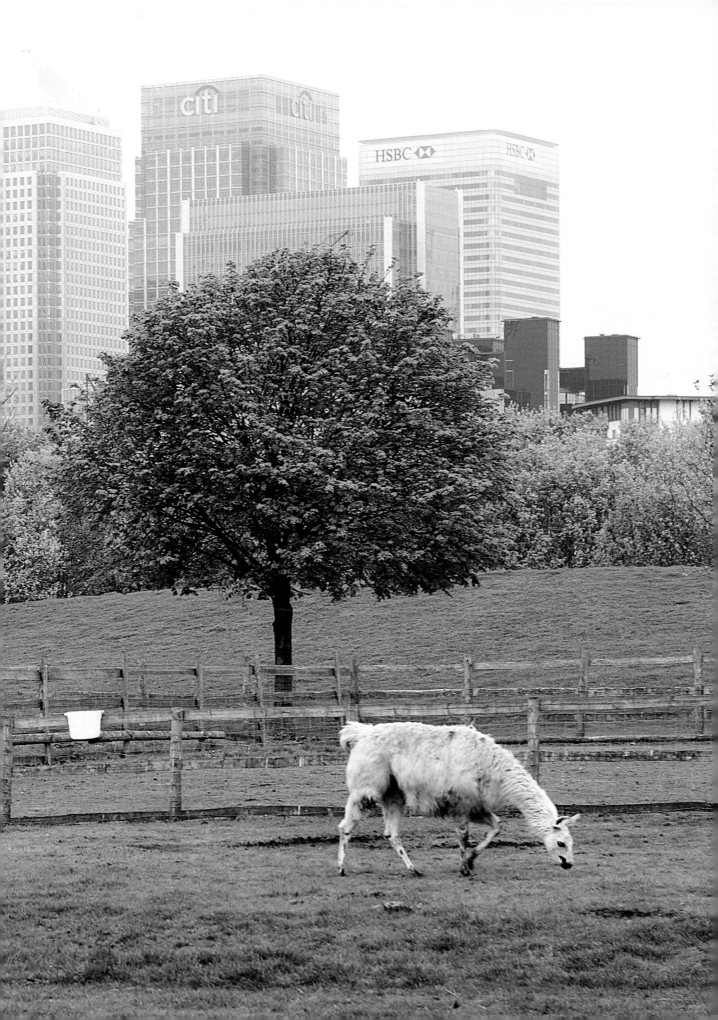

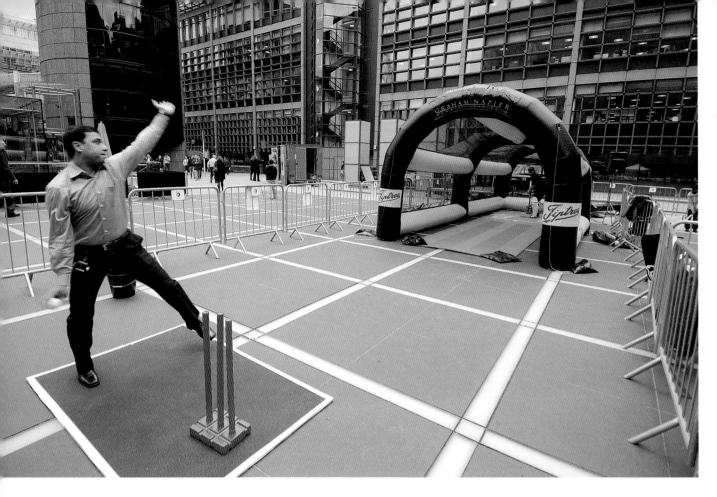

BROADGATE BOWL-OUT, THE CITY

One day in April 2012 the people working at Broadgate in the City found that a cricket net had been set up in the middle of their office blocks. A lot of them came down to find out why. And loads of people who happened to be passing through the square stopped to see what was going on too. What they were told was that they could have a bowl, if they liked. All they had to do was to pay a small sum, which would go to the Benevolent Fund for Professional Cricketers.

Who would they be bowling to? Essex all-rounder Graham Napier, who was just beginning his benefit season with the county side. People who know a bit about the county game might have mumbled an excuse about a dodgy elbow at this point and left. Graham is famous for his 'see ball, hit ball' approach to batting. He once scored 152 not out off 58 balls against Sussex. But either there were very few cricket enthusiasts in Broadgate that day or they fancied their chances anyway. Because Graham batted for the best part of four hours, while bowlers of all shapes and sizes tried to get him out.

What was the prize if someone did actually bowl Graham? Well, he autographed any ball that hit his stumps and you took it away with you. And you also got a presentation pack of Tiptree jams and preserves. (Wilkin, who make Tiptree products, are one of Essex Cricket's main sponsors.) Only a handful of people managed to do it during the whole afternoon. The first one was a ten-year-old boy. Graham was quick to shake his hand, had his photograph taken with him and made him feel 10 feet tall. **7**

CHESS IN BRICK LANE

Brick Lane at lunchtime on Sunday is a bustling, noisy place, especially if it's a fine day. The shops and restaurants are all open and some of them have people standing outside trying to tempt you in. Music's blasting though the doors of clothes shops at the top end of the street. The Sunday morning Sclater Street market hasn't closed yet and people are coming and going along Brick Lane. A steady procession of aimless dawdlers wanders along the street too.

In the middle of all this clamour, on the day when I took this picture, there were five guys sitting in complete silence staring down at the chessboards in front of them. One of them – he's the one in the umbrella hat – was taking on all the other four at the same time, moving up and down along the boards. As far as I could judge by the faces of his opponents, he was on his way to beating all four. **1**

SECOND-HAND BOOKSELLERS, SOUTH BANK

The South Bank has become a top place for a London stroll. It's a decent distance if you walk, say, all the way from Tower Bridge to Westminster Bridge. You get brilliant views and you go past lots of interesting things. The Globe Theatre, Tate Modern, HMS Belfast, the National Theatre, the BFI, the Hayward Gallery, the Festival Hall, the London Eye. And you can be entertained too by living statues, acrobats, jugglers, break-dancers, a traditional merry-go-round and the skateboarders in their graffiti-covered undercroft. Not far from the skateboarders, you can have a nice quiet browse among the lines and lines of second-hand books laid out on tables under the arches of Waterloo Bridge. **13**

? DID YOU KNOW about the prostitutes' burial ground in Borough?

On a rusty iron gate in a nothing street not far from Borough tube station, there's a confusion of ribbons, dead flowers, feathers, cheap jewellery and rag dolls. And a bronze plaque saying that this place, called Cross Bones, was a paupers' burial ground. Over the centuries, many prostitutes were buried here too and that's why people have put those decorations on the gate.

For hundreds of years, this area of Southwark was a pretty wild place. It was actually called the Liberty of the Clink and for a very good reason. You could get away with almost anything here. Many nefarious activities which were forbidden inside the City walls just across the river were allowed in the Liberty. For some of them there was even a system of regulation. So who was actually in charge then? Well, from the 12th to the 17th century, an unlikely lord of the manor, namely the Bishop of Winchester.

Shakespeare's time was typical. Along this stretch of the South Bank, taverns and brothels were crowded together. And of course, there were bear pits and theatres too, famously including the Globe. The brothels were called 'stews' and they were licensed by the bishop under ordinances dating as far back as 1161. The nickname for the licensed prostitutes in these places was 'Winchester Geese'. Once these women died, though, the Church wanted nothing more to do with them. They weren't even allowed a Christian burial. Instead, their graveyard was an unconsecrated plot of land as far as possible from the parish church, which was given the name 'the Single Women's Churchyard'.

This sad plot is what's commemorated today by the pathetic trinkets on the rusty iron gate.

BUNHILL FIELDS, THE CITY

There are two entrances to Bunhill Fields, one on City Road and the other on Bunhill Row. It's easy to miss both of them, though, and many people don't know about this refuge on the edge of the City. It's quite small. You can walk from one side to the other in a couple of minutes. But, despite that, it's surprisingly peaceful once you're inside. Perhaps because it's an old burial ground, people are more than usually circumspect.

There are a lot of bones under here. It's thought that its name derives from 'bone hill'. This may be because it was used as a burial ground in Saxon times or – and this is easier to verify – because cartloads of human bones were brought here in the mid 16th century to make space for more interments in the St Paul's charnel house. Then, in 1665, when the Plague was killing the inhabitants of the City in large numbers, the Corporation decided to bury the dead here.

All this time, the Church of England had never consecrated the ground. So when, later in the 17th century, the lease was taken over by a private individual and he continued to allow burials on the land, it became popular as a graveyard with Nonconformists. These were people who practised Christianity outside the Church of England, so they actually wanted to be buried in ground that was not consecrated.

There are seventy-five listed graves in Bunhill Fields and well-known figures buried here include William Blake, Daniel Defoe, John Bunyan and Susanna Wesley. The Wesley Chapel is just across City Road. 9

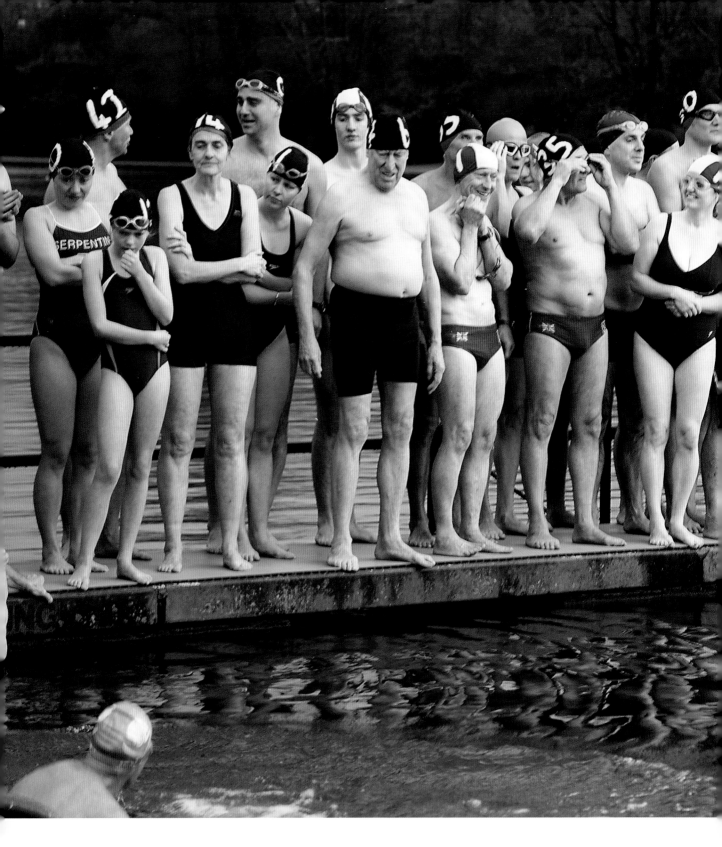

The important things about this photograph are the time and date when it was taken and the place where these swimmers were lined up. It was 9 a.m. on Christmas Day and they were all about to dive into the Serpentine Lido in Hyde Park. Just let that information sink in for a moment. Families with small children may already have been unwrapping presents by then.

But at that time on Christmas morning, most people would have been slowly surfacing and wondering about a leisurely breakfast. Not these members of the Serpentine Swimming Club.

It was a cold morning. I can't remember the exact temperature, but it was cold. And yet you'll notice that there isn't a wetsuit in sight. The Serpentine Swimming Club reckons that wetsuits are

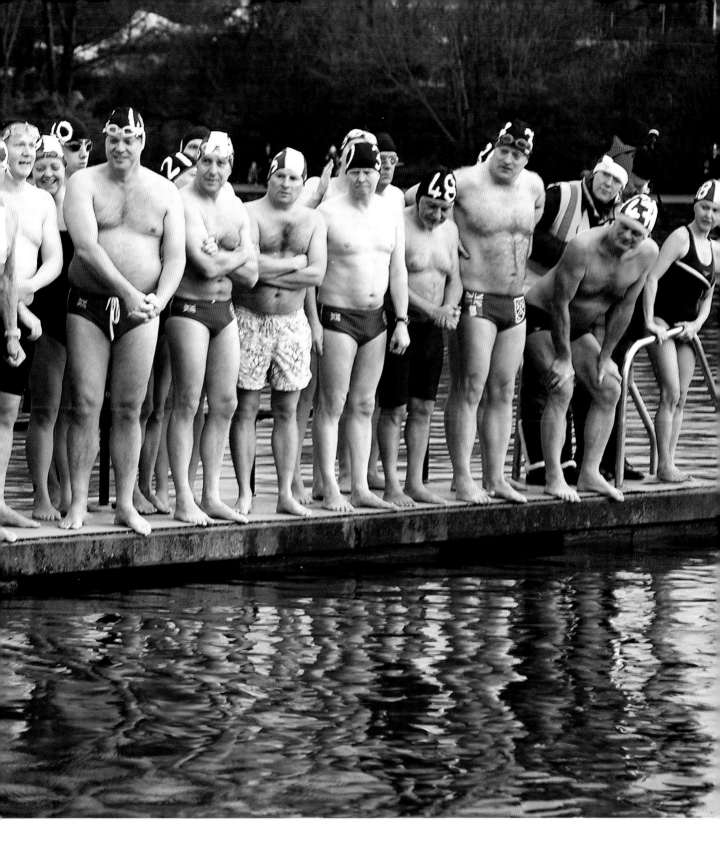

not in the spirit of all-year-round, open-air swimming and so they're not allowed for races. Even if the Lido freezes over and they have to break the ice to compete. Which happens. But, fortunately, it hadn't got to that extreme on the day when I took this picture, so everyone could dive straight in.

They were competing for the Peter Pan Cup. This is a 100-yard handicap race and it has taken place every Christmas morning since 1864. Whatever the weather. And whatever else is going on, in fact. Neither the First nor the Second World War was allowed to get in the way. You have to be a member of the club to take part and you also have to have swum in enough races in the year to be in the official handicap system. 14

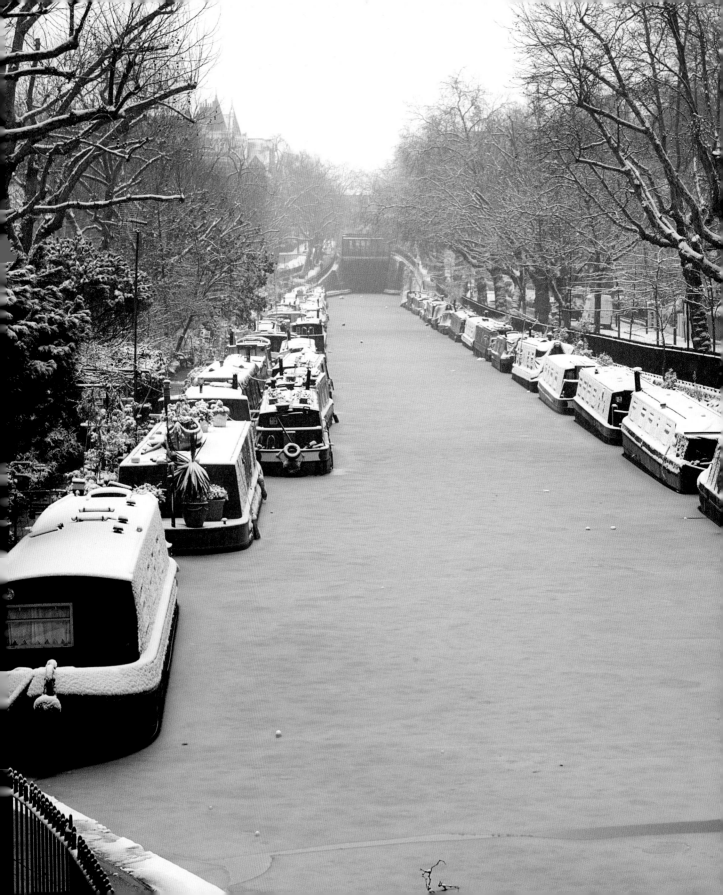

LITTLE VENICE

Local residents like to imagine that the area's canals make it a dead ringer for Venice (well, perhaps not quite a dead ringer but a bit like it). In winter snow, though, the scene looks more Dutch. You might take this for one of Amsterdam's canals. (10)

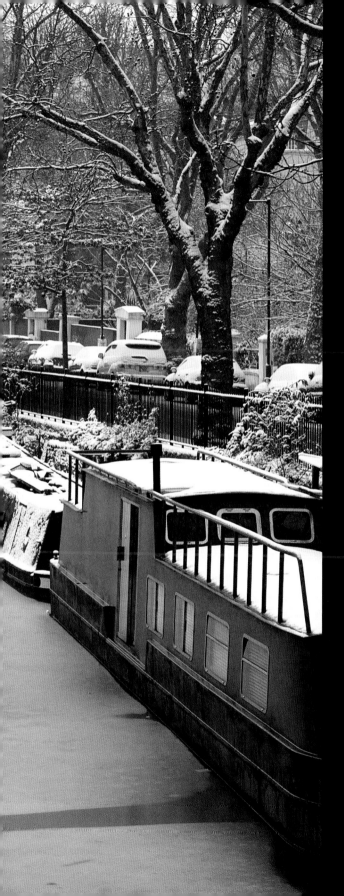

WOOLWICH FERRY

If you want to cross the river at Woolwich, you've got two options, both of them free. If you're on foot, that is. You can go down the steps into the Woolwich Foot Tunnel and walk under the river. But it's a long time since the tunnel was built and, frankly, it's not a great experience. Or you can choose the outdoor route and take the Woolwich Ferry. There's one boat which goes backwards and forwards every five to ten minutes all through the day from about six in the morning until eight at night. If you've never been on it before, you might be a bit surprised to discover that this is a biggish front-loading boat which doesn't look all that different from a ferry to the Isle of Wight or even one that might cross the Channel. And that you're sharing it with lots of lorries, buses and cars. How many Londoners know that there's a ferry like this operating six or seven miles from the centre of town? (16)

 A LONDONER TALKING

There are lots of interesting things about the Church of All Hallows by the Tower, which is right next to the Tower of London. For instance, it was founded in 675 AD, and so it was there for almost four hundred years before the Tower was built. The vicar, the Reverend Bertrand Olivier, talked to me about a few more things.

BERTRAND OLIVIER: People were beheaded on Tower Hill. One of our specialties in those troubled times of the Reformation was to look after the beheaded bodies. So we had the bodies of Thomas More, John Fisher and Archbishop William Laud. Some were eventually reunited with their heads, like William Laud, who went back to Oxford after twenty years here. Thomas More's and John Fisher's bodies are in the Tower and we say that we have John Fisher's head somewhere still in our building.

RICHARD SLATER: The Great Fire of London started not far from here. Was the church damaged?

BO: No, the church wasn't damaged at all. We were terribly lucky that William Penn Senior (father of the William Penn who went on to found Pennsylvania) was involved in the Tower and the Tower at that time was a big repository of gunpowder. He was very keen that [it] should avoid the fire and so he demolished whole rows of houses in front of the church. And as Samuel Pepys recorded in his diary, he and William Penn watched the fire from the tower of All Hallows.

RS: You have an unusual custom which involves beating the bounds.

BO: Yes, it's an ancient tradition for all parishes, which helped people to know the places where they lived and what were their own boundaries. It used to be terribly dramatic. Children might have their heads bashed against the border stones to remind them not to go beyond them. Here, we have been beating the bounds for a long, long time and one important aspect was to make sure that we protected the boundary with the City. The Tower of London, of course, is a Royal Palace. And the monarch many times tried to push into the City. The people from All Hallows were at the forefront to protect those boundaries.

We still today go round the parish boundaries on Ascension Day. We start in the middle of the river, which is of course one of our boundaries. So we go by boat with a group of children to the middle of the River Thames and one of the children beats the water. They used to be held by their two feet over the side of the boat but we're not allowed to do that any more. And then we go round the parish boundaries. And every three years, we encounter the Yeomen Warders and the people from the Tower, who do their own beating the bounds. So we have a commemorative battle to remember the times when the Tower and All Hallows were at loggerheads over where the boundary was.

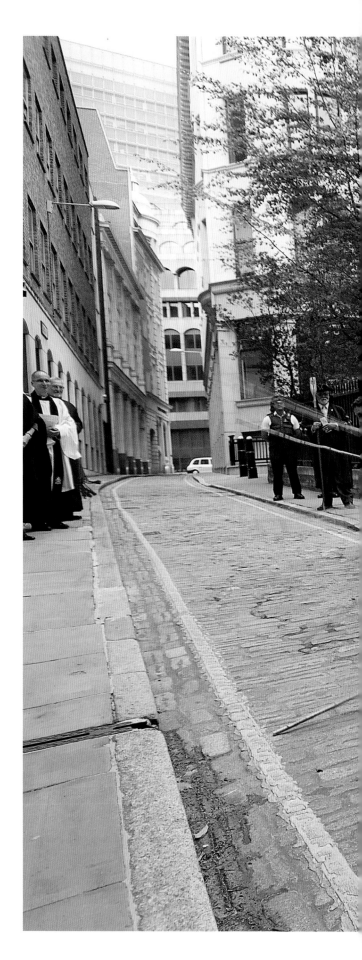

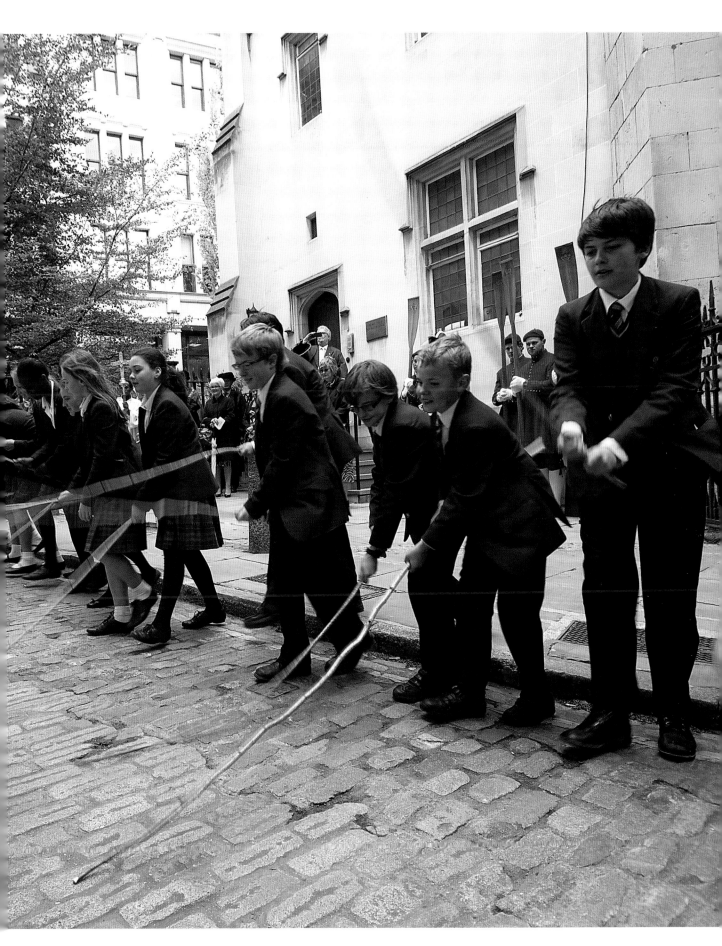

GOLDEN GALLERY, ST PAUL'S CATHEDRAL

Everybody's heard of the Whispering Gallery at St Paul's. It's a major tourist attraction and hordes of people climb the 259 steps from the cathedral floor to find out whether it deserves its name. They're all usually making too much muted noise to hear a whisper from one side of the gallery to the other. But it doesn't really matter because it's a great sensation looking down into the cathedral from up there.

Some of the visitors have heard that there's a good view out over London if they carry on higher to an outside gallery. But even if they have, a lot of them think that

they've made quite enough effort for one day and so it's surprising how few people climb the extra 119 steps to the Stone Gallery.

When they do go that extra distance, they certainly find that the views are wonderful. It's a bit annoying, though, that they have to look at them through the columns of a balustrade which runs all round the gallery above head height. Still, they take their pictures, say how great it is and head back down to ground level.

Only a tiny number of people notice that there are more

steps leading upwards. And even some of them are put off after they've started because there are 150 of these steps and you have to squeeze through some very narrow gaps in places. But when they get to the top, the select band can't believe how pleased they are that they made that extra effort. One of the best views in London is laid out before them. 360 degrees. No balustrades. No obstacles. They've climbed 528 steps to get here and they're 280 feet above the ground. This is the Golden Gallery of St Paul's Cathedral, one of London's best-kept secrets. **2**

WHITECHAPEL BELL FOUNDRY

There's a little old-fashioned shopfront on Whitechapel Road, just along from the East London Mosque (check out the Faith in London chapter for a Ramadan photograph). It's easy to miss because it doesn't look like much. But it's actually the entrance to the Whitechapel Bell Foundry. I was lucky enough to watch some bells being cast there, so I got past the inside of the shop. I discovered that it's a bit like C.S. Lewis's famous Wardrobe. First of all, we went through to a yard, which once formed part of a coaching inn. There were some massive bells lying about here. Then, beyond the yard was a series of large workshops. The first one had an impressive furnace, then being fired up, moulds in the centre of the floor and an overhead gantry. The others had vast collections of bells everywhere. Some were waiting to be recast. Others were being tuned. And the rest were finished and would be shipped off when the customers were ready for them.

Whitechapel is one of only two bell foundries in the whole country. It's been there since 1738 and, when it comes to important bells, it's hard to outdo it. Are there more famous bells in Britain and the US than Big Ben and the Liberty Bell?

I hadn't realised how very English our types of church bells are until they explained this to me. There are about 5,000 towers in the world with peals of bells and 4,500 of them are in England. Four hundred are in Wales, Scotland and Ireland, so that leaves only a hundred in the whole of the rest of the world. The significance of ringing the bells all over the country on Really Big Occasions finally dawned on me. **11**

CAVALRY BLACK PAIRS SHOEING COMPETITION, KNIGHTSBRIDGE

The Worshipful Company of Farriers is a City Livery Company. It takes part in Common Hall (featured in the Tribal London chapter) and all the other traditional City activities, like the Lord Mayor's Show (that's in the Celebrating London chapter). So you might think that it's a fuddy-duddy old organisation, going nowhere. You'd be utterly wrong. It's closely involved in helping significant numbers of young people to carve out careers.

Before motor cars, of course, horses were everywhere. And before railways, they were crucial to transport and communication. Even today, there are still plenty of horses in Britain. Just think of racing, showjumping, eventing, all the military horses, riding stables across the country and so on. All these horses need farriers to look after them. Because farriers are experts on the feet and lower limbs of horses and ponies. And they're blacksmiths too, which means that they can make horseshoes and fit them to horses' feet. It's not easy learning the skills to be a farrier. In fact, the apprenticeship lasts over four years. And it's the Worshipful Company which awards a diploma to a new farrier at the end of that long road.

The Army has lots of farriers. Well, it has lots of horses. And every year, some of the best ones come together in Knightsbridge Barracks to take part in what's known as the Cavalry Black Pairs Shoeing Competition. Each team has two men in it. There are three furnaces in the blacksmith's shop at the barracks and so three teams are competing against each other at any one time. Their job is to take some straight strips of cold metal, make them into two horseshoes of a specified design and fit them to the hind feet of the horses which are patiently waiting there throughout. The thing is, though, that they have only one hour to do all that. This requires a furious bout of measuring, cutting, heating, hammering, beating, twisting, reheating, shaping, punching, carefully trying out on the horse, heating again, more beating and shaping until the shoes are exactly right and they can be hammered onto the horses' hooves. All this manic activity takes place in the heat of the blacksmith's shop, where the furnaces are roaring away the whole time. **14**

GREENWICH FROM ISLAND GARDENS

I can't tell you the number of tourists who go down to Greenwich every year but it must be massive. And Londoners love it too. There's so much packed into a small area. The Cutty Sark is looking fabulous since its facelift. The Royal Naval College has its famous Painted Hall. Greenwich Park stretches up the hill and there's the Royal Observatory at the top. You get amazing views from in front of the Observatory. And you can have lunch at a historic inn on the waterfront. Greenwich is invaded daily by an army of people who are keen to enjoy all this. At some point, almost all of them try to take a picture of Wren's grand buildings on their cameras or smartphones.

But none of them can find a really good spot to take it from. If only they knew. All they have to do is hop back on the DLR and go one stop north to Island Gardens. There, they'd find a peaceful little public park right across the river from Greenwich. It has a wonderful view of the Royal Naval College and the Royal Observatory at the top of the hill.

And if History of Art was their thing, they'd get an extra thrill as well. Although Canaletto himself probably never came here, people think it very likely that this is the view on which his famous painting 'Greenwich Hospital from the North Bank of the Thames' was based. (8)

BRIXTON WINDMILL

Pretend that you hadn't just seen the caption to this photograph. So, before you knew the answer, where in London would you have guessed that there might still be a windmill, complete with sails, etc., which once actually milled grain? I'm willing to bet quite a lot of money that you wouldn't have come up with the answer Brixton. One of the reasons why the Brixton Windmill is so little known is that nobody ever drives past it. And that's because it's at the end of a cul-de-sac off Brixton Hill. A stone's throw, in fact, from Brixton Prison.

When it was built, in the early 19th century, it was in the middle of the countryside. But that didn't last long. By the

1850s it was surrounded by houses. Which meant that it didn't have the wind that it needed to operate. It was closed down and the sails were taken away. In 1902 the family which had always owned the mill got it going again by installing first a steam and then a gas engine to drive the millstones. But that effort was doomed too. By 1934 the demand for wholemeal flour was so low that there was no point in continuing to run the mill and it closed again. It never worked as a mill after that and it was nearly knocked down several times. But, one way or another, it survived and in the end got restored to the state that it's in today, complete with sails again. (12)

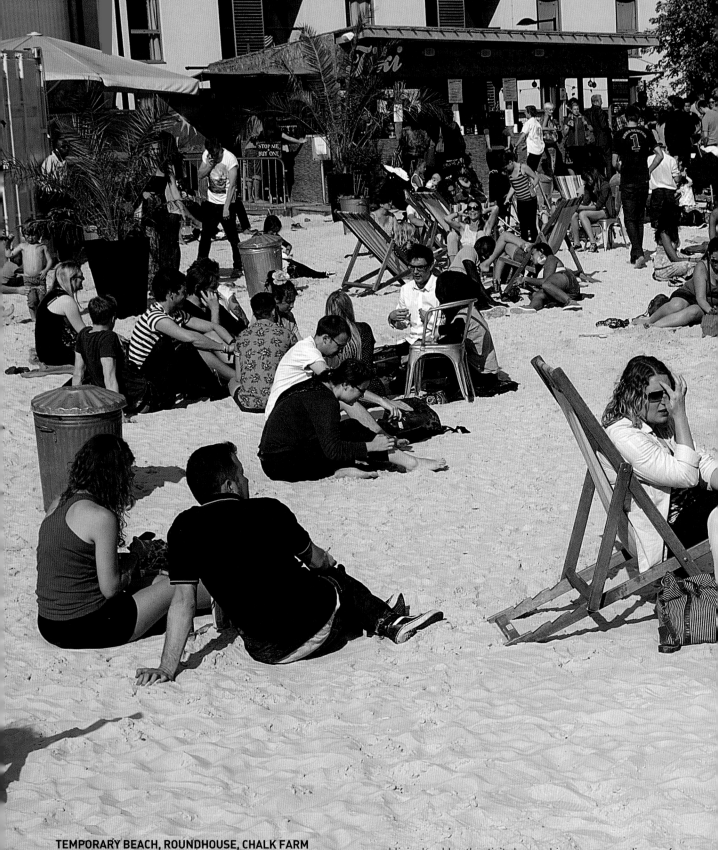

TEMPORARY BEACH, ROUNDHOUSE, CHALK FARM

For the last couple of summers there has been a beach on the terrace at the Roundhouse in Chalk Farm. They import tonnes of nice fine sand and set up deckchairs. For people who don't want to get too sunburned, they provide umbrellas round the edge of the beach. To help you feel as though you're on a real beach, there's a barbecue hut and a margarita shack. Seagulls obligingly add authenticity by perching on surrounding roofs from time to time. They've noticed that scraps get left over from people's picnics. Bad luck for the local pigeons, who stand no chance against seagulls. The only thing missing is some water to swim in. But that doesn't seem to put people off. On fine days, the beach is full of people doing all the other things that people do on beaches. **3**

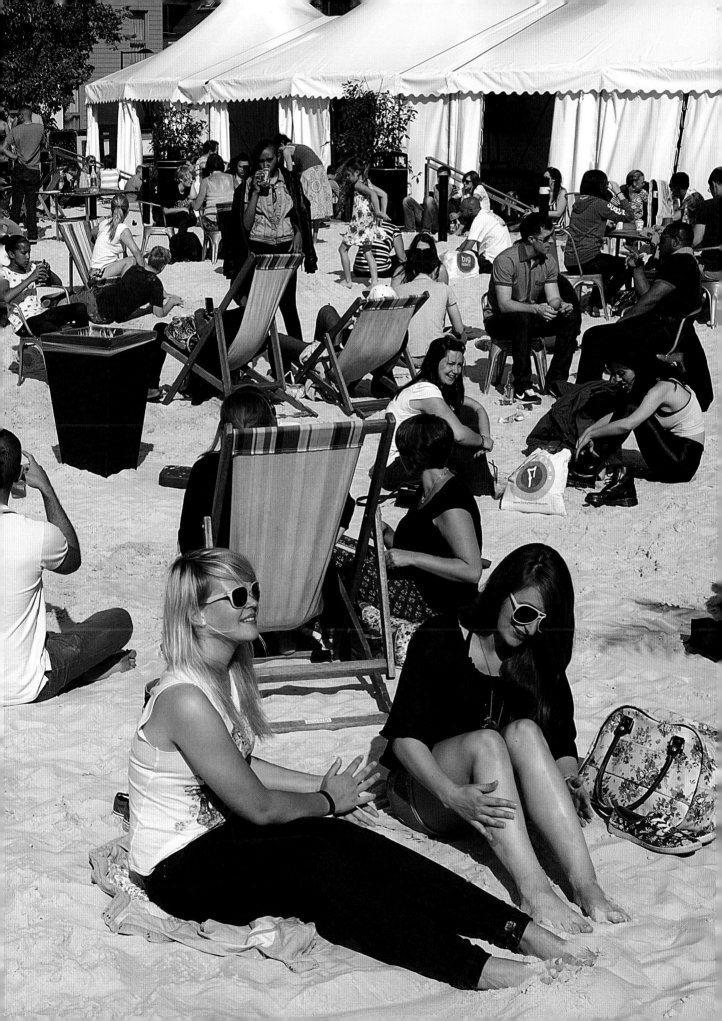

GEORGE INN, BOROUGH

If you don't know about this pub, you're unlikely to stumble across it. The wonderful galleried frontage is in a yard which you reach by turning down an alley in Borough High Street that most people don't ever notice. This building dates from the 17th century but there's been an inn on the site for much longer than that. The last one burned down. Galleries like these ones used to be common but this is the only pub in London now to have them. **5**

CHELSEA PHYSIC GARDEN

Kew Gardens are enormous and wonderful and it's not surprising that a lot of television programmes get made about them. But there's a gem of a botanic garden a short walk from Sloane Square tube station which is older than Kew and which seems to get hardly any publicity.

It started life in 1673 as the Apothecaries' Garden and its main purpose was to train apprentices in that line of business to identify the plants which they used. Not long afterwards, Dr Hans Sloane (as in Square, Street, etc.) bought the Manor of Chelsea from Charles Cheyne (as in Row, Walk, etc.) and leased the garden to the Society of Apothecaries for £5 a year in perpetuity. Deservedly, he gets a statue right in the middle of the garden.

Back in 1673 the site of the garden had been chosen with some care because, in this spot down near the Thames, there was a particular microclimate which was warmer than the rest of the country. This made it possible right from the beginning to cultivate lots of non-native plants. The first rock garden in Britain appeared here, at the edge of a pond, in 1773. The rocks that they used included stones from the Tower of London, Icelandic lava brought to England by the great botanist Sir Joseph Banks, fused bricks and flint.

The garden's origins are reflected in its collections today, as it focuses mainly on medicinal, pharmaceutical and edible plants. These collections have become crucially important as the world has come slowly to realise more and more that plants hold the key to our health and wellbeing. **15**

GRIMALDI SERVICE, DALSTON **17**

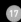 **DID YOU KNOW** that clowns go to church?

I mean, in their costumes and together in one group. There are about sixty of them. It happens once a year on the first Sunday in February at Holy Trinity Church, Dalston. They come in their suits-of-many-colours, enormous bow ties, Pierrot collars, stripy socks, green-and-yellow curly wigs, jesters' caps, painted faces and false noses, carrying feather dusters and trick flowers. In other words, their full performing rig, as if they were about to go on stage. They gather in the church for a service which pays tribute to Joseph Grimaldi, the father of modern clowning, who died in 1837. They remember too all the members of their profession who've died over the past year. This service, which is named after Grimaldi, started seventy years ago and clowns have been coming to it in their costumes since 1967.

Acknowledgements

've had an enormous amount of support from a lot of people during the five years that I've been travelling this road. When I glance through the images in this book and at the *People in London* exhibition, I'm reminded that many organisations, institutions and religious bodies kindly gave me special permission to take photographs on their premises or at their events and then went out of their way to help me when I got there. I look at the people pictured in them too and remember that many of them were exceptionally generous with their time and especially co-operative and friendly. I wish that I knew all the names of everyone who was so helpful to me and that there was enough space to list them all here.

As it is, there are quite a few people whom I do want to mention by name and to offer my very special thanks to. Alasdair Macleod of the Royal Geographical Society was unwavering in his support for the People in London project from the very beginning and I shall be forever grateful to him for everything that he did to help me. One (or should it be two?) of those things was to put me in contact with Johanna Stephenson and Sally Stiff. Johanna, in her turn, introduced me to Raymonde Watkins and, working as the editorial and design team, they've been responsible for making this book look as wonderful as I hope you think it is. Sally, for her part, worked as a design team with Chris Keeble on the exhibition and, together, they did an equally brilliant job on that. Jennie Condell and Pippa Crane at Elliott & Thompson guided me sensitively and patiently through my first experience of publishing. It's no exaggeration to say that I simply would not have completed the journey if it had not been for the people mentioned here.

There were some difficult legal issues involved in the publication of many of the images in this book and I'm extremely grateful to Anita Bapat and Bridget Treacy of Hunton & Williams for the invaluable advice which they gave me and which they continue to give me, some of it on a *pro bono* basis. I'd also like to thank Slaughter and May for the sponsorship that I received from them. I said above that I couldn't name the organisations that had given me permission to take pictures at their events but I'd like to make an exception for the Worshipful Company of Farriers and one of their Past Masters, Stephen Scott. Not only did Stephen arrange for me to photograph two Farriers' Company events. He was also instrumental in gaining me admission to the Common Hall ceremony in the Guildhall, an event not usually photographed by outsiders.

Steve Pirrie educated me in everything to do with social media. For the video film which was such an essential part of the Kickstarter crowd-funding campaign to raise funds for this book, the director was Gemma Rawcliffe, the cameras were operated by Bud Gallimore and Magda Przybylski and the editor was Becky Solomons. They all did a fantastic job. Special thanks, too, are due to John Warr, who gave us permission to film the ride out of the Chelsea and Fulham HOG (Harley Owners Group) and Yogesh Patel, who arranged for us to film at BAPS Shri Swaminarayan Mandir, better known as the Hindu Temple, in Neasden.

There's a long list of people who generously gave retrospective consent to the appearance in this book and at the exhibition of photographs taken on their premises or at their events, in some cases as an exception to their normal policy.

My thanks to all of them. They are, listed in alphabetical order: the Ancient Order of Druids, the George Inn Borough, the Greater London Authority, Hackney Council, Hyde Park Stables, the International Society for Krishna Consciousness, Mudchute Farm, Network Rail, the Royal Parks, the Serpentine Swimming Club and Tower Hamlets Council. I'd also like to express my gratitude to Aryz, Phlegm and Ben Slow for allowing me to reproduce their street art.

My biggest thank you of all goes to my wife, Julie, who, for the last five years, must have felt that I'd deserted her for a life on the streets. My never-ending search for photographs frequently took me out of the house at weekends, in the evenings and at other anti-social hours. And the task of producing this book and staging the exhibition has been astonishingly time-consuming too.

Finally, I was amazed and delighted by the support that my Kickstarter campaign received. My grateful thanks to everyone below:

The Marquess of Aberdeen
Charles Babumba
Andrew Balfour
David M. Barnard
Anthony Beare
Mark Bennett
Marie-Jeanne Binet
Mark Bingley
Simon Blakey
Nigel Boardman
Sarah Boardman
Tim Boeckmann
Jessica Borthwick
Philip and Marie Breene
Victoria Bullen
Ralph Bunche
Lachlan Burn
Cecile Buxton
Philip and Sarah Campbell
Susan Chisholm
Sarah Chisnall
Tim Clark
Edward Codrington
Lucy Codrington
Philomena Codrington
Simon Codrington
Janet and Alan Collingwood
Daniel and Suzanne Colson
Steve Cooke
John Crosthwait
Jennifer de Lotz
Ian and Belinda Derrin
Sarah Dietz
Mark Dwyer
Gary Eaborn
Graham Earles
Charmian Eggar

Tim Eggar
Carl Elliott
Giles Elliott
Laura Elliott
Lars Evander
Ben Evans and Ingrid Postle
Nick Forde
Steve Forden
David Frank
Dieter Goldschmidt
Michael Goold
Sam Gordon
Andrew Graham
Colin Grant
Simon Hall
Hamilton & Neale
Katie Hardyment
Martin Hattrell
Catherine Hickman
John Hickman
Isobel Holland
Martin Hunt
Melvyn Hughes
Tim Ingram
Andrew Jackson
Glen James
Patrick Jennings
Nigel Johnson-Hill
Martin Jones
Bir Kathuria
David Kaye
Alexandra Kett
Peter Kett
Ben Kingsley
Jane Kinnersley
Chris Knight
Sarah Knight

Yusef Kudsi
Paul Lamb
Penny Levinson
David Lightfoot
Sara Luder
Robert D. Lutes
Dana Lynch Jenkins
Gwyneth Macaskill
John Macaskill
Robin MacCaw
Morgan Lloyd Malcolm
Ellie Mann
Michael Mann
Roddy Mann
Roger Martin-Fagg
Dermot and Pam McMeekin
Angela McDonald
Richard Mead
Patrick Meier
Maria Melville
Ann Montier
Annabell Morrissey
Nick Morrissey
Alison Musgrave
Rob Neil
Di Nicholson
Malcolm Nicholson
Juliet Nissen
George Oks
Bertrand Olivier
Phyzzie Page
Charlie Philip
Darrell Porter
Jane Postle
Alexander Priestley
Jamie Priestley
Jeremy and Susie Priestley

Roddy Priestley
Haroun Rashid
Charles Richards
Margaret Robinson
Simon Robinson
Nick Roditi
Emma Rose
Pauline Russell
Christopher Saul
Brian Selvadurai
Ham Shields
Amy Slater
Andrew Slater
Freddie Slater
Mark Slater
Christopher Smith
Paul Stacey
John and Caroline Stephen
Edward Stephenson
Johanna Stephenson
Gardner Thompson
Simon Trigwell
Primo Vanadia
Richard and Lesley van den Bergh
Igno and Liesbeth van Waesberghe
Sanjev Warnakulasuriya
Elaine Waterhouse
Michael Watts
Diego Wauters
Martin Whelton
Graham White
Nicholas Wilson
Michael Wotton
John Wright

RICHARD SLATER is a professional
photographer based in London. He was born
there and has lived most of his life there too.
He thought that he knew his native city until
he set out on the five-year exploration which
resulted in this book.

He would like to thank Prichard Mhlanga
for taking this photograph.